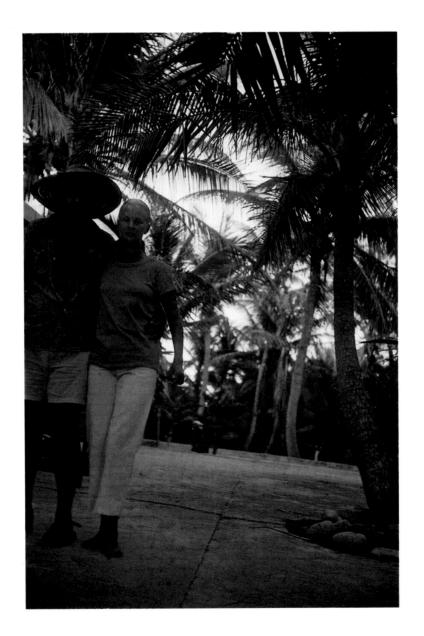

SALT CAY, BAHAMAS | JANUARY, 1967 | This picture is one of the author's first photo-
graphs, taken at age 6½ of her parents, Aram Avakian and Dorothy Tristan.

WINDOWS
of the SOUL

[MY JOURNEYS IN THE MUSLIM WORLD]

نوافذ الروح

Alexandra Avakian

FOCAL POINT

NATIONAL GEOGRAPHIC

WASHINGTON, D.C.

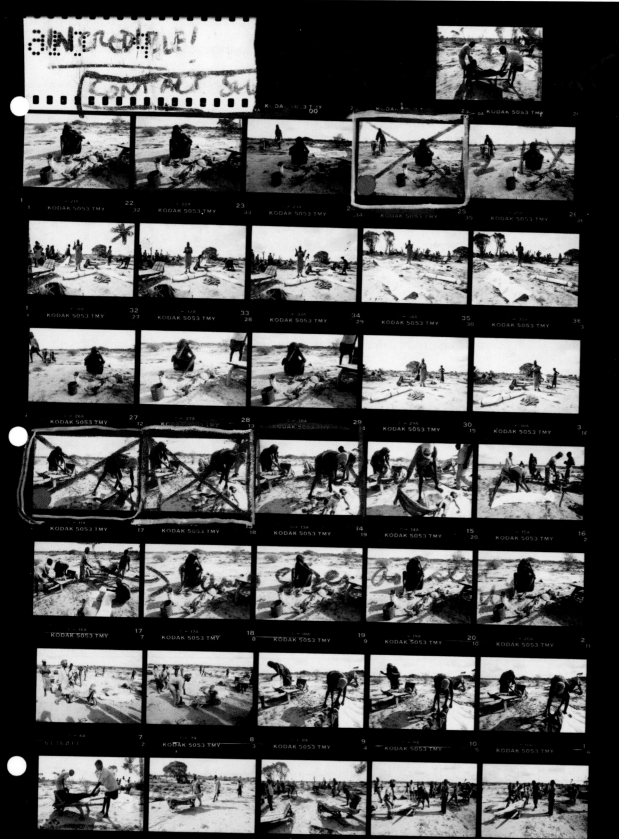

[C O N T E N T S]

PREVIOUS PAGES: SHATI REFUGEE CAMP, GAZA | FEBRUARY 1994 | Cold rain streaks the window of my car at sunset as I scout for pictures.
OPPOSITE: BAARDHEERE, SOMALIA | NOVEMBER 1992 | A contact sheet shot by the author, with editing marks by Robert Pledge, Contact Press Images director and editor. Photographers out in the field need the help of their editors, who help choose pictures for publication.

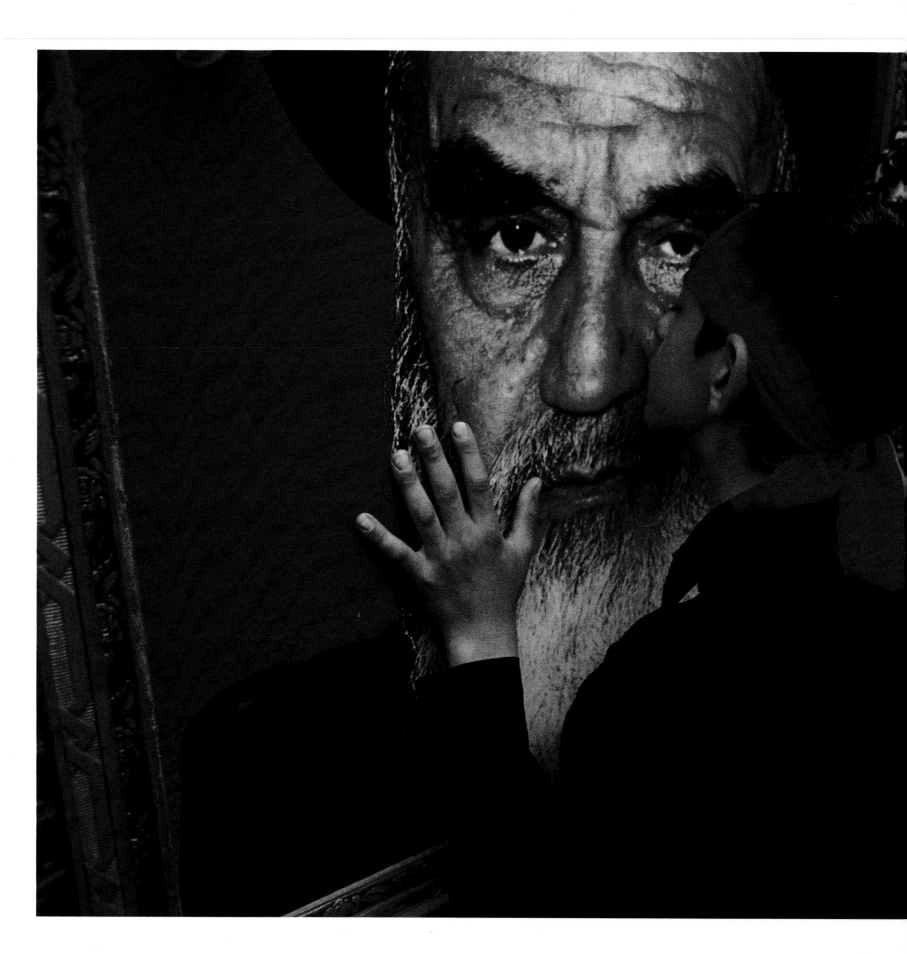

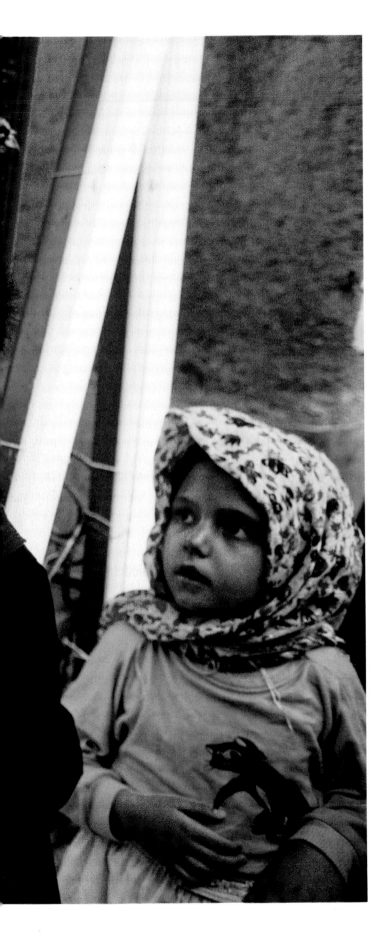

JAMARAN, IRAN | JUNE 1989 | Children mourn Ayatollah
Khomeini's death outside his modest house in a north Tehran suburb.

OUZANE, MOROCCO | MAY 1989 | A boy smokes a cigarette while playing foosball in a café.

10

BAARDHEERE, SOMALIA | NOVEMBER 1993 | A boy who died in the famine that
resulted from the Somali civil war awaits burial.

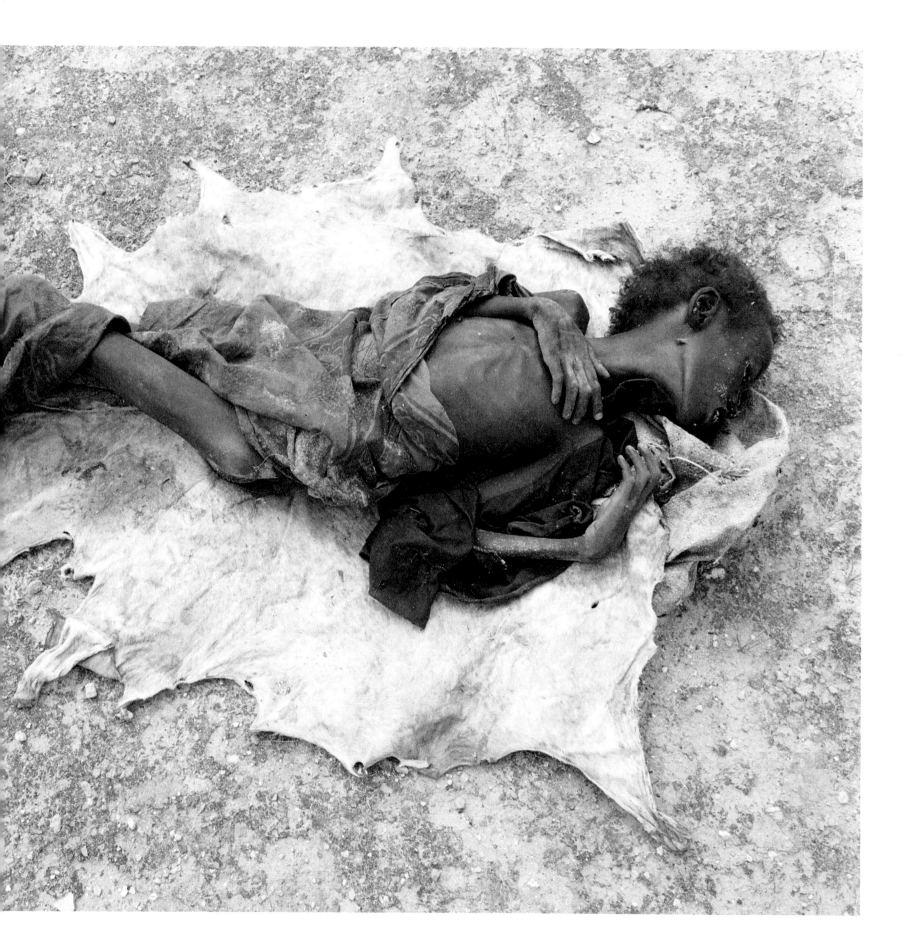

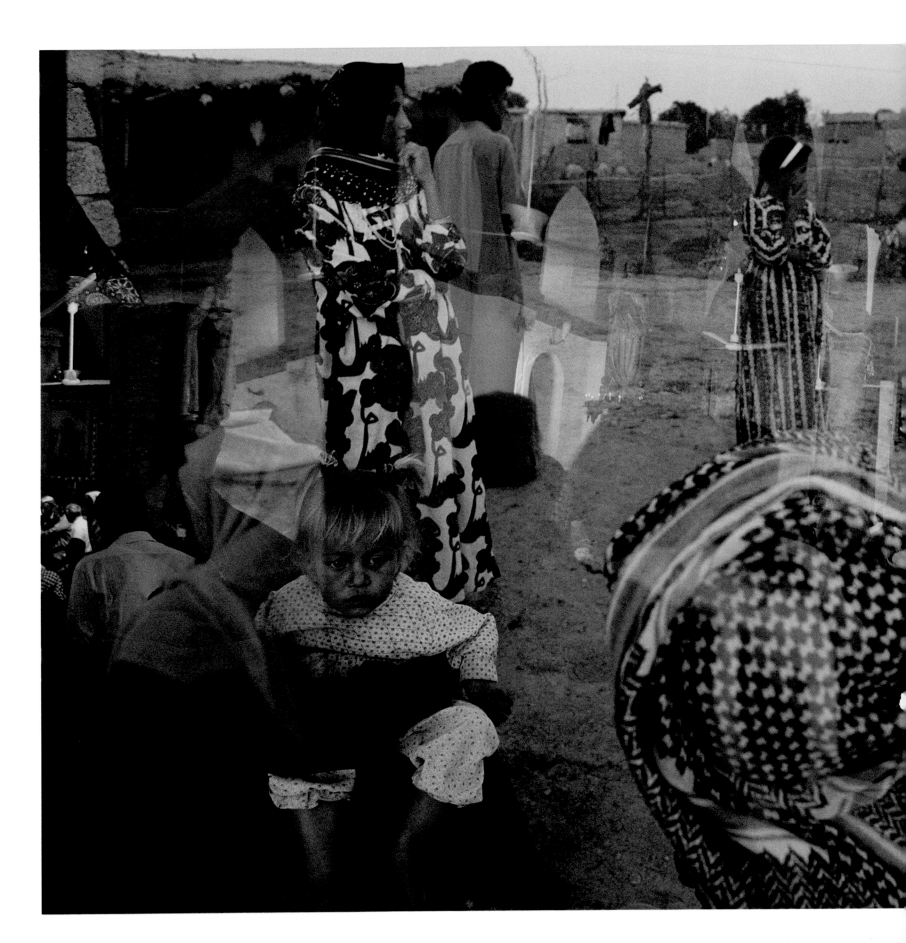

NEAR NIMRUD, IRAQ | MAY 1999 | This double exposure shows a Muslim family
resting at the end of the day and Karakosh al-Tahera, a Catholic church.

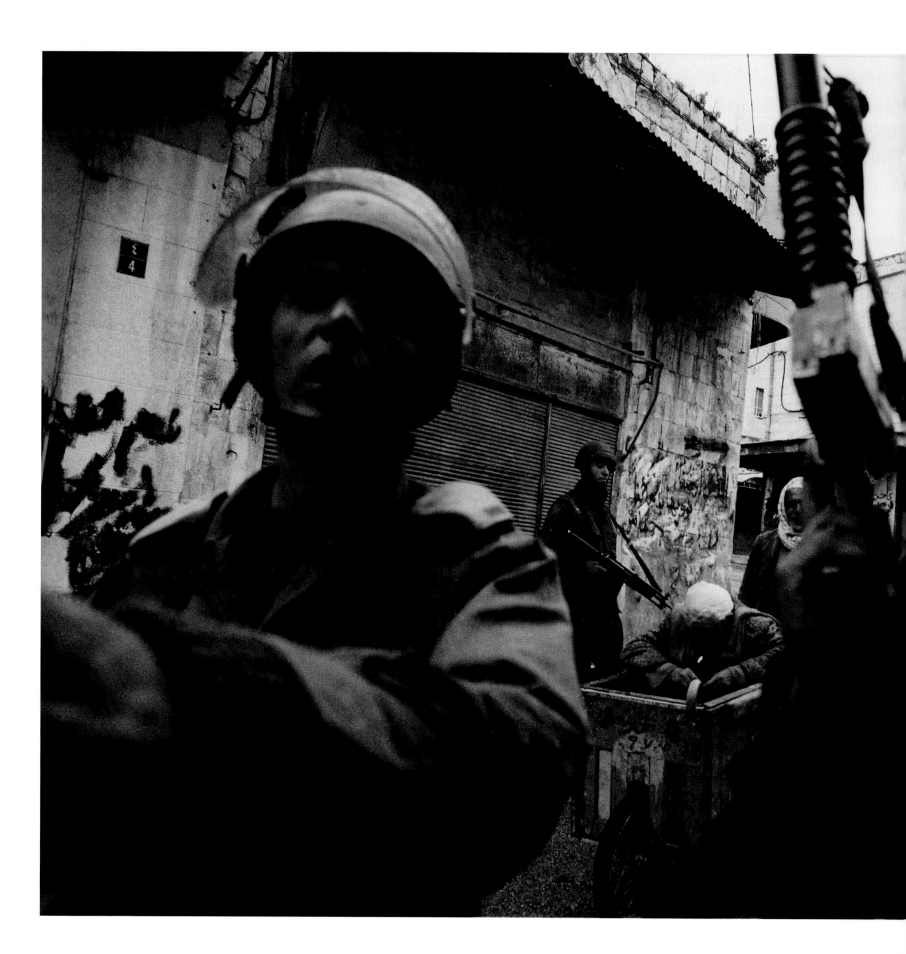

NABLUS, WEST BANK, OCCUPIED TERRITORIES | APRIL 1989 | Israeli soldiers patrol
and a Palestinian man is pushed in a makeshift wheelchair during a daytime curfew.

CAIRO, EGYPT | DECEMBER 1991 | Women wait for a bus in front of a mosque.

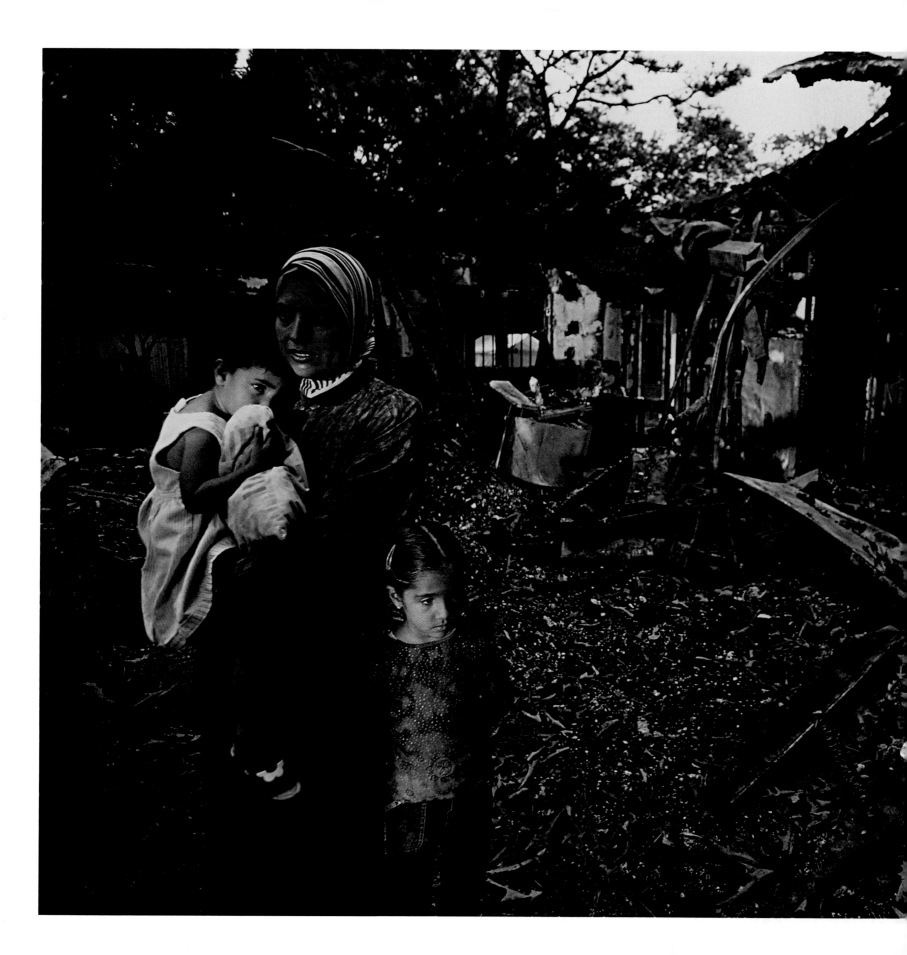

SAVANNAH, GEORGIA | SEPTEMBER 2003 | Janeth Hammid and her children stand in the burned-out ruins of their mosque. The Islamic Center of Savannah was torched by an arsonist who was never apprehended.

تقديم

[F O R E W O R D]

I met **Alexandra Avakian** for the first time in winter 1998, but I knew something about her work well before that: At the end of 1994, she approached **National Geographic** with

pictures she had made in Gaza after living and working there for more than a year. The photographs she brought to us were striking for their directness, their chaotic authenticity, and their human feeling. Perhaps most impressive of all to me was the fact that Alex was obviously willing to face enormous danger to get these great pictures. National Geographic sent her back to Gaza to finish her story.

When I finally met Alex in person her Gaza story had been published in the magazine's September 1996 issue, she had won the Pictures of the Year Award of Excellence for that work, the magazine had gone on to publish her story on Romania, and she was deeply involved in photographing an article for us about the Islamic Republic of Iran. As before I was drawn by the power of her work, but this time I was impressed by the gentleness of the person behind it.

In Iran Alex gained unprecedented access for an American photojournalist. She traveled with Iranian president Muhammad Khatami and visited moderate spiritual leader Ayatollah Mahallati in his rose garden at home in Shiraz; she photographed the daily lives of nomads, villagers, and city dwellers. She visited Iranian Kurdistan, where she saw a Qaderi Sufi Dervish ritual normally off-limits to women and a

holy shrine forbidden to non-Muslims—all in a country the U.S. government has considered an adversary since its 1978–79 revolution.

Our mission at National Geographic is to show our readership the life behind the news—and to do this with objectivity, texture, depth, and intimacy. Alexandra Avakian has made and continues to make a unique contribution to this aspiration of ours. In the Palestinian territories and Israel she lets us into the daily lives of people struggling to survive an excruciating, at times seemingly endless, conflict; in Somalia and Sudan she shows us the innocent victims of civil war and famine; in post 9/11 U.S.A, we go behind closed doors and out in the street with Alexandra as she shares with us the lives of American Muslims; and in Lebanon she brings us into the world of Hezbollah, a highly secretive guerilla, political, and social organization that the U.S. government has classified as a terrorist group.

During the first decade of her career—between 1986 and 1996—Alexandra actively sought out conflict and danger with an urgent desire to show its cost. She often worked at great risk, braving missile fire in the former Soviet Union, land mines and violent militias in Somalia, and gunfire and a beating in the Palestinian territories.

For seven months in 1986 and 1987, Alexandra covered violence and daily life in Haiti after the fall of "Baby Doc," dictator Jean-Claude Duvalier. While based in Moscow for two years, she covered the fall of the Soviet Union and the struggles of its republics to break free of oppression, some of them falling into civil war. Then she happily and with relief also had a break from the violence, covering two stories that unfolded relatively peacefully—the fall of the Berlin Wall and Czechoslovakia's Velvet Revolution.

Alex has delved deeply into the broader contexts of her subjects from early on in her career. She wanted to understand where conflict originates—whether from poverty, struggles over land, or oppression or from age-old ethnic tensions. In Romania, she photographed the lingering challenges of street children and Roma rights, left over from the Ceauşescu era, while documenting the robust Romanian embrace of capitalism and Western-style freedoms. In the Islamic Republic of Iran in 1998 people were pushing for more cultural freedom after nearly twenty years of Islamic rule, and Alexandra showed us a country teetering on the brink of changes it would not for the moment fulfill.

In the course of Alex's explorations and coverages she never lost sight of her photographic values, and these are many. Her approach is often a cool one: let the photograph unfold. Her pictures are straightforward in their portrayal of reality, yet as layered and subtle as life itself. At times her style is cinematic, at other times still. She wants diversity: the simplicity of a portrait or a detail or a landscape is occasionally better than complexity. And these images have the power of intimacy that allows the viewer in and up close. A tall order, but Alex never was one to choose the simple path.

It is hard to know what has drawn Alexandra to cover stories such as those on the pages that follow. Perhaps it's "in the genes," given her family's rich cultural heritage. Maybe it's a personal counterpoint to her comfortable youth, having grown up in Malibu and Manhattan.

I think above all it's because Alex is a true humanitarian. Her photographs are driven by great passion and a great heart. With courage and sensitivity she offers a rare insight into unfamiliar cultures and societies. Her inspired photography in terribly fraught circumstances bears witness not only to pain but also to beauty and joy. She shows us oppression and also freedom, poverty and also power. This book—Alexandra Avakian's Muslim Journey—is sure to enlarge your understanding and inspire your admiration as it has mine.

John M. Fahey, Jr.
PRESIDENT AND CEO
NATIONAL GEOGRAPHIC SOCIETY

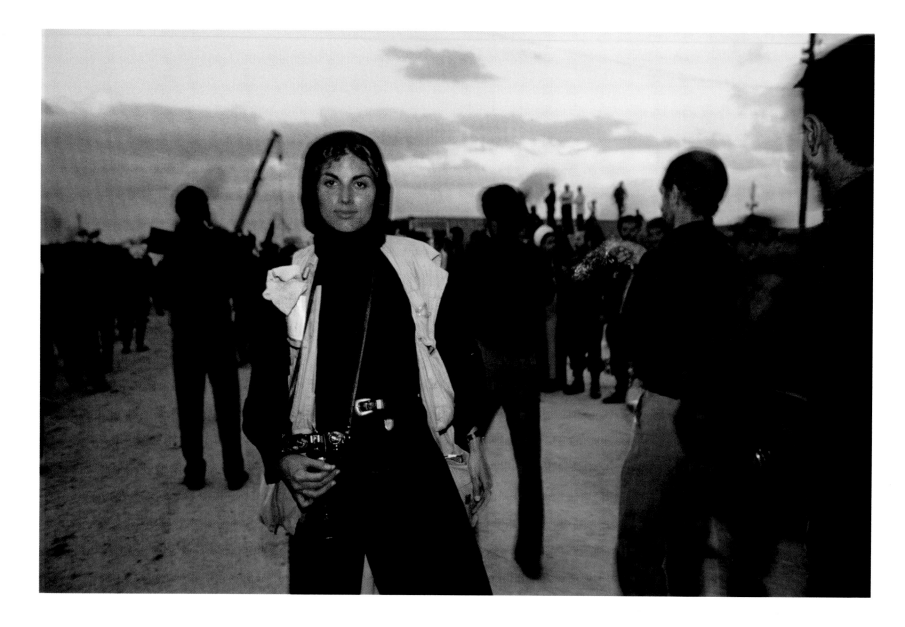

SOUTH OF TEHRAN, IRAN | JUNE 1989 | The author was photographed at the temporary grave of Ayatollah Khomeini in Beheshti Zahra cemetery as men beat themselves with chains in mourning. *Photographer unknown, collection of author.*

مقدمة

[I N T R O D U C T I O N]

For nearly twenty years I have photographed Muslims around the world. I have witnessed life, death, weddings, prayer, famine, and uprisings. The photographs in this book are a memoir of that time.

I left my native New York and California to work for extended periods of time in countries in the throes of political upheaval, countries like the former Soviet Union, East Germany, and Czechoslovakia. However, even as I was covering the death of communism in Eastern Europe, I felt myself constantly drawn back to Muslim countries, themselves sometimes in the grip of political change. As my family watched our home in Malibu burn to the ground, I was sleeping in a Palestinian refugee camp thousands of miles away. When my own Manhattan loft caught fire years later, I was in the Syrian Golan.

It may seem unusual for an American woman to have risked so much in these sometimes dangerous situations and mostly male-dominated societies, but for me it was the most natural thing in the world. Nothing could have kept me away.

A third-generation Manhattan native, I led a charmed life as a child. My parents were at the cutting edge of counterculture in the 1960s. My father, Aram Avakian, was a movie director and editor whose film *End of the Road*, was hailed in 1969 for pushing aesthetic limits and political buttons. My mother, Dorothy Tristan, began as a Ford model, but for the past fifty years

has been a stage and screen actress as well as a screenwriter. My stepfather, John D. Hancock, is a distinguished theater and film director.

My brother and I grew up on the movie sets and theatrical stages where they worked. Our family friends were famous actors, choreographers, and writers—artistic inspiration was everywhere. And our many travels whetted my appetite for adventure.

Lessons in photography began early with my father. I remember sitting on his lap as a child, watching him edit a movie and being allowed to cut film. I drew stories on blank strips of film and played them for him on the Moviola. My father often let me look through the camera to show me how the director of photography had set up a shot.

We pored over photo essays in *LIFE* magazine together, and at the age of nine I announced that I wanted to be a National Geographic photographer when I grew up.

As a teenager living in Malibu with my mother and stepfather, I spent hours in my school's photography darkroom, loving the smells of freshly opened film and fixer. When it was time to get serious about college, I moved back

to New York to finish high school and attend Sarah Lawrence College.

Again, my father took me in hand, often spreading out the black-and-white prints I'd made in the darkroom he'd built for me and helping me edit them into a story. He often sent me out to shoot more if he felt I needed it.

He allowed me to grow and change, even when some of my professors worried about my choices. I left Sarah Lawrence for a year to study photography and take classes at the International Center of Photography and the New School. And I threw myself into a project documenting the life of a transient hotel in Greenwich Village. By the time I returned for my senior year, I was ready for my first exhibit.

My photographic boundaries were expanding. During a Christmas vacation in 1982, I photographed Haitians forced to work for fifty cents a day in the Dominican Republic, hiding out with a priest whose life's work was to help the poor .

Within a year I had graduated from Sarah Lawrence, gotten an agent, and had my first paid assignment for a national news magazine. To support myself, I worked for a fashion

photographer. My personal project was a months-long photo essay about a homeless family.

Still, since college I had been fascinated by revolution and civil war and longed to learn more about the lengths to which people go to change their living conditions and achieve basic human rights. I was less interested in ideology than in the human capacity for bravery in the fight for freedom.

The idea of covering conflict intrigued me. Even when I slept, I often had dreams of working in a foreign city in the midst of an uprising, with demonstrators and fires in the street. My first chance to see such things in my waking hours came in Haiti in 1986, when President Jean-Claude Duvalier was thrown from power by people who were fed up with poverty and repression.

Despite all his earlier help, my father now refused to edit my work. He did not want me to be a conflict photographer. His role shifted from mentor to father.

Then he died suddenly of a heart attack in 1987. I was devastated. I realized his influence on me was not merely artistic. Though my mother is of European descent, I became fascinated by my father's side of my family—the Armenian side—and the tragic past that had only been vaguely alluded to when I was a child.

I had heard about the roughly one million Armenians who had been killed by the Ottoman Turkish government in the genocide of 1915. After finally learning the family history in my early twenties, I came to understand the horrors my ancestors had experienced. More than ever, I felt the need to photograph refugees, uprisings, fights for freedom.

My paternal grandmother's family, from T'bilisi, Georgia, had been wiped out under Stalin in the Soviet Great Terror of the 1930s, when millions of people were taken away and executed, or sent to prison camps in Siberia. She never heard from them again and lived silently with that pain until her death in 1969.

My grandmother survived because she was already an American, having arrived at Ellis Island in 1923 with her two small children, George and Mary. My grandfather, Mesrop, had come to Manhattan before her, sent by his older brothers to establish the family business with a bale of Oriental carpets they had sent ahead.

Their business—Avakian Brothers—grew and the Fifth Avenue store became a huge success. My brother and I loved to jump among the piles of lustrous rugs in the showroom until we collapsed, laughing, coughing from the dust. In the 1960s, when gourmet rice was virtually unknown in this country, we received our own priceless stash from Iran, grown from ancient seed, rolled into rugs, and shipped to Avakian

Brothers in New York. It was doled out to family members as the precious commodity it was.

My grandparents belonged to that generation of immigrants who wanted their families to grow up absolutely American, unburdened by their own past, yet we were Armenian in so many little ways.

I wish I had been old enough when my grandfather was alive to understand and appreciate what he did for us in bringing our family to the United States. Having fled the Armenian Genocide, experienced the Russian Revolution, the Great Terror, and the general instability of existence in the region, the Avakians

OPPOSITE, CLOCKWISE FROM TOP LEFT: T'BILISI, GEORGIA, USSR | DATE UNKNOWN | The author's grandfather Mesrop and grandmother Manushak, seated, with her brother Khoren Avedisian, who was arrested and disappeared in Stalin's Great Terror. *Collection of author.* | PINEWOOD STUDIOS, U.K. | 1973 | The author's father, directing the British actors James Mason and Sir John Gielgud in the film *11 Harrowhouse. Collection of the author. Photo by James Mason.* | A caption envelope from a *Time* assignment in the West Bank, occupied territories, March 1988. | GIZA, EGYPT | DECEMBER 1991 | The Pyramids seen through a car windshield during a vacation. | HAFTVAN, IRAN | FEBRUARY 1908 | The funeral of Garobed Avakian, the author's great-grandfather and a village elder of the town. Many Armenian women, Christians, wore head and face coverings at that time. *Courtesy of Medik Babloyan.* | MOSCOW, RUSSIA | DATE UNKNOWN | Garobed Avakian, the author's great-grandfather, had his portrait done while on a business trip to Moscow. *Collection of the author. Photo by Opitich.*

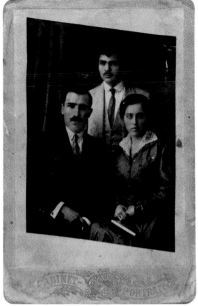

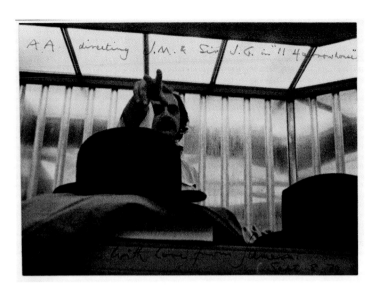

A.A. directing J.M. & Sir J.G. in "11 Harrowhouse"

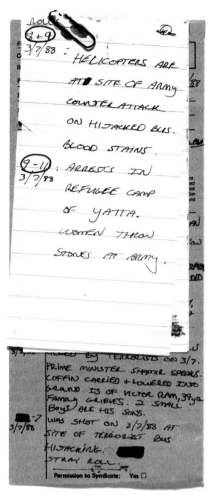

Rou
2+9
3/7/88 : HELICOPTERS ARE
AT SITE OF ARMY
COUNTER ATTACK
ON HIJACKED BUS.
BLOOD STAINS.
9-11
3/7/88 : ARRESTS IN
REFUGEE CAMP
OF YATTA.
WOMEN THROW
STONES AT ARMY.

KODAK 5052 TMX

3/7 ...KED BY TERRORISTS ON 3/7.
PRIME MINISTER SHAMIR SPEAKS.
COFFIN CARRIED + LOWERED INTO
GROUND IS OF VICTOR RAM, 39 yrs.
FAMILY GRIEVES. 2 SMALL
BOYS ARE HIS SONS.
7
3/7/88 ...WAS SHOT ON 3/7/88 AT
SITE OF TERRORIST BUS
HIJACKING.
STRAY ROLL.
Permission to Syndicate: Yes ☐

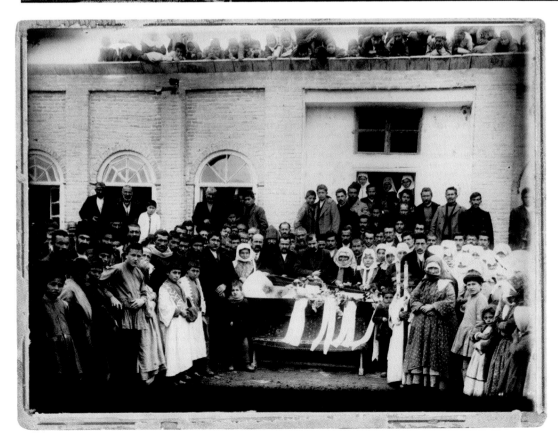

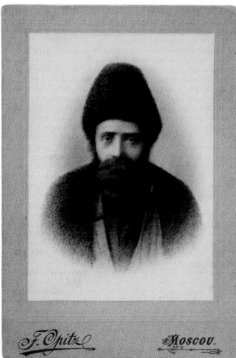

F. Spitz Moscou.

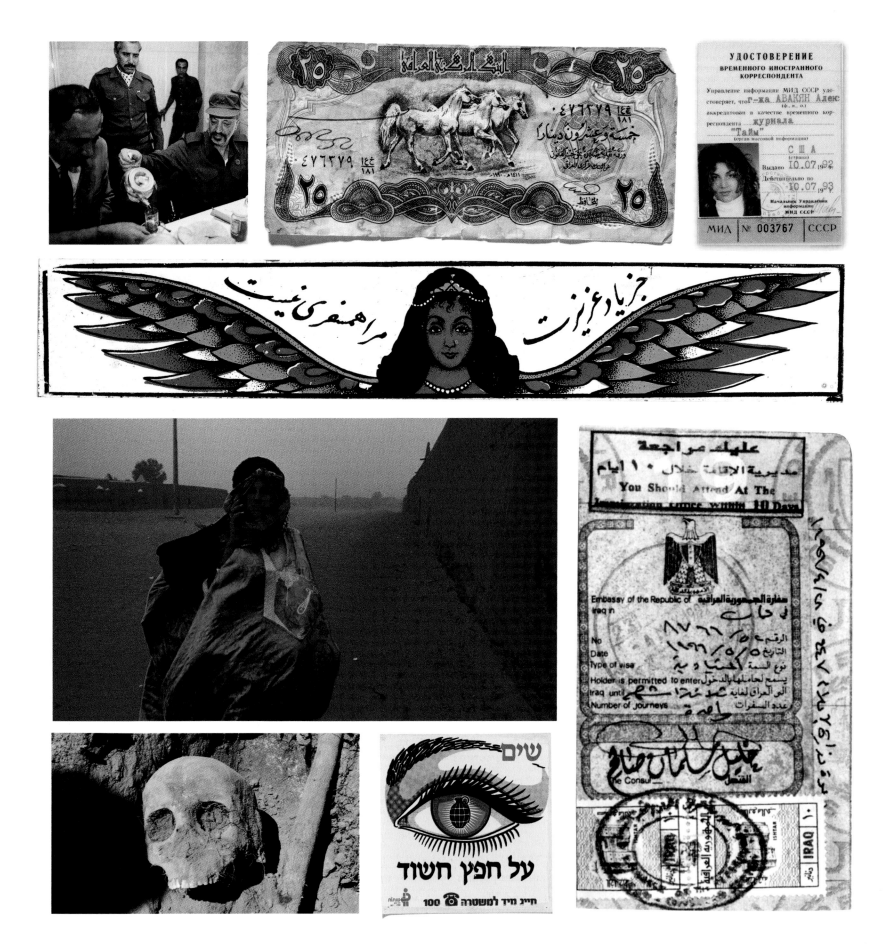

understood how to survive. As the 1915 geno-cide spilled over the Ottoman Turkish-Persian border, my family joined the ragged, terrified exodus of Armenians to what later became the Soviet Caucasus. After the Russian Revolution, they moved back to Persia.

Even as my grandfather lay dying in New York at the age of 92, he would sometimes ask urgently in Armenian, "Are the gunmen in the streets? Are the children safe?" Often he

would shout, "Hide the women, the children! Get your guns!"

The Armenian diaspora still lives all over the world. Arab countries, too, have been a safe haven for the survivors and their families, embracing them as citizens even now. Persians have also lived peacefully with their Arme-nian population for centuries. In 1915 there were some brave Muslims who rescued and hid Armenians as they were hunted down, and sometimes arranged escape.

In 2005 I traveled for a third time to Syria, which was part of the Ottoman Empire in 1915. I photographed the sheikhs of twelve Muslim Arab tribes that had saved Armenian children and raised them as their own. They had come to Dier el-Zor church on Genocide Day. Then I photographed some of the mass graves of the genocide at Margada and Ras-ul-Ain, where I found children's molars and the bones of women; most of the men had been killed back in Turkey.

My work has allowed me to combine my passion for photography and telling a story through pic-tures, my ancestors' shared history with peo-ple in conflict, and my fascination with revo-lution. I learned early the hazards of being a woman in the heavily male photography world. There have been times when editors, subjects, and even peers tried to trivialize the abilities of a "girl." There are certainly more women in

photography now than when I graduated from college, but freelance female photojournalists working abroad for ten or more years are still relatively rare. And with good reason.

The loneliness of life on the road can blow through the heart just as the financial instabil-ity strikes at the bank account, whether you're a man or a woman. Sometimes, in very hostile countries, my only true friends were BBC radio and a good novel at the end of the day.

One needs to be born for this life of a freelance international photojournalist, willing to sacri-fice security, relationships, and the comforts of home. It's hard, but thrilling. A photography teacher advised me a long time ago, "Embrace the insecurity," and they were words I lived by. I married and am a parent now, but that kind of love was out of my reach for years, lost in the pursuit of hard news.

For many years I documented violence and political struggles. I took pride in being a mes-senger of the news and had to assess dangerous situations in seconds, finding the best place to shoot from without being shot at and always finding the quickest means of escape.

I learned the unfolding anatomy of a riot and how best to navigate it. Knowing when to sim-ply stay inside was also important. Mostly the fear was manageable, but did get away from me sometimes, leaving me scared when I needn't

have been, or fearless when I should have been afraid. Now I still work in troubled countries, and peaceful ones, and do not pursue open conflict as a subject.

As I've traveled the Muslim world, I have been moved by its acceptance of me and the help I've gotten from so many ordinary and extraordinary people. I dress modestly and, when circumstances require, in Islamic attire, in consideration for cultural boundaries. At times the traditional *hijab* is as necessary for my work as a passport or a camera.

Some secular Muslim women have complained to me that if I wear hijab, they will never have a chance to refuse to wear it. But it was never my role—or my desire—to challenge local mores. Another complaint I heard from some women was that I am allowed more freedoms as a foreign woman in their countries than they were. I can't deny this.

Among the most interesting lessons was that headscarves are not necessarily symbols of oppression for Muslim women, as many Westerners believe. Whereas secular Muslims prefer to shun the scarf, some Islamic feminists believe that to cover oneself is empowering. They say the hijab denies men the ability to assess a woman's physical beauty, forcing them to deal with the human being.

In Jordan, Turkey, and Syria, women have more freedoms, but while countries like Saudi Arabia and Iran are officially Islamic they differ greatly. In Iran women work, vote, drive cars, and represent the majority of university students. The same is not true in Saudi Arabia.

There is a notion that it is easier for foreign men to work in Middle Eastern countries than it is for foreign women. But that is not necessarily so. In fact, women have access to both the male and female worlds of a conservative Muslim society, whereas men are mostly restricted to the male side.

Even with great access, sensitivity and etiquette are key. Every culture is different, so it is always important to learn its rules quickly. Apologize for turning one's back on a person. Never show the soles of your feet. Know how to speak about a newborn baby to its mother. I've found eyes often say more than words, that I absorb the essence of a place best if I like the local music, and being open and clear about my angle on a story is the best way to gain trust— and access. My aim is always to go as unnoticed as possible in the street, to become the fly on the wall, to cover both daily life and exceptional circumstances from an unobtrusive spot.

I developed a special connection and enduring friendships with members of a community many Americans know only through images they see in the news. I have been given many nicknames: *Ostaazit al shams* (teacher of the sun), *amiirah* (princess), and in Somalia *fanahaleyn* (woman with the space between her teeth), to name a few. Twice, Muslim fathers asked me to convert to Islam because they wanted me to marry their sons. Other times, Muslim clerics have asked me to convert after our lengthy conversations. Each time, I was touched and flattered.

But many Americans have a different impression. They see only brief news reports, which tend to prominently feature violence and anger. While my own photographs contributed to these quick news bites, there is much more to the story.

Here, I hope to share a wider view of my journey. I am neither an academic nor an authority on Islam, nor the Middle East. This book is not a statement about Islam or of the peoples of the Muslim world. It is simply a memoir of what I saw and experienced in these lands.

I am fortunate to have had great editors and mentors, particularly at *National Geographic*, *Time*, *The New York Times Magazine*, and Contact Press Images. Without their support I never could have worked abroad as long or as successfully as I did.

This book is dedicated to the people in it, to those left out of it, to those who helped me along the road. Last but not at all least this book is for my family—especially for my father.

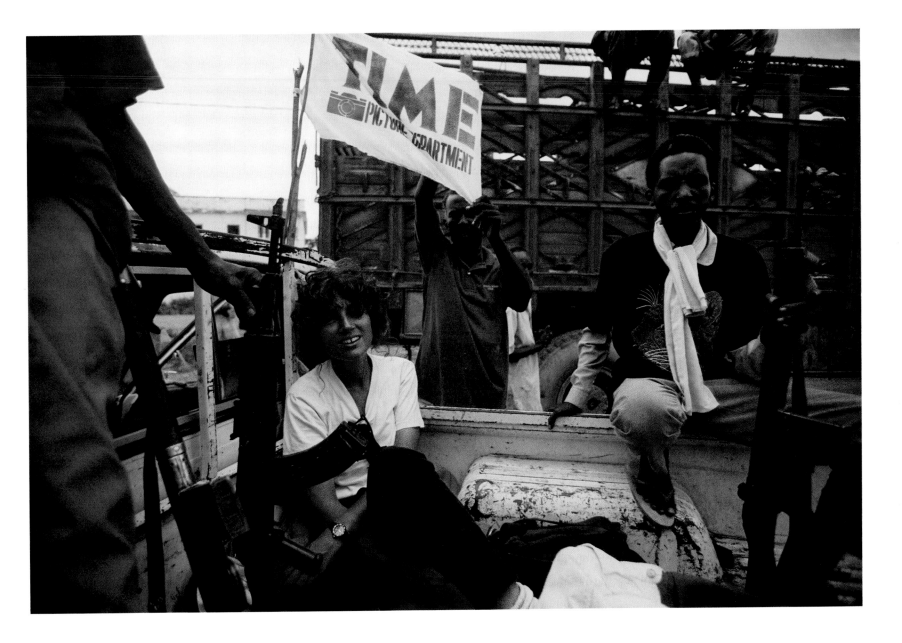

BAIDOA, SOMALIA | DECEMBER 1992 | The author travels with her Somali bodyguards.

Photo by Alfred Yaghobzadeh.

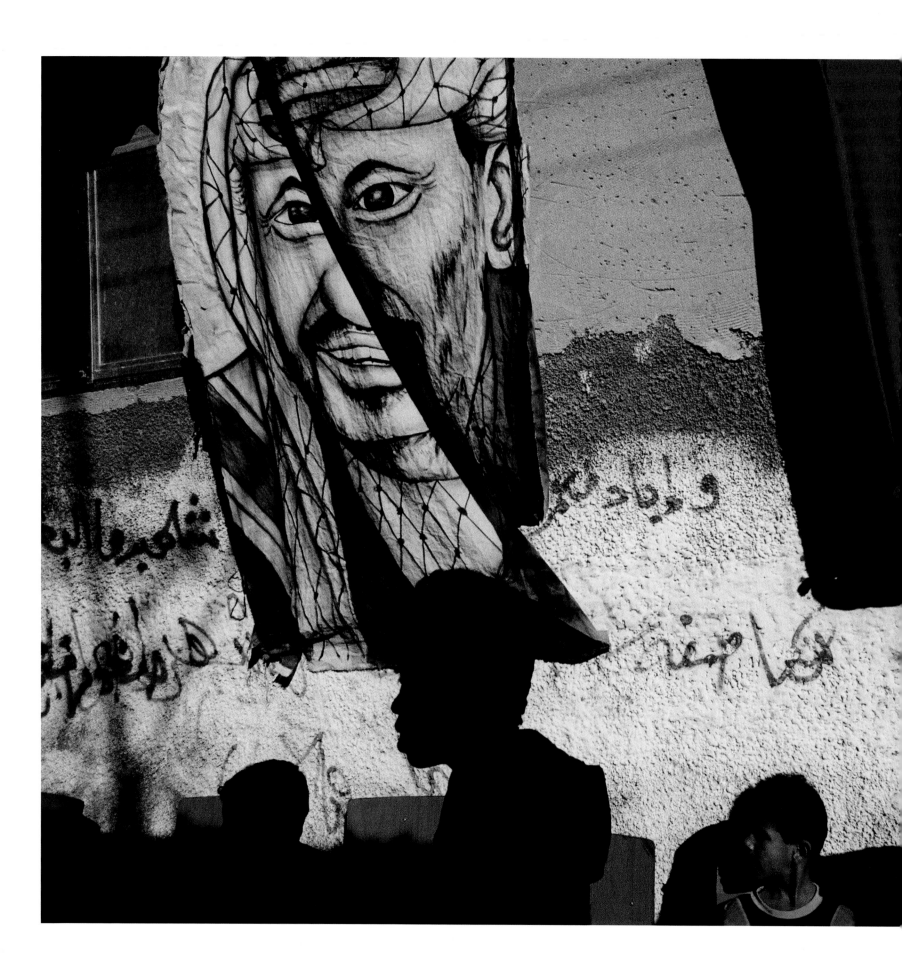

1
PALESTINIANS

GAZA CITY, GAZA | DECEMBER 1993 | Fatah demonstrators mill about near a painting of PLO Chairman Yasser Arafat.

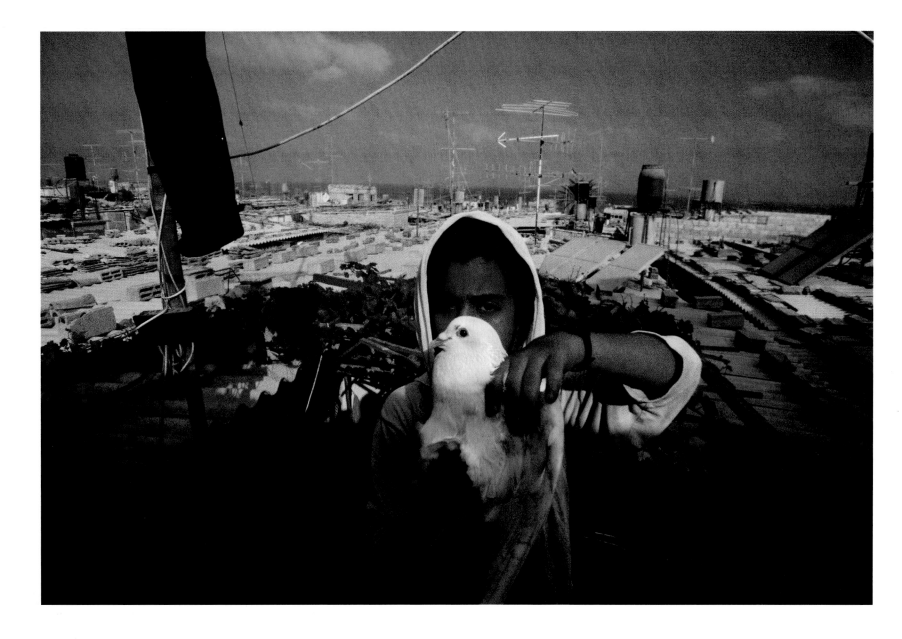

SHATI REFUGEE CAMP, GAZA | AUGUST 1994 | Fatima al-Abed stands on the roof of her home with one of her doves.

الفلسطينيون

[PALESTINIANS]

My first visit to the Middle East, in January 1988, began an odyssey that would span nearly two decades. During this period, I succeeded in gaining

extensive and unusually deep access to PLO Chairman Yasser Arafat, and to Palestinian politics and society while shooting assignments for *The New York Times Magazine, Time, National Geographic,* and others.

I lived in Gaza for two of those years, from 1993 to 1995, covering the Oslo Peace Accords, the return of Arafat to Gaza, the withdrawal of Israeli troops from most of the Palestinian territories, and the human suffering endured by Palestinians and Israelis. Over time, I would be beaten by Palestinians, shot at by Israeli soldiers, and detained. I breathed tear gas and encountered staggering amounts of violence. But I wouldn't have missed it for the world.

My first home upon arriving in the Middle East in 1988 was a tiny, austere room at the Palestinian-run American Colony Hotel in East Jerusalem. It became my refuge, where I could sit in a hot bath and listen to the BBC on my short-wave radio at the end of the day after documenting the violence of the Palestinian intifada. I wept there after one especially rough day several months into my stay.

Following Friday prayers at a mosque in Nablus in March 1988, teenage boys and a handful of old men spilled out into the casbah, the old

center of town, openly defying curfew. The boys started yelling "Allah-u akbar," God is Great. I knew by then what would happen. Israeli soldiers entered the square, the boys started throwing stones at them, and the soldiers fired shots. That day there were no rubber bullets. A 14-year-old Palestinian boy, Bassal al-Jitan, was shot in the back of the head. His uncle came to me, weeping and screaming, with the boy's brains in a plastic bag.

It wasn't only boys who were experienced in the ways of the intifada. When tear gas enveloped us, Palestinian women rushed out of their houses with onions cut in half—an antidote to the burning and tearing caused by the gas. And in Ramallah, one could often see teenage girls taking part in protests.

I rented my first Gaza apartment in September 1993, on the second floor of a villa abutting a wall of the Israeli prison. Above the wall's razor wire, I could see a horizontal slice of the prison from the kitchen window as I washed dishes or made coffee. At night, searchlights fell across the kitchen and dining room, and I heard the spooky, whistling language invented by Palestinian prisoners and the shouted orders of Israeli soldiers. Winters in Gaza and the West Bank bring bone-chilling cold, but Palestin-

ians in the territories had no central heating systems. I relied on small space heaters.

Despite the nightly curfews, I often snuck down to the UN Beach Club, a haunt for UN officials and aid workers, for a drink with a friend, hiding in shadows on the way. One could be arrested or shot if caught out during curfew, but we longed for diversion on those bleak nights.

Before Arafat's return in the summer of 1994, Hamas ran the streets, and I lived in *hijab*—Islamic head cover for women—when out in public for nearly a year. During one deadly riot, I pulled down my scarf for better peripheral vision. The leader of the riot used his fingers to angrily mime pulling up a scarf. Back up went my scarf. People on both sides mostly accepted and helped me.

I spent time in the Israeli settlements covering their side of the story, as well. I accompanied an armed settler leader on her rounds for several days. She and her husband lived in a little house on the edge of the Palestinian beach, with just a few other settlers' houses nearby. I found their isolation terrifying.

On the way to her home, I caught the Palestinian teenage boys' dark, steely stares, filled with

utter hatred. The Israeli settler insisted she had great relations with her Palestinian neighbors, but the awareness of the possibility of Palestinian attack made me dread traveling those settlement roads.

In an apartment overlooking the tatty Gaza City port and fish market, sand blew in steadily, coating my floor if I didn't sweep daily. At night I sat at a plastic table on my balcony watching the bobbing lights of small fishing boats, and in the mornings I made big American breakfasts for my Palestinian friends after photographing at dawn.

The sounds that floated through my windows were so different from those back home in SoHo. I heard the surf, the jingling bells of donkey carts, vendors yelling *"Khiyaar! Khiyaar! Bandurah! Bandurah!"* (Cucumber! Tomato!) I loved the sound of Muslim calls to prayer that floated in from all over the city.

But respites from the conflict were few and far between, and things were not always what they seemed. One young man we journalists thought we knew well turned out to belong to Izzidine al-Qassaam, then a secret military wing of Hamas.

He came from a family of many Hamas activists, one of whom had died in conflict with the Israelis, while throwing stones. Another died in 1948 while defending his village. But this young

man's involvement in the secretive Izzidine al-Qassaam apparently shocked even his family. They told me they suspected nothing until he came to bid his mother goodbye before going into hiding. To me, he just seemed painfully shy, a provincial and self-effacing young man of the camps.

In fact, he led the cell that kidnapped Israeli soldier Nachson Waxman in 1994. The cell members and the 19-year-old Waxman died several days later in a firefight with Israeli commandos during a rescue mission.

The 1993 Oslo Accords had inspired hope in many, signaling a step toward self-determination with the return of the exiled Arafat to the Palestinian territories. But the months between the signing of the accords and Arafat's actual return in July 1994 were littered with horrific bomb attacks by radical Palestinian groups on Israelis, meant to unravel the peace.

Before Arafat returned to Gaza in 1994, Israeli troops began their withdrawal in the dead of a May night. Despite the hail of rocks that accompanied their departure, many looked elated to be leaving.

Israeli settlers, on the other hand, watched in horror as the first Palestinian guerrillas arrived on May 10, a nightmare come true. The Palestinians were giddy for three days; children

and teens climbed abandoned watchtowers, toured former jails, and collected stray bullets and other military flotsam. The guerillas who would become Arafat's new Palestinian Police were hoisted on shoulders, hugged, kissed, and rewarded with food and flowers. There was great happiness in the streets.

But after the fanfare surrounding Arafat's return in July 1994, pressure mounted as the Palestinian Authority cracked down on Hamas. In November, the struggle turned bloody. Riots continued for three days, and more than fifty Palestinians were killed. I worked in hijab among the Hamas rioters, so comfortable in Gaza that I strayed far from the journalist who was my shooting partner that day.

As I approached a burning police car in front of a Hamas mosque, a wild, screaming Palestinian policeman aimed his Kalashnikov rifle at me, stopping me in my tracks. I looked down that gun barrel for what seemed like many minutes. But he backed off, leaving me unhurt, and I made my way to the burning car.

I had only snapped a few shots when four young Hamas rioters pounced on me from behind. They grabbed my camera strap and bent my head down as they punched me in the stomach and face until my lips bled. I fought for my gear. They yelled, *"Inti jasuusah! Inti Israiliyya!"* You're a spy! You're Israeli!

They took one camera, ripped out the insides, shutter, and film, and threw them into the flames. They wouldn't stop hitting me. I screamed for help; my partner and two other Palestinian journalists ran across the dirt field and beat them back. My lips were swelling, and my front teeth wiggled back and forth.

Moments later, as two of us sat quietly in a car on what we thought was a safe street, a stray bullet whizzed through our open front windows. We decided it might be best to work from Al Shifa Hospital.

On the way, we passed Palestinian Police headquarters and saw my shooting partner being forced into the back of a police car, a pistol jammed to his temple. I jumped out of the car and ran over to them, beating on the chest of a policeman, imploring him to let my friend go. They did, and they took away my second camera.

At last we arrived at Al Shifa Hospital. All the journalists were there. Nobody dared stay in the streets. Three Palestinian journalists lay wounded inside, as did more than a hundred Hamas supporters. We lost count of the bodies coming through the door: dead, dying, wounded.

The next day, I went to the top Hamas sheikh of the neighborhood where I had been beaten to complain. Scruffy and swollen, I sat drinking tea on his plush and endless couch. The house was large, and the dingy walls looked as if they had not been painted in decades. Hamas security men were everywhere. The sheikh listened to my account and apologized. I hoped he might have a word with the leaders of the demonstrations. To my surprise, the next day an announcement issued from the minarets of mosques in the area amid the continued violence: journalists must not be attacked.

Arafat was struggling to maintain control. Despite the unrest, he was due to fly to Oslo in December 1994 to accept the Nobel Peace Prize with Israeli Prime Minister Yitzhak Rabin and Foreign Minister Shimon Perez. I hadn't planned to cover it, but then one of his advisers invited me along.

Arafat's entourage included the usual peacemakers, politicos, former guerrillas, and his wife, with whom I had also spent a good deal of time. I remember their obvious delight as we approached Oslo, with its pristine snow and glistening fjords, so different from their desert homes. For a moment they were tourists from the Muslim world.

I stayed in the same stately hotel as the Arafat and Rabin entourages. Both delegations looked pleased. Arafat and Rabin, on the other hand, eyed each other with suspicion and dislike, even as they accepted their prizes. Almost a year later, Rabin would be assassinated, and all they had worked for, taken so many risks for, would be undone. I covered his funeral and the emotional public mourning for him, too.

By the end of the following year, I was distancing myself from death and funerals. The violent conflicts that had fascinated me since college graduation were taking their toll. I felt lucky to be alive and in one piece—and ready to celebrate the beauty of life in the subjects I chose.

I last saw Arafat in 2000. Seven months pregnant, I visited Gaza while my husband was working there. My Gaza friends took me on a tour, showed me the massive, forbidding building that was owned by Preventive Security, one of many intelligence organizations under Arafat, and the luxe villa of Mahmoud Abbas, also known as Abu Mazen, today the president of the Palestinian Authority.

I went with my husband's Harvard delegation one evening to the West Bank to see Arafat. He looked at me with eyes that were watery and weak. His hands shook. He did not recognize me. But when he began speaking, he soon snapped into classic form. The frail old man receded, replaced for a few moments by the Arafat of old as he spoke of Palestinian politics and the prospects for peace with Israel. Now Abbas rules the West Bank. Hamas rules Gaza.

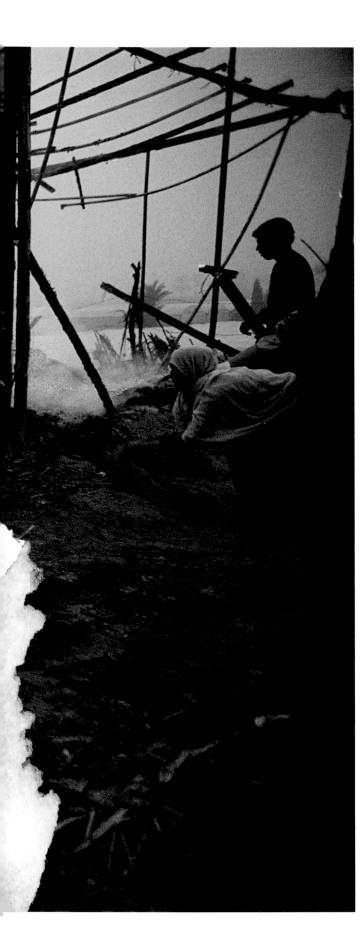

NEAR KHAN YUNUS, GAZA | NOVEMBER 1993 | Israeli settlers burned this Palestinian farm at dawn.

NEAR KHAN YUNUS, GAZA | JUNE 1995 | These Bedouin children sleep in tents and keep camels, although their family can no longer roam.

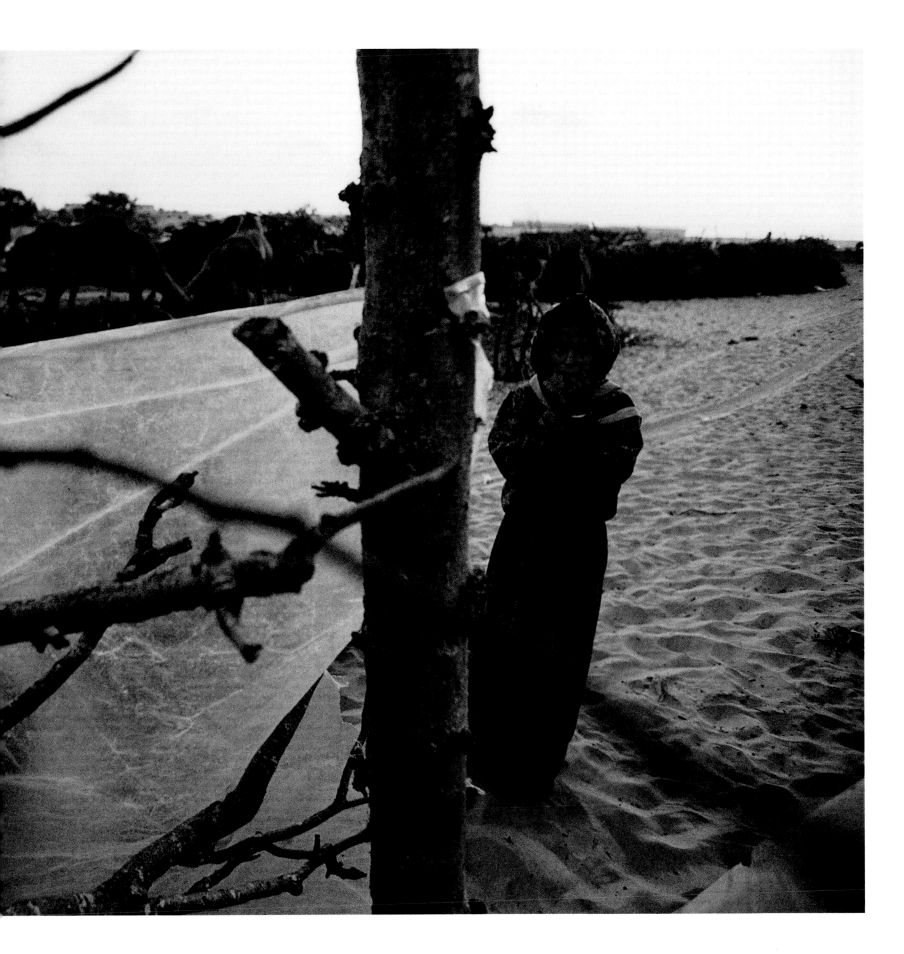

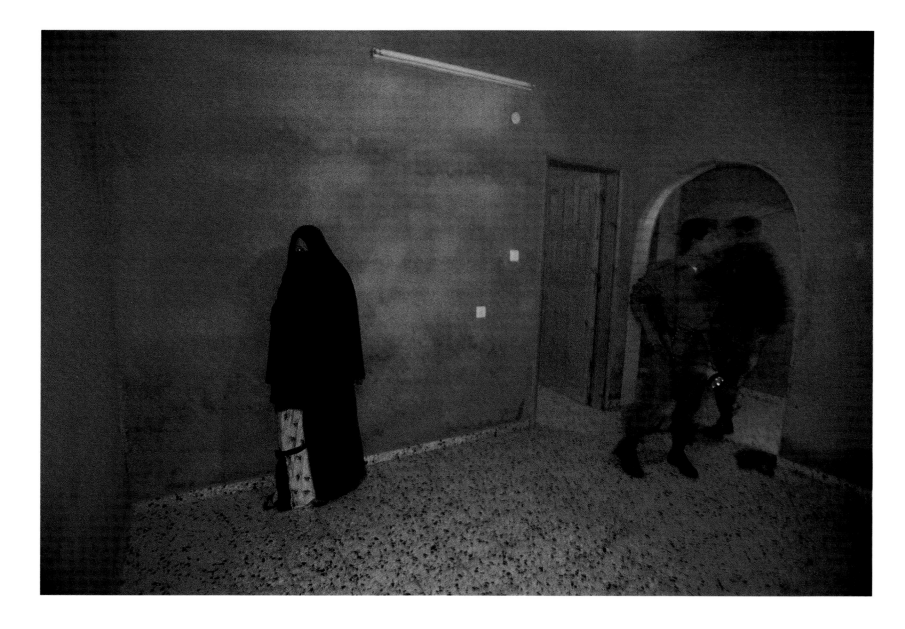

JABALYAH REFUGEE CAMP, GAZA | MARCH 1996 | Palestinian Police search a Hamas
home at night.

GAZA CITY, GAZA | APRIL 2005 | Palestinian children play near an old Eastern Orthodox church.

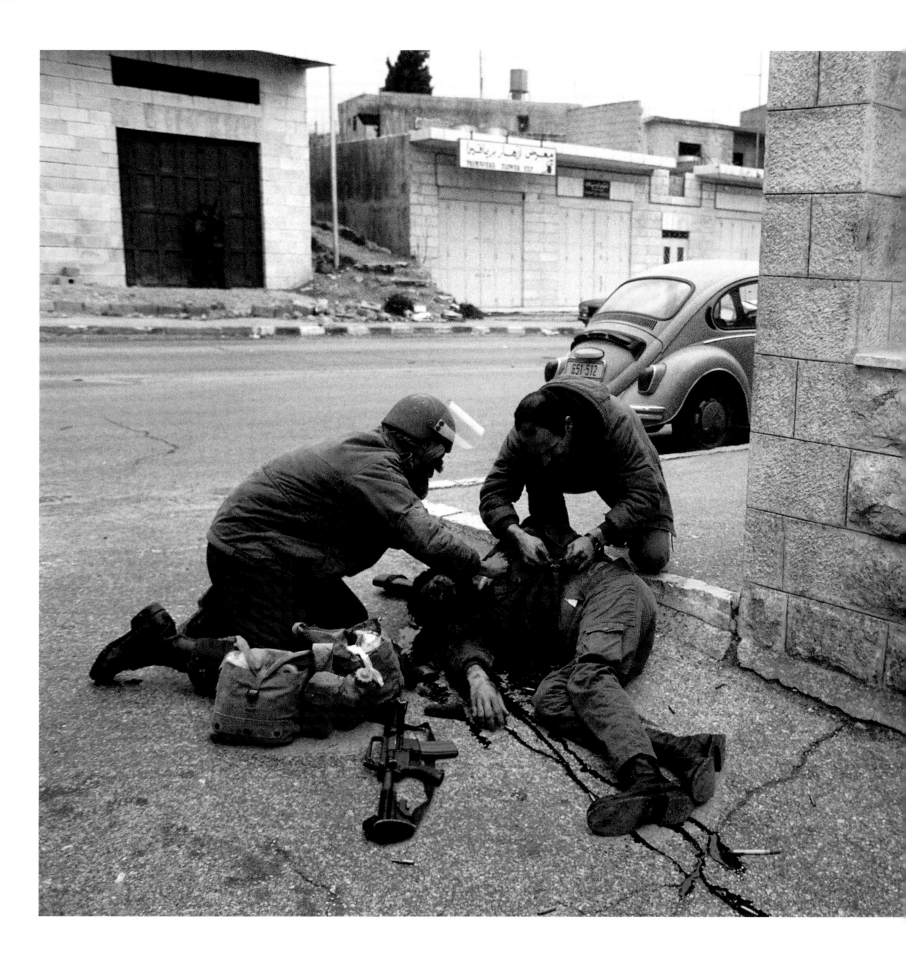

[BETHLEHEM, WEST BANK | MARCH 1988]

It was a Sunday in the West Bank during the first intifada, and we journalists covered the usual Christian demonstration near Bethlehem: women protesters in high heels with no headscarves, little old ladies throwing stones. On the way back to Jerusalem, we heard what sounded like a short burst of crossfire and saw an Israeli soldier dying in the street. Moshe Katz, a reservist and father, had been shot by a Palestinian at close range. He became the first soldier killed in the conflict. Israeli domestic intelligence, Shin Bet, detained us. Soldiers took our film. In my right vest pocket, I had a hole that I pushed my film through, hiding it along the lining. They took only blank dummy rolls from my breast pocket, and one good roll still in the camera. They roughed us up, but let me go first. *Time* published my photo of Katz dying for their issue on Israel's 40th anniversary.

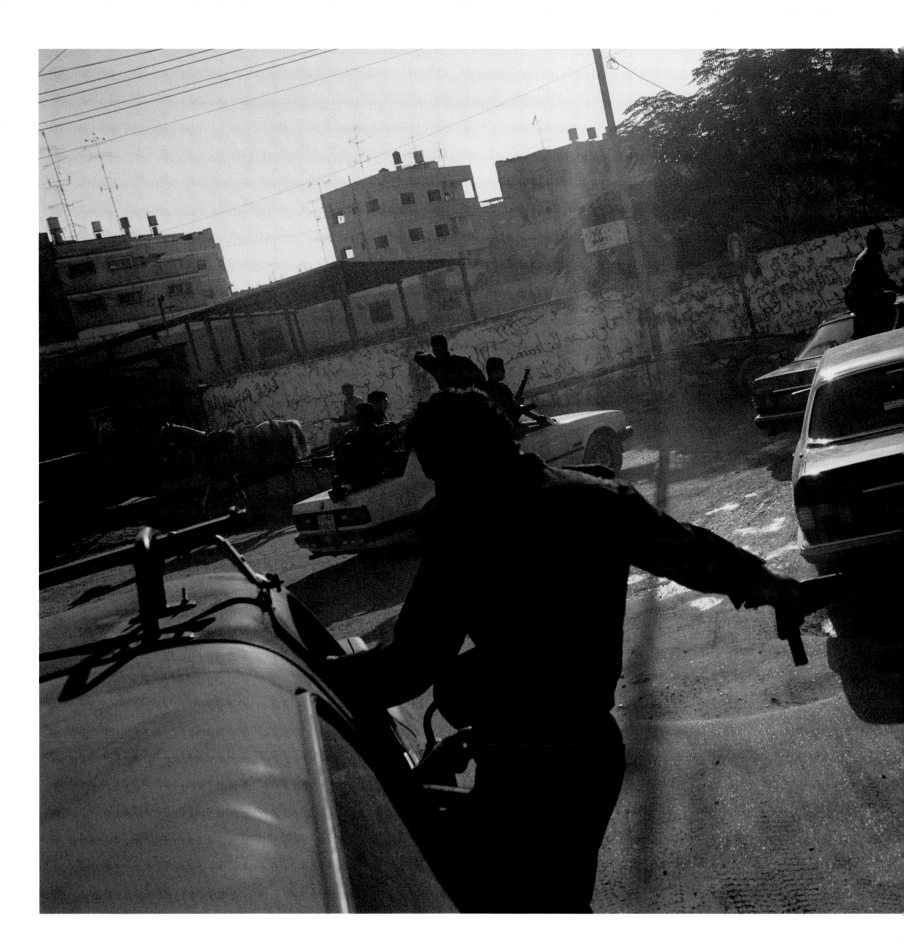

GAZA CITY, GAZA | JULY 1994 | Arafat and his entourage careen through the streets in the
days after his return from exile.

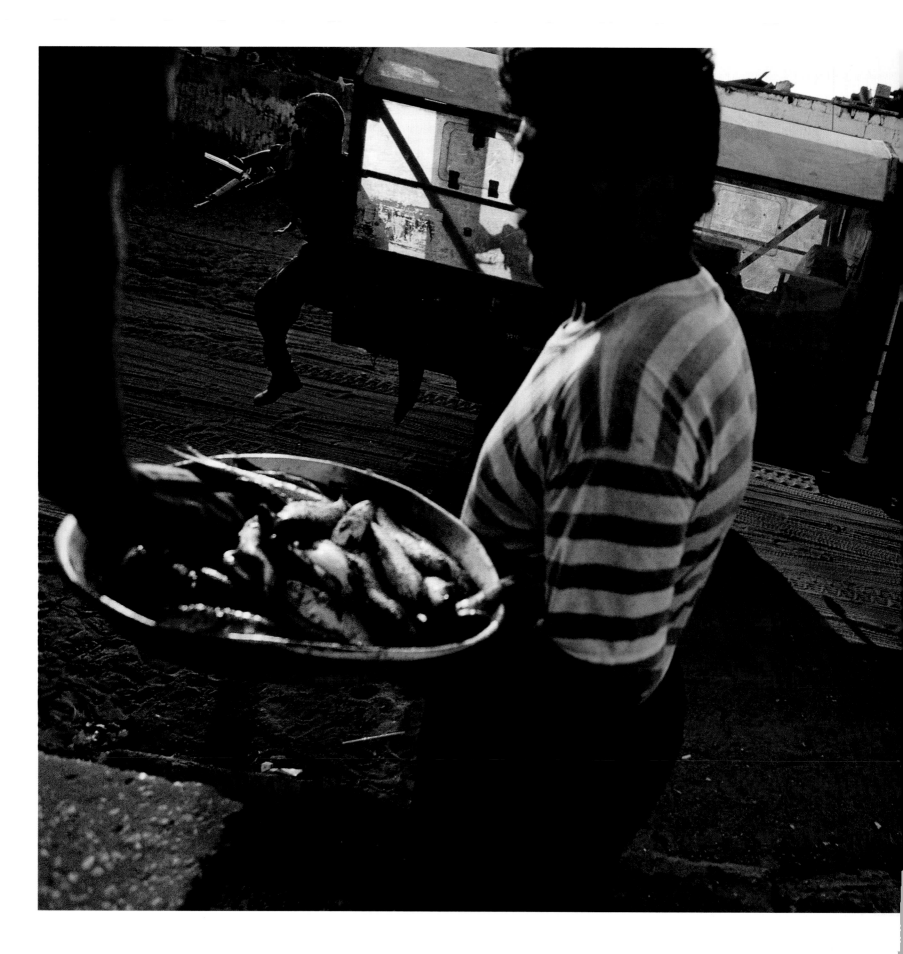

GAZA CITY, GAZA | JULY 1993 | A man sells fish while an Israeli soldier jumps out of his truck
to chase Palestinians who had been throwing stones.

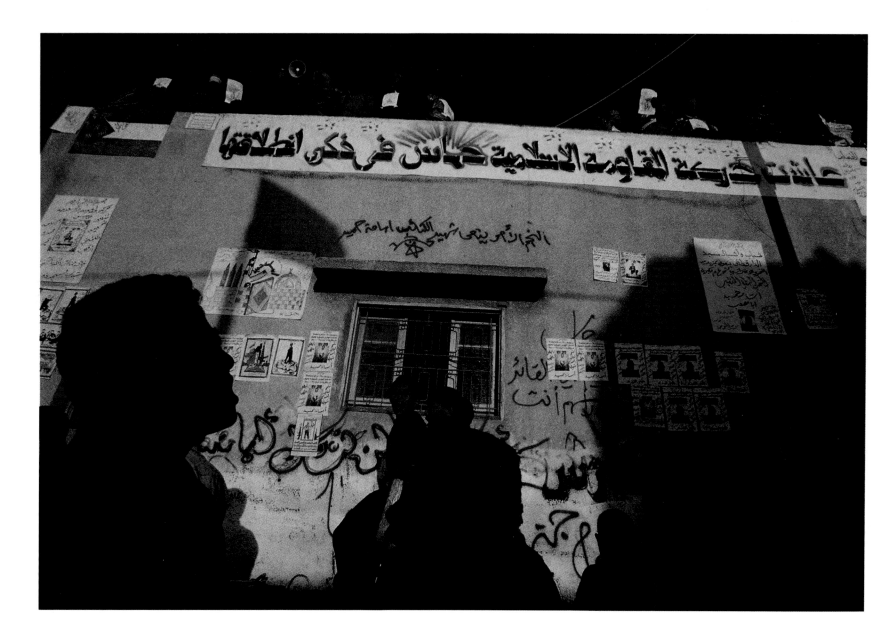

GAZA CITY, GAZA | DECEMBER 1993 | At a Hamas demonstration one afternoon,
hooded teenagers on a roof read a communiqué from the Hamas leadership.

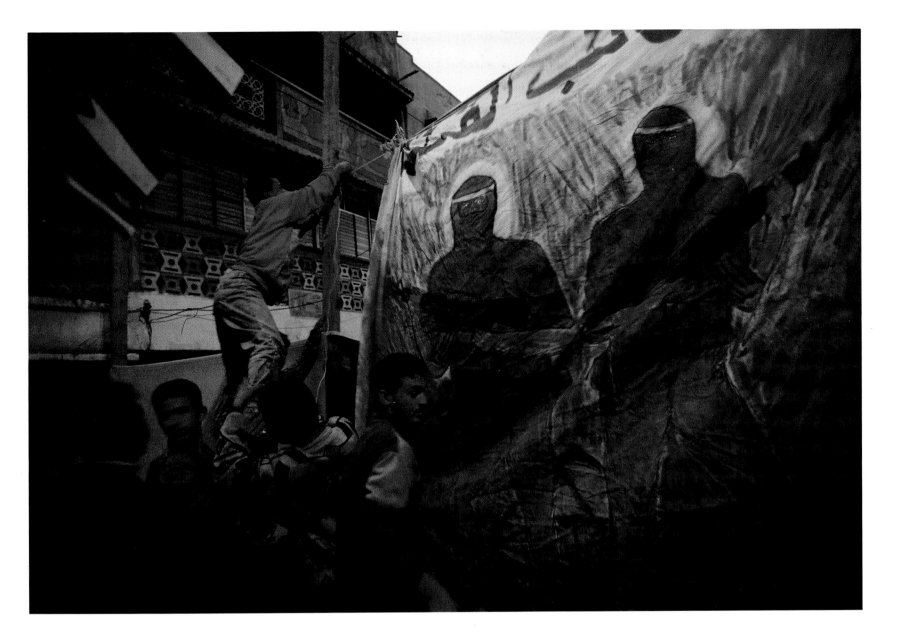

GAZA CITY, GAZA | MARCH 1995 | In preparation for a Hamas bachelor party, young men erect a painted backdrop of *shuhadaa*, or 'martyrs'—in this case, Hamas gunmen killed by the Israeli Army.

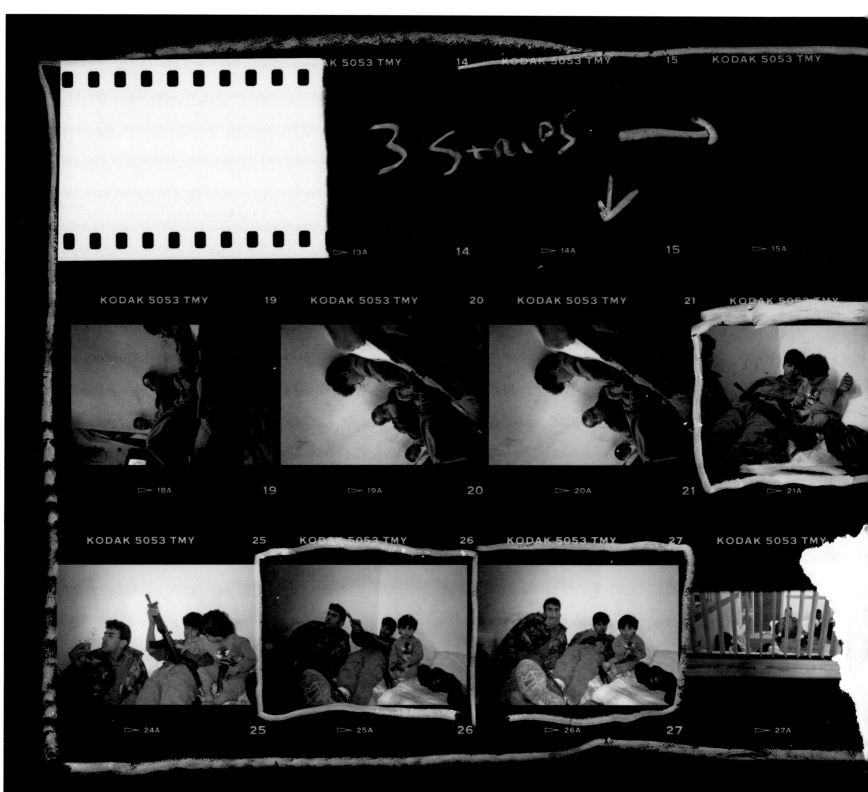

[SHABURA CAMP | NOVEMBER 1993]

During one of many stays in Shabura refugee camp, I was picked up from a friend's house by the Fatah Hawks, an underground group of armed fighters. I was photographing their daily lives as they went about their patrols when we heard there was an attack on Israeli soldiers in the camp. We rushed from the sewer-lined alleyways to a gray, cinder-block safe house, where other armed young men already were hiding. A 24-hour curfew was slapped on the camp, and I found myself confined with a bunch of Palestinian guerrillas. Two little boys were on the roof watching for Israeli soldiers. I heard the soldiers' boots in the dust outside the doorway as Riad stood silently by the door with his gun, alert and ready to die. What could I do? I was stuck. As interesting as it was, I didn't relish being there with them. I knew we would all die if the house was discovered, even though the Hawks had nothing to do with the attack. All held their weapons close that day. Finally, they relaxed a bit. There was a violent American film on TV. One of the guerillas in a blue-and-gray striped, traditional cotton robe and with a Kalashnikov across his lap, asked me, "Why is America so violent?" I told him, "In America, people kill for money, drugs, love, out of craziness. Not politics so much." *"Ahhh,"* he replied, as if this explained everything.

[EN ROUTE TO LIBYA | OCTOBER 1988]

PLO Chairman Yasser Arafat flies from Tunis to meet with Libyan leader Muammar Qaddafi, the first of many trips I would take with Arafat, who was still considered a pariah then. I had just gained unusual access—accompanying him to meet another leader considered a pariah, Qaddafi, whom President Ronald Reagan had labeled "this mad dog of the Middle East." I was not told where we were going until we landed. Arafat got off the plane in Tripoli carrying his machine pistol, the only time I ever saw him hold a weapon. He grew angry when Qaddafi kept him waiting during that trip. The reporter and I were sent back to the airport, an Arafat ploy that finally won Qaddafi's attention. When we met, Qaddafi seemed to puff up like a male bird displaying its colors. He politely chatted with me and the other female journalist. Arafat, on the other hand, called me troublemaker and dictator, though he always gave me great access.

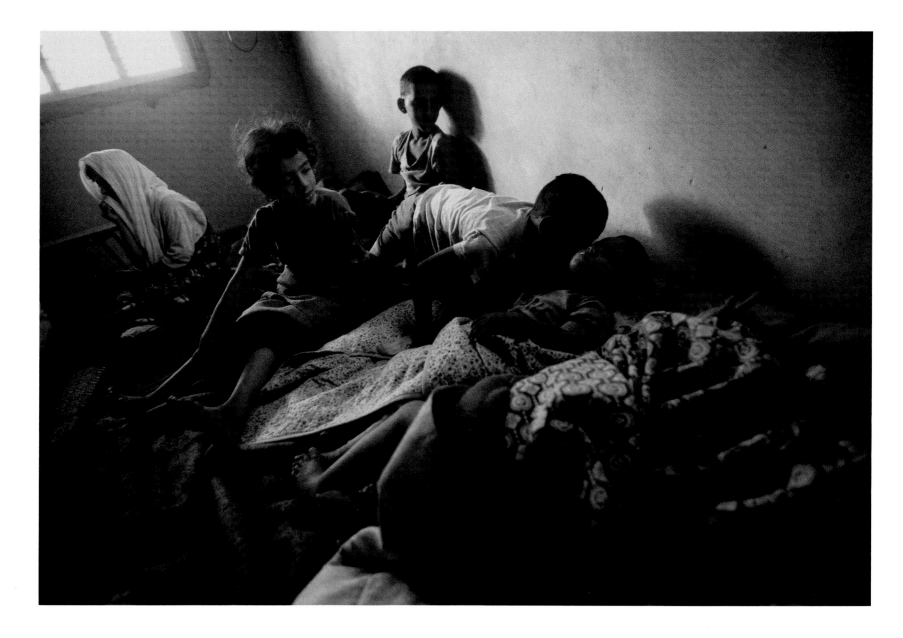

SHATI REFUGEE CAMP, GAZA | AUGUST 1994 | Fatima al-Abed shares a bedroom with seven siblings.
They sleep on thin mats.

OPPOSITE: NEAR GUSH KATIF, GAZA | MAY 1995 | Israel's Independence Day was celebrated with gusto
in Gaza's Israeli settlements. The settlements of Gaza were evacuated and closed by Israel in 2005.

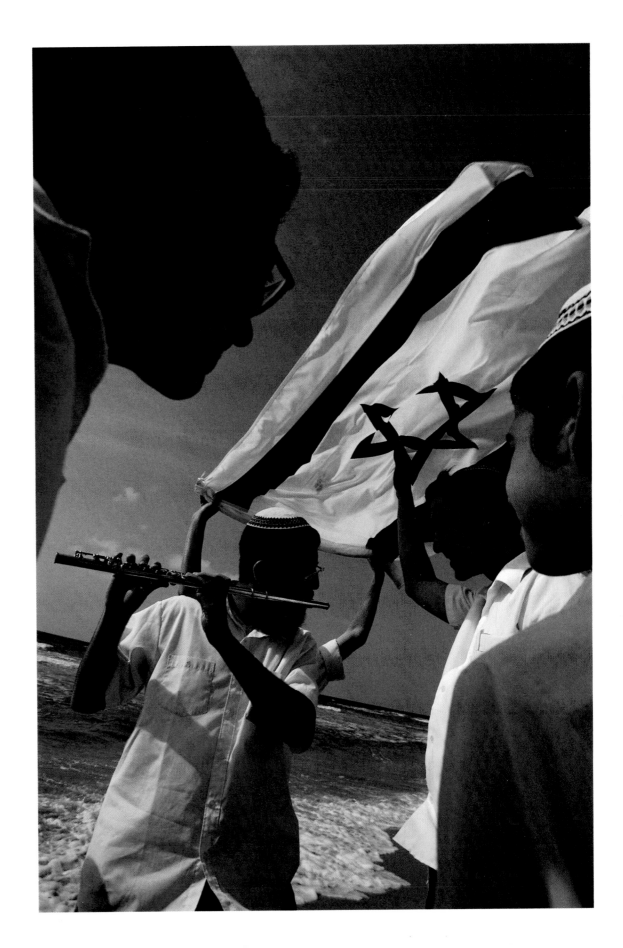

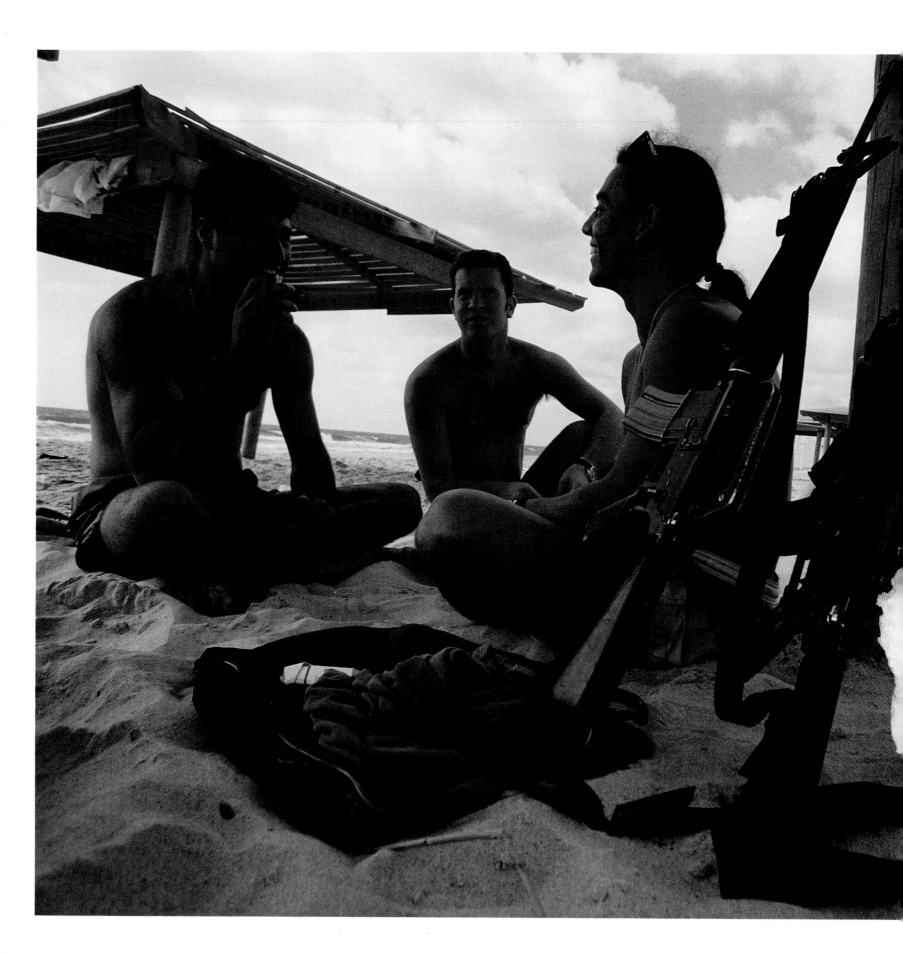

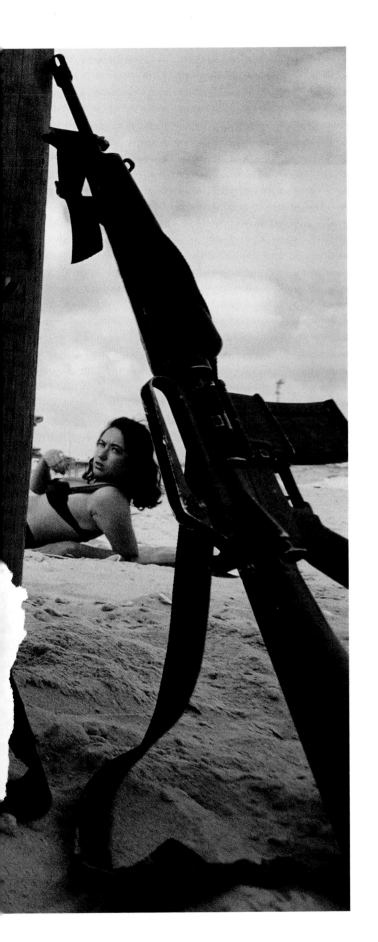

[DOGEET, GAZA | JUNE 1994]

I went to this beach in an Israeli-settlement on Gaza's northern edge a few times because I could wear a bikini instead of the Islamic dress required then on Palestinian beaches. When I swam in full dress, waves would often wrap the cloak around me until I lost balance and fell in the surf. I was welcome on the settlement beach and would drive there in my car with its yellow Israeli license plates.

I also photographed in the Israeli Gush Katif settlement bloc, which was self contained, with its own horseback-riding corrals, mini-golf, supermarket, and hotel. The settlements resembled middle-class, American developments except with soldiers and electric fences. Like these off-duty Navy personnel, settlers were usually armed, even while relaxing. On a settlement road, I photographed a Palestinian suicide bomber who died trying to destroy an Israeli bus. He failed and was blown up. Patches of his flesh hung from nearby bushes; his severed leg, still in its sneaker, lay nearby.

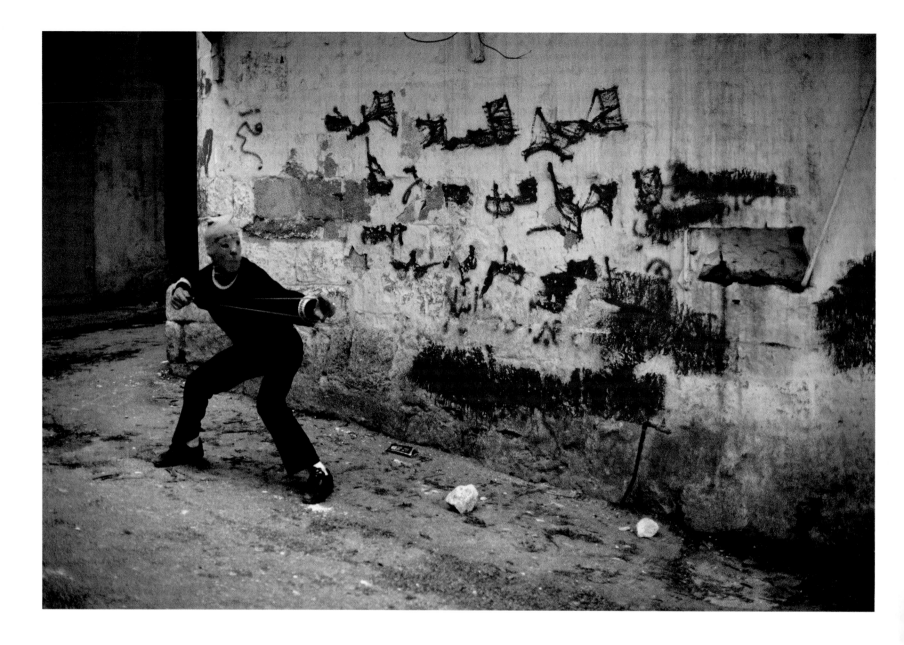

NABLUS, WEST BANK | MARCH 1988 | A boy takes aim at Israeli soldiers with a
slingshot in the Nablus casbah, which was shut down by striking shopkeepers.

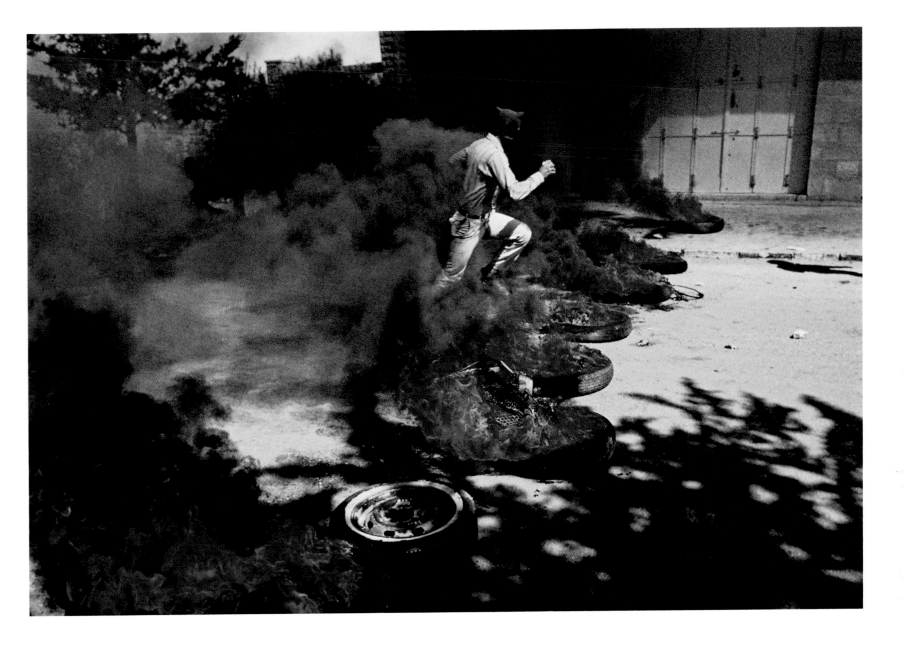

BETHLEHEM, WEST BANK | MARCH 1988 | A young Palestinian protester flees as Israeli troops fire shots in his direction.

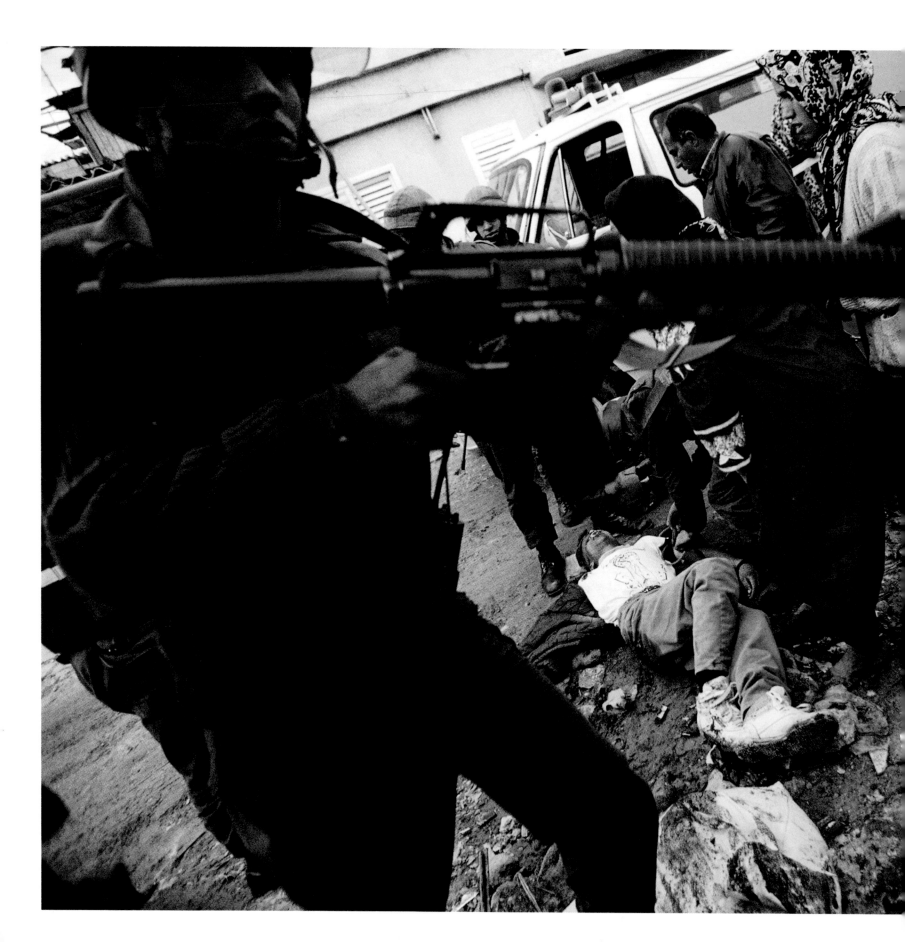

[SHATI CAMP | FEBRUARY 1994]

We heard gunfire and ran toward it. Splashing through an open sewer that ran between cinder-block homes, my friends and I found a Palestinian teenager dying in the dregs of the alley's sewage. Violent outbreaks were common in Gaza. In Shabura refugee camp, while I was photographing a young girl with eyes like the sea and a long, dark-blond ponytail, gunfire sounded just around the corner. We peeked and saw Israeli soldiers spraying the camp with bullets. They had just been attacked by gunmen of Islamic Jihad and the Popular Front for the Liberation of Palestine. The alleyways emptied in seconds and a daytime curfew was imposed. We took my friend's car and slipped out, then witnessed Islamic Jihad guerillas escaping in a four-wheel-drive over the dunes. They pulled onto the road ahead of us, stopped, and transferred to a battered, old Peugeot 404, the most common car in Gaza. They quickly disappeared in a river of Peugeot 404s.

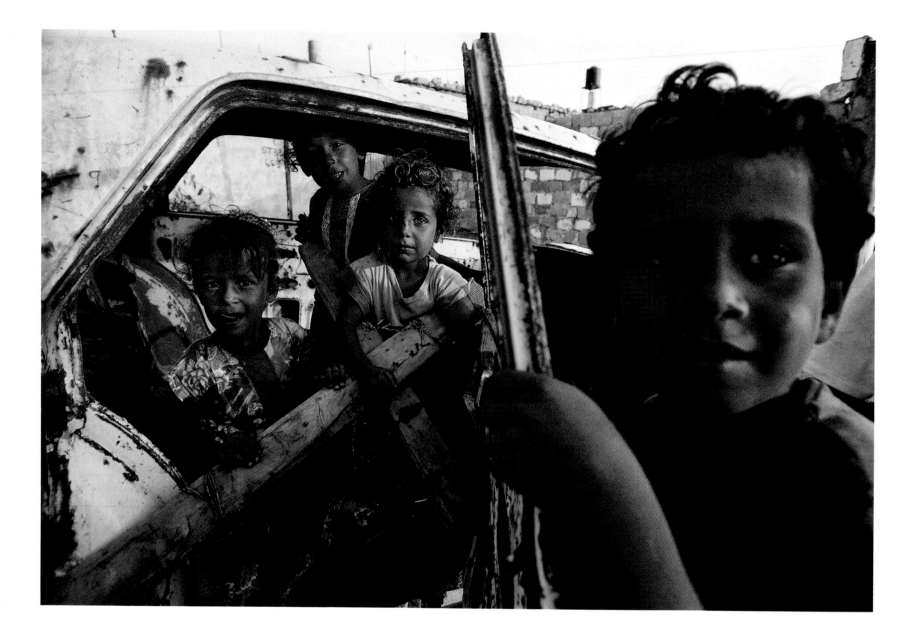

SHATI REFUGEE CAMP, GAZA | JULY 1993 | Children nearly always play unsupervised
in the streets of Gaza, and dangers abound.

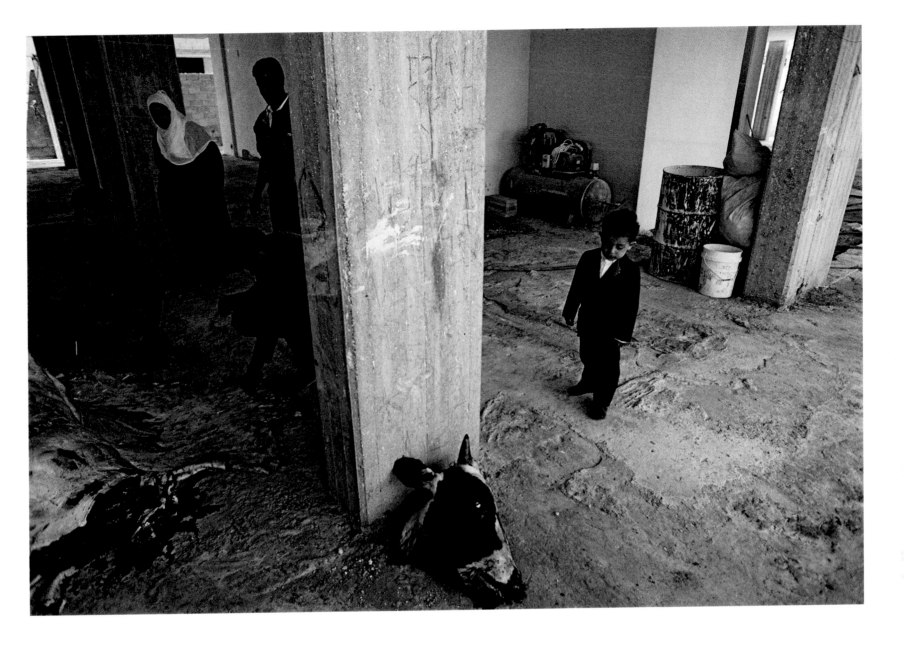

GAZA CITY, GAZA | MAY 1994 | During the holiday of Eid al-Adha, my landlord and his family sacrifice a bull on the open ground floor of the building. Only the wealthy can afford such a large animal, but being observant Muslims, they gave away two-thirds.

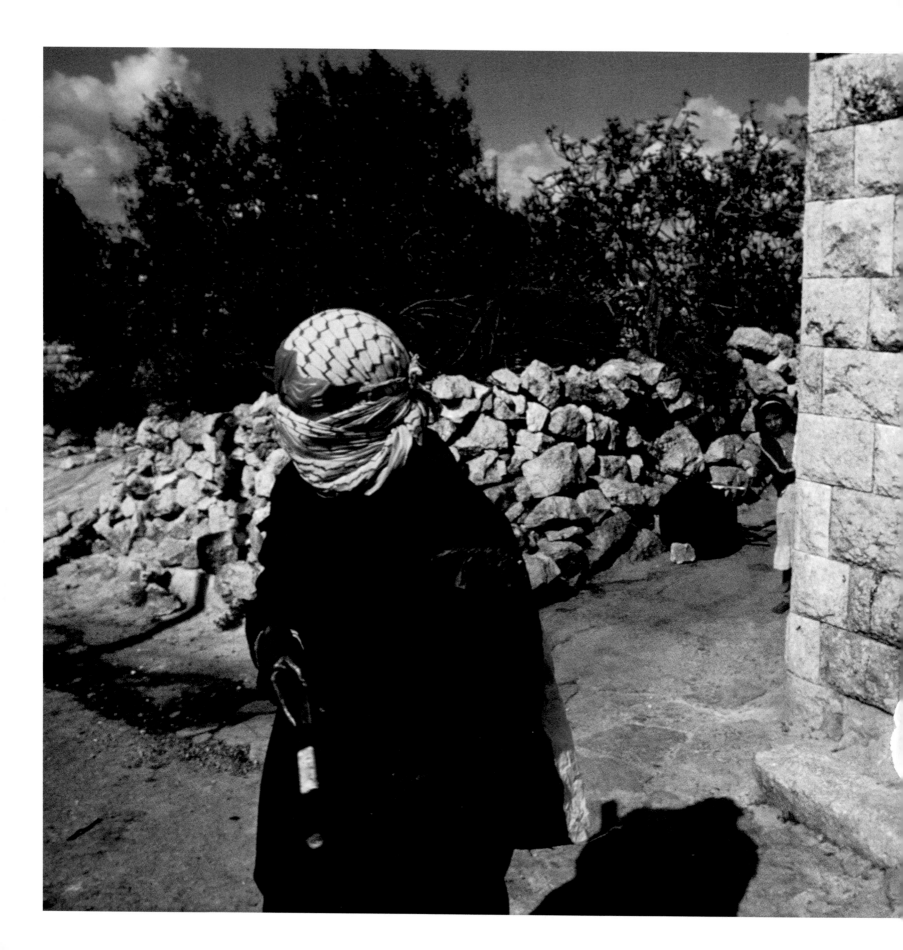

KAFR AL-DEEK, WEST BANK | APRIL 1989 | A Palestinian youth, on the lookout for Israeli soldiers, guards the entrance to his village during a demonstration.

[SHATI CAMP, GAZA | MARCH 1994]

My second apartment was in a relatively nice neighborhood, but still there was garbage in the sandy streets, even outside the luxurious villas belonging to members of the Palestinian Authority. A few blocks away at the edge of Shati this little girl was daydreaming. Fetid water routinely burst forth from sewers in every neighborhood, including mine, and the telephone wires sometimes crackled with sparks and flames. In Shabura refugee camp after a Hamas attack, the Israeli army imposed a round-the-clock curfew. I hid in the impoverished two-room home of a local photographer, his pregnant wife, and three children. The ceilings were made of unattached corrugated tin held down by stones. The rooms were purple, the light fluorescent. With the door bolted, they watched an ancient copy of *Love Story* on the VCR. Their house had been searched the night before at 2:30 a.m. and was left a wreck. The kids screamed when they heard soldiers pounding on the neighbor's door.

We went out shopping to a clandestine store during curfew after we started running out of food. Two women, we sneaked through dusty alleyways, covered head to toe in black cloaks and headscarves. When some locals spotted me with my big black sneakers sticking out, cameras clanking under my robe, they fled thinking I was an Israeli undercover. I slept on a pad on the floor in the children's room. The pillow was embroidered with little birds and a cheery *"Sabaah al- kahair!"* Good Morning! Once every few days water was boiled so we could bathe in a tub in the space between the shack and the toilet, which was just a concrete hole in the ground.

EREZ CHECKPOINT, GAZA | AUGUST 1994 | Palestinians pass Erez checkpoint at dawn to get to dishwashing, construction, and other menial jobs in Israel. Often the border is closed due to violence.

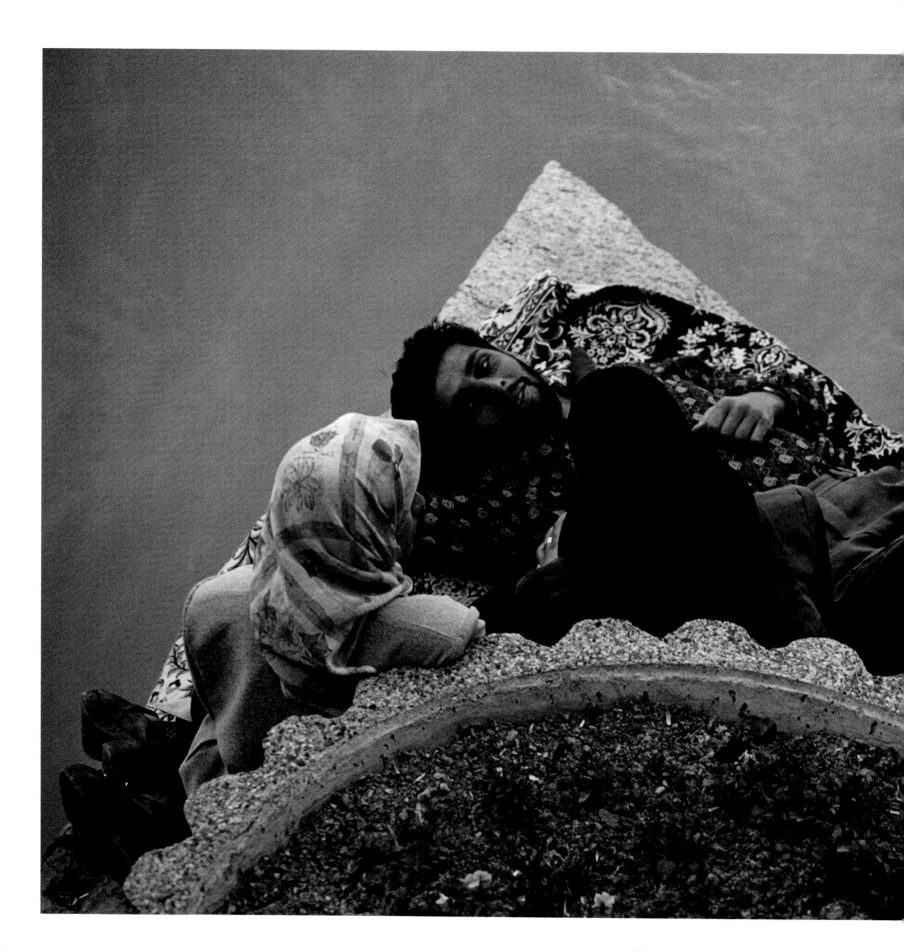

2

[CHAPTER TWO]

IRAN

ISFAHAN, IRAN | MARCH 1998 | On Khajou Bridge, an engaged couple enjoys a
chaperoned visit out of sight of morality police on the other side of the bridge.

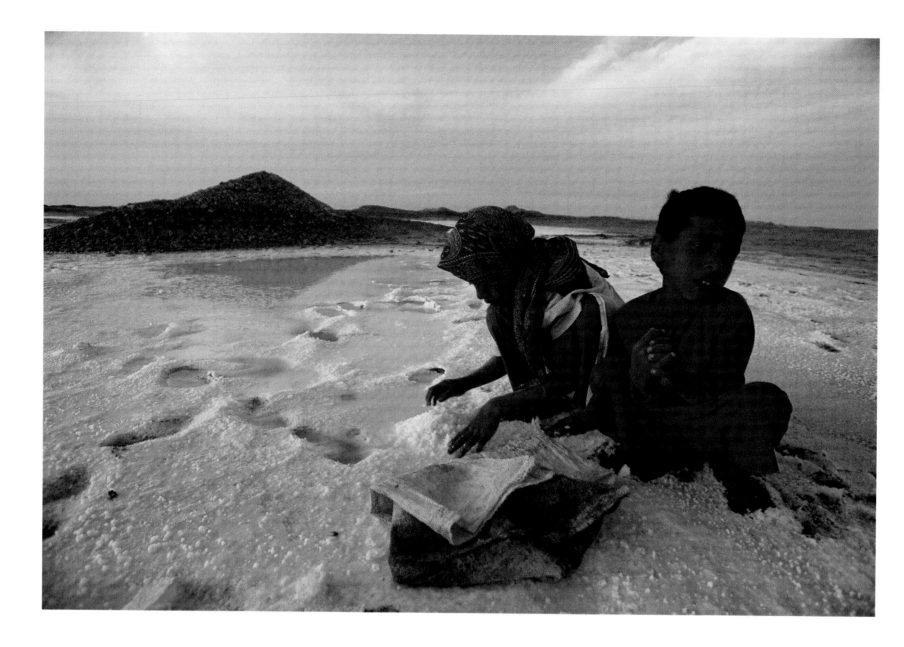

KHUZESTAN PROVINCE, IRAN | APRIL 1998 | Nahid, 9, and Hussein Saboee, 6, collect salt to
sell to bakers.

إيران

[I R A N]

A Revolutionary Guard commander ran fast and hard across the salt flats toward me in the barren desert of Khuzestan, a remote, war-ravaged province close to the Iraqi border.

I was worried. The Guards are famous for their enmity toward the United States. I thought my peaceful months of working in the Islamic Republic of Iran were about to end. I had been photographing children harvesting salt to sell . I steeled myself for an unpleasant encounter.

"Stop" he said, "I have to talk to you. I heard you are here working for *National Geographic* magazine." I told him I was.

"Well, I have to ask you: I have been a subscriber for a long time, but I haven't gotten my subscription in a few years. Can you help me?"

Such is Iran: beautiful, challenging, lively, at times spooky, maddening and endearing. The land of my ancestors, for me Iran was also about my family and my cultural heritage. It was personal and professional, intimate yet distant. And it became one of the most affecting stops of my journeys in the Muslim world.

In June 1989, I arrived on the last planeload of journalists allowed into Iran to cover the funeral of Ayatollah Ruhollah Khomeini. The revolutionary leader's passing was a historic moment to arrive in the Islamic Republic of Iran. I was elated to gaze upon the same mountains as my grandfather, to explore the Tehran bazaar where

my family owned a building, and to savor the beauty of Iran.

"Cover your wrist! You're inciting the crowd!" growled my minder from the Ministry of Culture and Islamic Guidance. I had been given layers of heavy polyester Islamic clothing before being allowed to leave the airport. Now, the right sleeve of my coat had slid back a few inches to reveal some wrist. I quickly pulled it down.

Approaching Khomeini's gravesite in a helicopter, I saw what seemed like millions of tiny, black figures streaming toward the temporary shelter for Khomeini. Security had placed his body under a large, overturned, shipping container for protection. Already, mourners had nearly toppled the body while trying to grab a piece of his white shroud to keep as a relic.

I covered the grieving for several days. Men marched around, striking themselves with chains and weeping. At night, a female colleague and I would slip out to surreptitiously visit some friends, as it was not safe for Iranians to have Westerners in their homes during that time.

Like all Iranians, my family's fortunes had been affected by the 1978–79 revolution. Many of

them emigrated to Western countries in 1979. By 1981, our family business in the Tehran bazaar had been confiscated by the revolutionary courts, and some large carpets taken for "safe-keeping" until the family could ascertain they had no links to the old government. It took them over fifteen years to prove this through the courts. They finally won the property back, but the carpets were never returned.

I was forbidden by my family in New York from looking up relatives during that first trip to Tehran. We did not want to bring them the trouble that was sure to accompany an American relative—a photojournalist no less—dropping in unexpectedly.

When my friend and I boarded the plane to Paris at the end of our trip, the first thing we did was to whip off our headscarves. I had not yet lived or worked in *hijab* for long periods, and the relief was fantastic. In the years since, I've become so accustomed to wearing *hijab* that I hardly notice anymore.

In 1997 Iran elected a new reformist president, Muhammad Khatami, who called for a "Dialogue of Civilizations" between Iran and the West and invited academics and journalists from around the world to visit Iran. *National Geographic*

74

accepted my proposal to do a major feature on Iran two decades after the Revolution. At last, I would be able to go deeper into Iran.

I spent more than four months traveling in the Islamic Republic in 1998, gaining unprecedented access, for an American, to many parts of the country. Every moment was precious, even the frustrating ones. The bureaucracy was endless, and I needed permission letters constantly. The Ministry of Culture and Islamic Guidance granted most requests. But sometimes people denied me access out of fear of Iranian officials. I was turned down nearly two dozen times when I asked to photograph weddings, before finally succeeding twice.

Working through Islamic Guidance was a condition of being a journalist in Iran, but I also discovered that I gained some protection through them. In Kordestan province, I drove toward the mountains bordering Iraq, attracted by small Kurdish villages nestled there. I was stopped and detained for 24 hours in my hotel while intelligence officers checked my identity. I did not have permission to be so close to the Iraqi border, but when Islamic Guidance explained that I was no threat, the officers let me leave. Islamic Guidance got me out of another jam near the Afghan border in the town of Mashhad, where I did have permission to work but was detained nonetheless. I saw how people lived far outside the Iranian capital. I often

photographed Iran's active female population: a surgeon at work, women in the commodities exchange, competitive horsewomen, and a bare-headed teenage girl playing basketball outdoors with boys her age, something quite illegal. But Tehran's properly covered female soccer team would not let me photograph them because parliament was in the midst of a fierce debate just then over whether soccer was an un-Islamic pastime for women.

Other times strangers opened their doors to me, even when I had no official permission to work with them. I went on house visits with a rural midwife from a village clinic, watching her use an old, fluted listening device made of wood to hear fetuses in their mothers' bellies.

Mostly I worked with an official and a semi-official minder, both of whom admitted they wrote daily reports about me. One made me quite nervous, always saving up her prayers for sunset, the time I most needed to be shooting. She also criticized my white socks as un-Islamic.

Four Iranian friends helped me get what I couldn't through official channels. One even tipped me off when news was about to happen. I went to beauty parlors with my friends, poetry readings in homes, and parties where alcohol was served—illegal for Muslims in Iran. Large parties were possible when the local vice squads were paid off. Accompanying President Muham-

mad Khatami on a three-day goodwill trip to the sometimes-restive province of Kordestan was exciting. An old friend cut red tape with the president's office, and I was off for what I was told was a first: a U.S. photojournalist in the entourage of a post-revolution Iranian president.

I flew in Khatami's helicopter, ate on the floor with him, visited a factory, and photographed as he spoke to adoring crowds. He was known by some Iranians at the time as Ayatollah Gorbachev because he was loosening so many restrictions and trying to liberalize Iran without giving up Islamic rule, as Gorbachev had tried to do with Communist rule in the Soviet Union.

On the anniversary of the takeover of the U.S. Embassy, about a thousand leftist reform supporters gathered there to show their enthusiasm for President Khatami and their desire for rapprochement with the U.S. Some former leaders of the radical student group that took the hostages in 1979 spoke to the crowd that day. But from the sidelines, hard-liners yelled "*Marg Bar Amrika*," Death to America. Some teens burned American flags, while two others followed me, sneering, "How does it feel to see your flag burn?"

I had to check in with the local office of Islamic Guidance in each regional capital I visited. In Khorramshahr, I spent a long day waiting for the mullah in charge. He was a Sayyid, a descendant

of the Prophet Muhammad, and wore the signifying black turban. He was a dedicated amateur photographer who would accompany me anywhere in town to ease my way.

I was often moved by how far Iranians I had just met would go to help me. Some even invited me to stay in their homes. In Rafsanjan, a well-off pistachio-farming family insisted I stay with them. In their home, women wore no head-scarves in the company of unrelated male visitors. They watched foreign programs on their forbidden satellite dish and let me work in their orchards and processing plant. At night, they showed me millions of stars dotting the black sky of the Iranian desert. We lay down, the whole family next to one another in the back of their beat-up, blue farm truck to take in the constellations.

I visited the ancient, mud-walled city of Bam, which was home to the largest, standing adobe structure in the world and an impressive site before an earthquake hit in 2003 and devastated the area. I convinced the guard at a local pool to let me in, and when he disappeared, I had a memorable moonlight swim with a half-dozen delightful lizards. I roamed the ruins of Persepolis for three days, documenting classical beauty of that great capital of the Achaemenids.

Nearby in Shiraz, I developed a special friendship with the distinguished Ayatollah Majdeddin Mahallati and his wife. A pious, moderate, and worldly man, the Ayatollah took me under his wing. He invited me for meals at his home and invited me to join him in his mosque during Muharram gatherings. He let me photograph him as he tended his rose garden. The Ayatollah also asked me to join him, his wife, and his son on a pilgrimage to Mecca. I said I was honored but could not go, as a non-Muslim. He said, "Don't worry about it. We can fix that!"

A highlight of my time in Iran that year was visiting my ancestral village, Haftvan. The town is Azeri and Kurdish now. My family had given their lands to the last Armenian family in the village. The family brought me to the adobe compound where my grandfather had been a child and shared the walnuts from my great-grandfather's old orchard. They showed me the theater my family had built there. My great-grandfather was one of the leading elders of Haftvan, as his mother, the formidable Hrispime Avakian, had been. My family owned the lands of three other villages near what is now Orumiyeh. I arranged to renovate my great-grandfather's grave with a simple, dignified, flat stone.

On my final trip to Iran in the fall of 1998, I photographed Friday prayers at the grand square outside the ancient turquoise-tiled Imam Mosque of Isfahan. This spot was a flash point in the struggles between the reformers and the hard-liners, with the latter having taken over the weekly gathering. A group of Iranian Ansar e-Hizbullah members learned American journalists were present and started shouting, "Death to America," and whipping up anger. A man from the local Islamic Guidance office led us into Imam Mosque, where the caretakers shut and bolted the enormous door so we would be safe.

The next morning, two hard-line newspapers sympathetic to Ansar e-Hizbullah accused me of being a spy for Israel and said I was married to an American reporter whom they said was working for the CIA. The Ministry of Culture and Islamic Guidance knew none of it was true but subtly encouraged me to leave Iran immediately. On my way through airport security, a Revolutionary Guard member rifled through every roll of film I had, looking at me in disgust. He held my film and my passport for so long I nearly missed my flight. When I reached Frankfurt at dawn, I sat in a café and counted my rolls. Three were missing.

The 1999 *National Geographic* story was well received in both the U.S. and Iran. The Iranian government realized I had done nothing wrong, and I was welcomed and encouraged to return. In 2005, Iranians elected a new president in another upset election. Mahmoud Ahmadinejad, a hard-liner with a populist message directed toward Iran's disenfranchised, seemed to signal the end to the promise of the Khatami era. Iran remains a place of mystery and contradiction to those on the outside.

Then-President Muhammad Khatami's advisers confer below a painting of Ayatollah Khomeini before Khatami's speech to a jubilant crowd of thousands. Khatami was like a rock star in those days, following the seemingly dark, dour politics of Iran's previous rulers. The Ayatollah Khomeini had overthrown the Shah of Iran in 1979 and considered the United States the "Great Satan" of world affairs. But Khatami won the presidency in 1997 in a landslide, upset victory with a mandate for reform. In a country where citizens could vote at 15, Khatami drew support among the younger generation of Iranians. Many of these voters were born just before or after the 1978-1979 revolution and knew only the restrictions of life under Khomeini and his successor, Ayatollah Khameini. Khatami gave voice to an aspiring reform movement in Iran that sought more freedom. The conservative influences on politics remain powerful, however, and the reform movement has suffered many setbacks since the exhilarating early days of Khatami's presidency. Iran is currently under conservative rule once more.

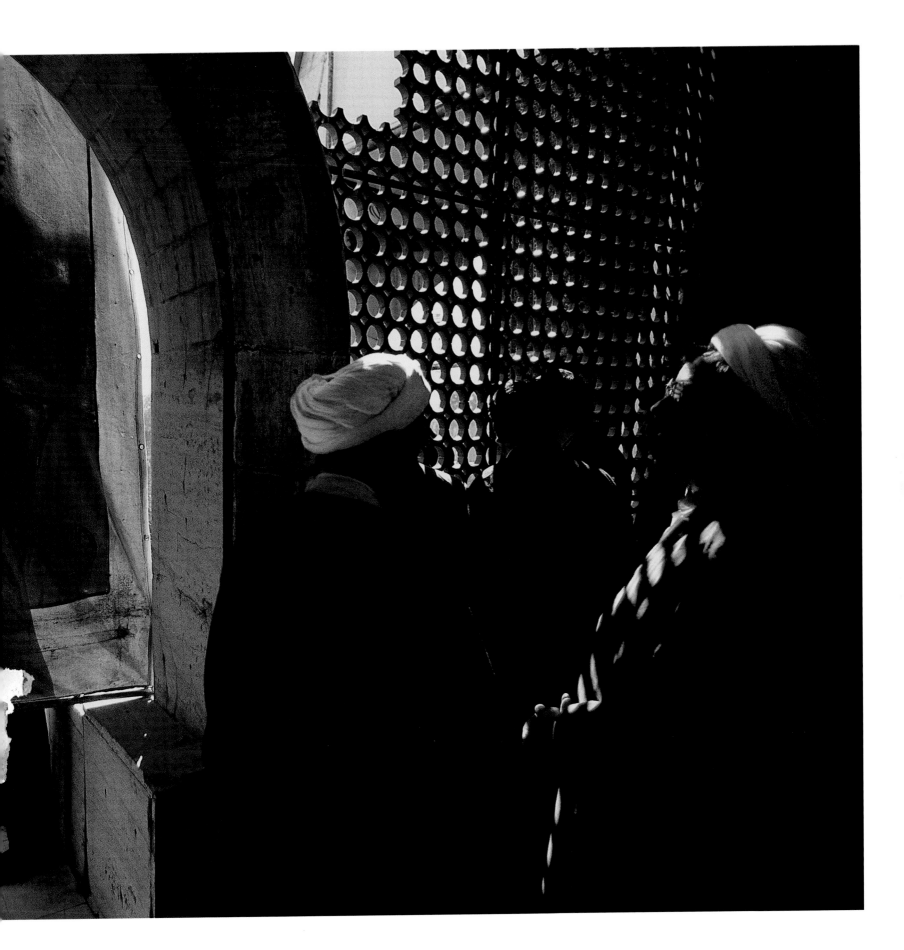

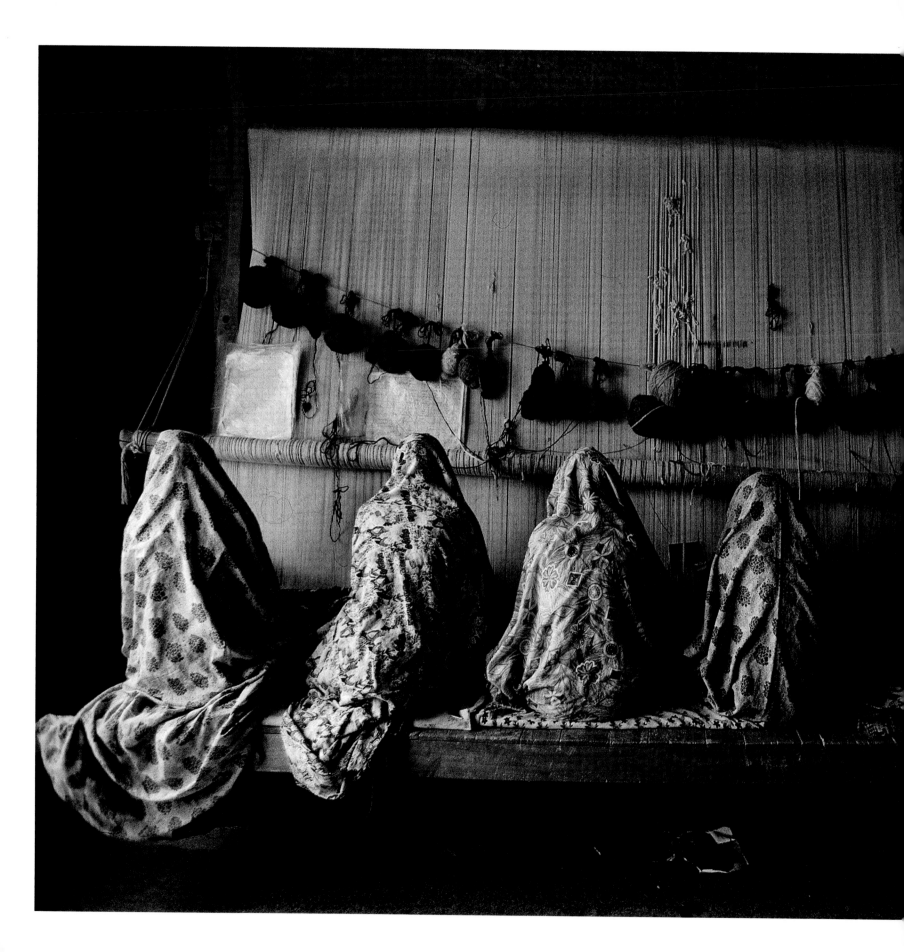

In Heris, women of the Mahbouban family weave a rug for export. Carpet weaving is hard work that is often done by whole families, and Heris is one of many Iranian villages and towns famed for the unique quality of their carpets. A rug the size of this one can take many months of painstaking daily labor. In addition to being their livelihood, weaving can also be an important creative outlet, especially for village women who might not have access to training in other arts. The antique rugs of the local villages often incorporated red floral designs and remain highly desirable today. I still regret not having purchased one of those beauties offered to me by the current owners of my family's old shop in the Tabriz bazaar. Though the United States has an embargo against most trade with Iran, carpets have been exempt for a few years. Recently, Congress has discussed widening it to include carpets again.

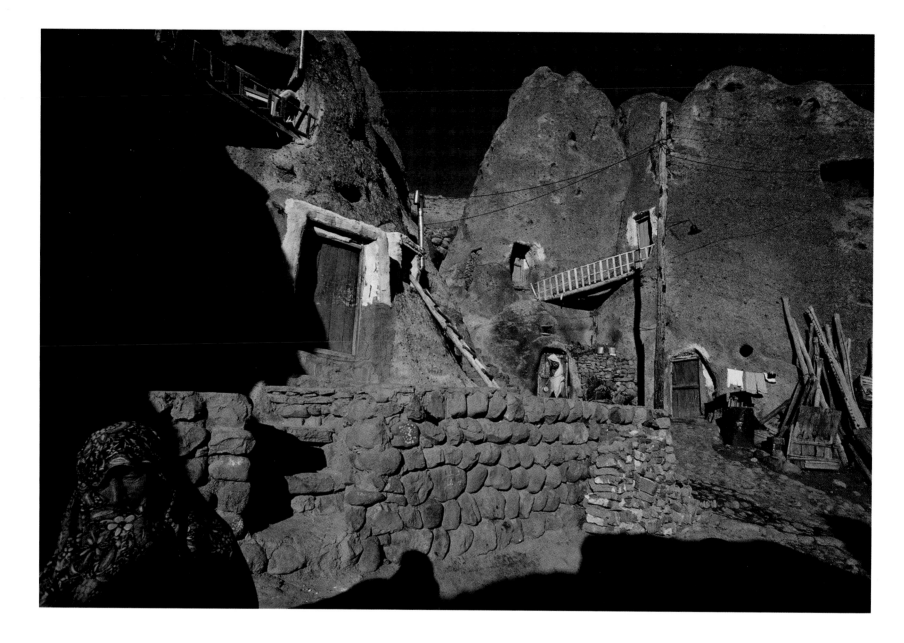

[KANDOVAN, IRAN | DECEMBER 1998]

For centuries villagers have lived in homes built into the volcanic rocks of these mountains. Some historians say the ancestors of current inhabitants fled the 13th-century Mongol invasion. Others believe the people of Kandovan have lived here much longer. The cave dwellings resemble a charming fairytale village, and I found the inhabitants a bit weary of all the strangers who come to see how they live. The walls were rounded and whitewashed; the people sat on cushioned mats on the floor. They had electricity, running water, televisions, and other appliances. The cave homes were cozy, clean, and full of character. Hand-carved niches held family photos and other beloved objects. Windows allow in as much of the sun as possible since the temperature drops quickly at night. Villagers use donkeys to carry their needs up and down the mountainside. Many make their living in animal husbandry and agriculture in nearby fields. As the population has grown and spread, villagers have built regular houses at the mountain's base.

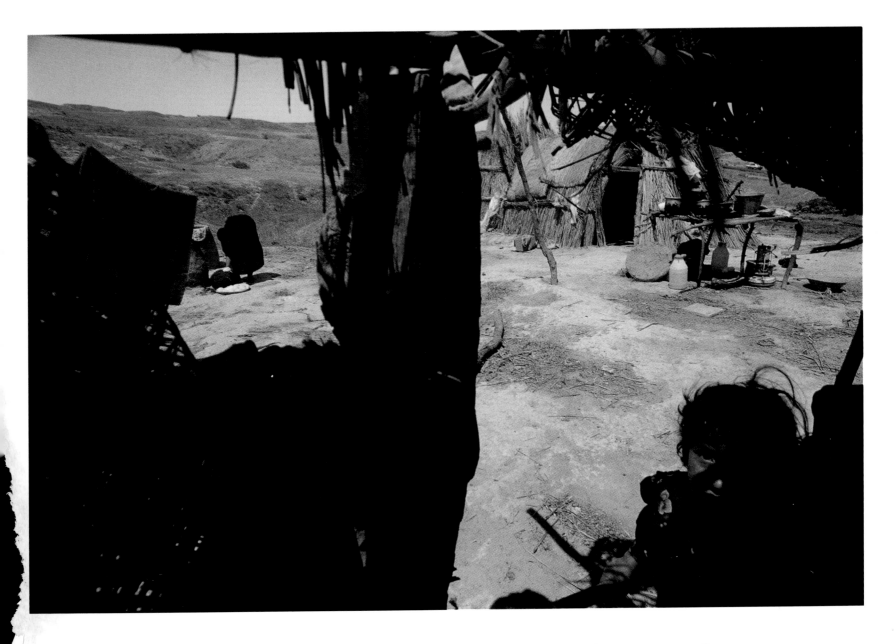

[KHUZESTAN PROVINCE, IRAN | APRIL 1998]

These refugees from Iraq's southern marshes lived in little reed homes in the desert after fleeing Saddam Hussein's regime. But many others lived in cinder block homes in squalid refugee camps with open sewers. The Iranian military controlled access to the camps, and the refugees were not allowed to leave without special permission. The Marsh Arabs were brutally repressed under Saddam, who patterned his dictatorship on the Stalinist model. He drained their marshes, arrested, tortured, executed, and deported many thousands after they revolted against his regime with the other Iraqi Shia during and after Desert Storm in 1991. Saddam ended a 5,000-year-old way of life built around the marshes. Once his regime was overthrown in 2003, the refugees were able to return. The marshlands were flooded and life is slowly returning. Marsh Arabs, with the help of Iraqi and foreign nongovernmental organizations, are planning a resurgence of local culture in the marshes, with modern services this time—including telephone, Internet, satellite television, and healthcare and sewage systems. Many Marsh Arabs believe their "traditional" lives also meant poverty.

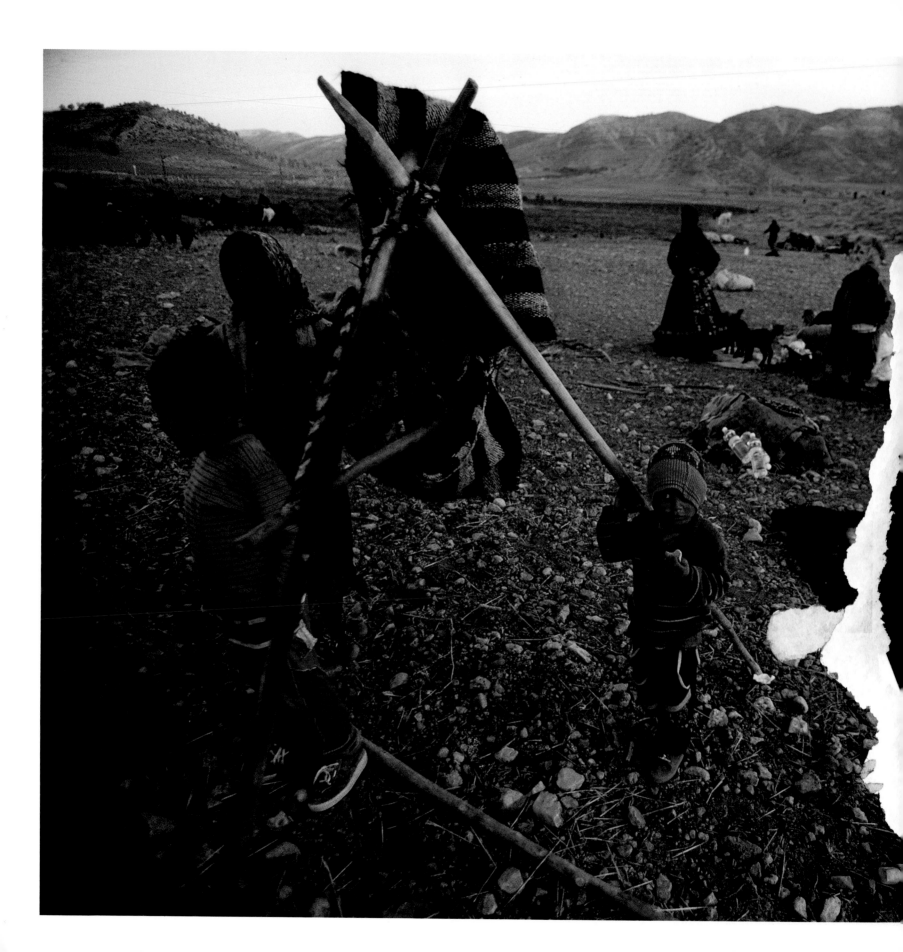

[FARS PROVINCE, IRAN | APRIL 1998]

In springtime, Qashqai nomads set up camp for the night as they head to higher ground with their herds. I found this group riding donkeys and walking across the land. But many Qashqai take the paved road as far as they can, accompanied by family members in pickups full of supplies. School is often taught in tents once they settle into campgrounds for the warmer months. Their women wear loosely tied, sparkled scarves—displaying long braids, hair at the forehead—and colorful skirts. Most Qashqai have been encouraged and at times pressured by various Iranian governments to settle down in houses at least part of the year. Most are settled or semi-nomadic now. They were crushed when they rose up against the Shah in the 1960s and against the Islamic Republic in the early years after the revolution. Like all Turkic peoples, the Qashqai tribe comes originally from Central Asia.

Several nomadic and semi-nomadic families let me accompany them on part of their journey, while settled families invited me to their homes. Iran has many ethnic groups—from the African Iranians of the Gulf to the Asian Turkmen of the northeast.

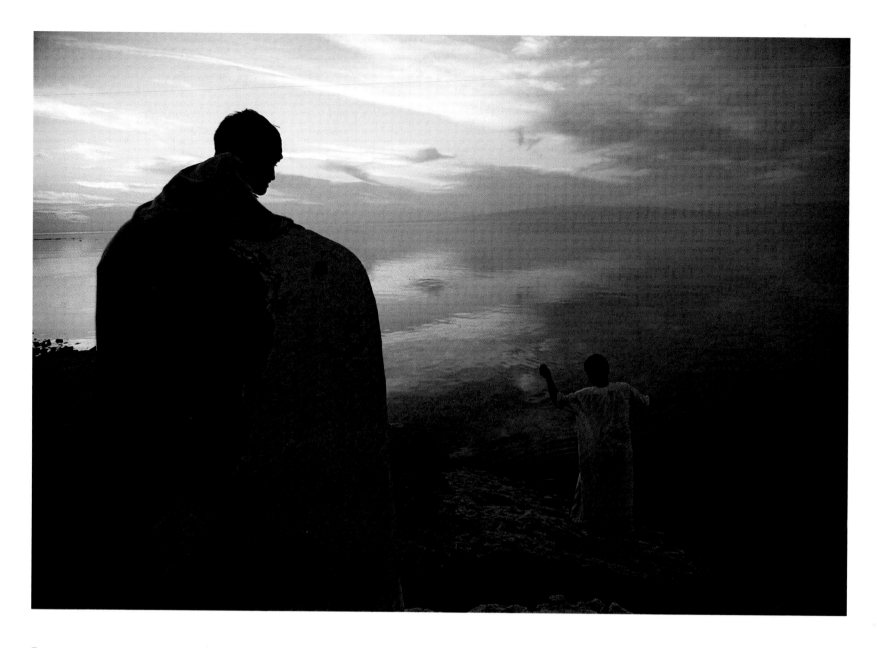

Arab boys fish on the sparsely populated resort island of Kish. The villages are tiny and traditional. Many of the women wear a greenish-black leather mask with their headscarves, covering the top half of their faces.

In contrast to village life, duty-free malls and hotels with goods from all over the world can be found on Kish—even American products coming through third countries. When I was there, Kish was a popular destination for vacationing Iranians who not only loved the shopping, but also enjoyed the only restaurants in Iran at the time where pop bands were allowed to sing love songs. It was only in Kish that women were allowed to ride bicycles then, as it was considered un-Islamic elsewhere in Iran. At that time, cutting-edge Iranian movie directors—one of them a famous dissident—were making films on Kish, supported by the Ministry of Culture and Islamic Guidance, through which all scripts must be vetted. I met several families on beaches and in cafés who spoke frankly to me about missing the days of the Shah, but only when my minder had stepped away.

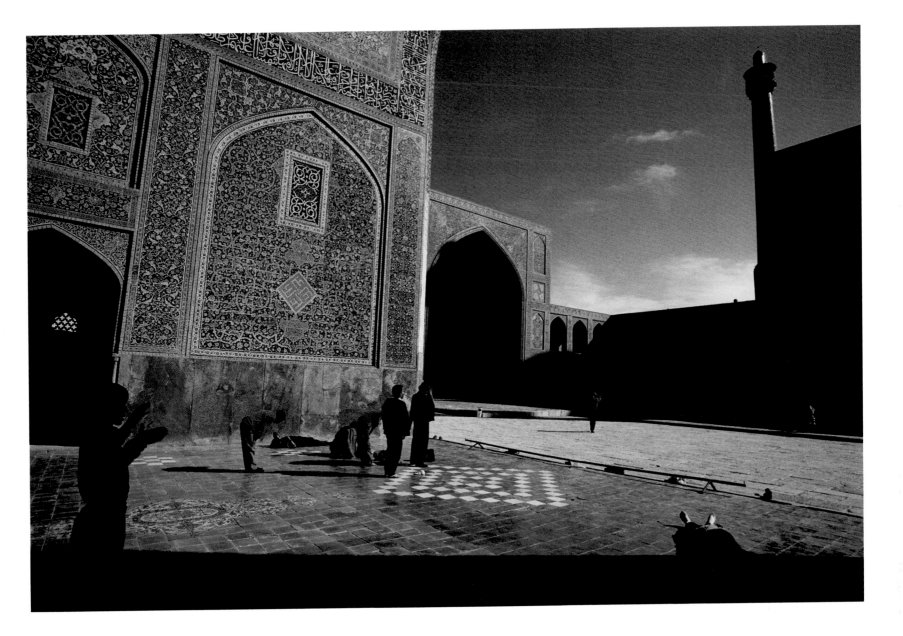

Built by Shah Abbas I at the beginning of the 17th century and completed in 1638 after his death, the Imam Mosque is one of the great architectural works of the Muslim world. It stands among gorgeous neighbors Lotfollah Mosque and the Ali Qapu Palace on Imam Khomeini Square, one of the world's largest public squares, where kings once watched polo matches. Famed for its beauty, the Imam Mosque embodies the special character of Persian-Islamic architecture. Its splendor lies partly in the masterful glazed tile work, the colors of which change subtly with the light. The mosque is part of a UNESCO World Heritage site. Over the past decade, Isfahan has been an ideological battleground between hard-liners and reformers. Once the capital of Persia, Isfahan sits close to the approximate geographic center of the country. The old Persian expression Isfahan Nesf-e-Jahan— "Isfahan is half the world"—is still used today to express the greatness of the city in its heyday.

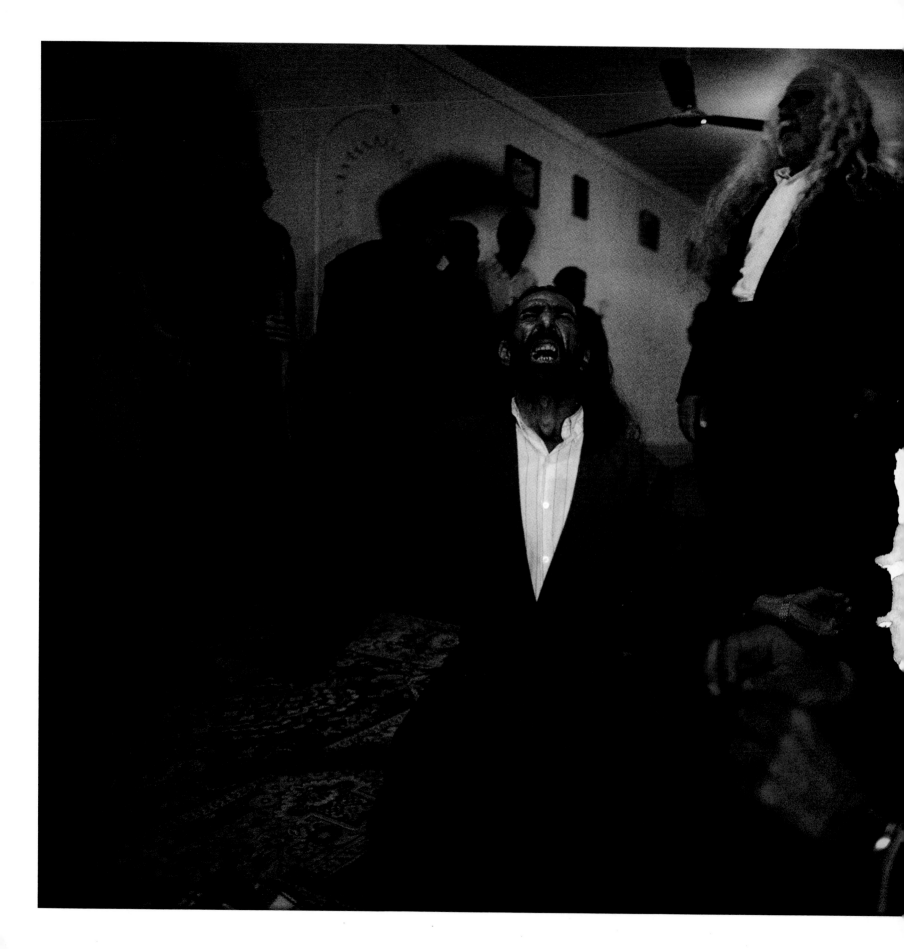

[MARIVAN, IRAN | SEPTEMBER 1998]

Unlike most Sufis—who worship without physical penitence—these Kurdish dervishes of the Qadiri order do. They believe their love of God is what allows them to endure great physical trials in His honor. I photographed these men in their *khaneghah,* a Sufi meeting place for their rituals. After entering a trance achieved through hours of rocking and chanting, this man has swallowed broken glass and a set of car keys and will next eat a razor blade that the man on his right is wrapping in paper. When asked how he felt, he said, "Oh, it will hurt tomorrow, but my wife takes care of me until I feel better." Older men whipped their long tresses up and down as they rocked quickly up and down from the waist, having entered the trance. The group's gray-haired leader owns a bakery known for its sweets, which is where I found him to ask permission to attend one of the ceremonies. He told me they were glad to show me their love of God. The gatherings are normally forbidden to women, but they made an exception for me.

[QOM, IRAN | MAY 1998]

The Holy Shrine of Hazrat Fatemah Ma'soomeh, sister of Imam Reza, one of the 12 imams of Shiite Islam, is forbidden to non-Muslims. Here, mosaics made of mirrors decorate the mosque while breaking up the graven image in the women's section. This shrine is the site of many pilgrimages, as prayers are believed to receive special consideration here. Though I had official permission from Tehran to work inside, local officials would not allow it, and I was heartbroken. As I hung around the entrance, despondent, an Iranian geologist donating his time as a security guard that day asked what was wrong. I explained my frustration to him, and he brought me inside to the women's and men's sections saying, "Do your work, but be quick. I know *National Geographic* magazine and like it very much." Qom is a famous center of Shiite scholarship and is intellectually alive with different perspectives. Ayatollah Khomeini studied and taught here, as have many ayatollahs. During my visit to Qom, I was followed everywhere by men in an official car. They never spoke and seemed so bored with me. I invited them to join me for lunch, but they declined.

Goldfish symbolize new life during No Ruz, the Persian New Year, celebrated on the equinox of spring. The roots of this holiday are Zoroastrian and pre-Islamic. Celebrated by all faiths in Iran, 13-day No Ruz is one of the happiest times of the year. The Wednesday before the holiday, known as *Chaharshanbeh-Suri*, Iranians jump over seven fires to ensure good health and luck. The government has tried to prevent this practice at times, but the tradition has endured. Tehran falls so quiet during No Ruz that the air becomes crisp and fresh—a welcome change from the heavy smog created by daily traffic jams the rest of the year. Persia was the birthplace of Zoroastrianism, which held sway until the Arab invasion brought Islam to Persia by the mid-7th century. The Zoroastrians fled to Yazd, a stark desert province, where I visited their ancient cave temple, Pir-e-Sabz. There, it is said Ahura Mazda [God] miraculously hid a fleeing princess and daughter of the last Sassanid king, ahead of the invading Arabs.

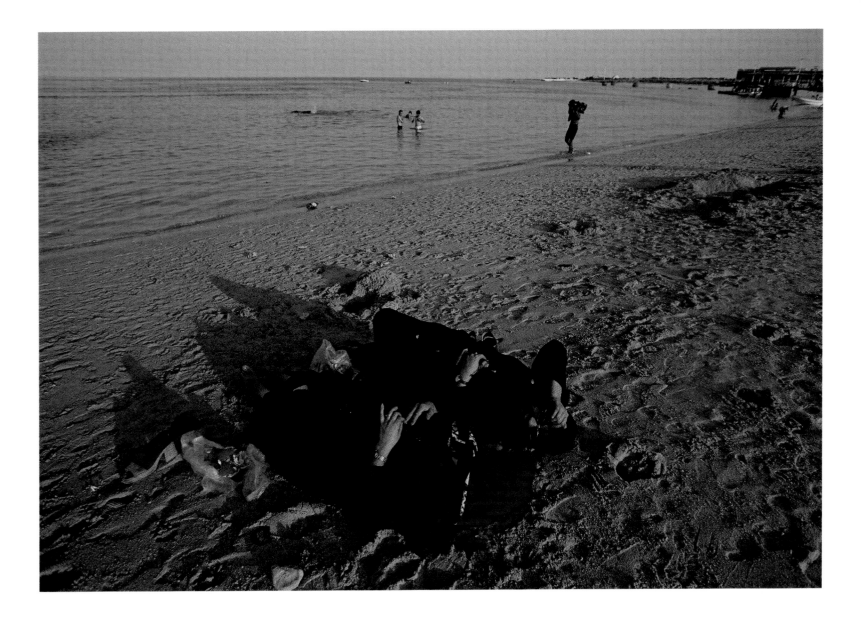

[KISH ISLAND, IRAN | MARCH 1998]

At a family beach on Kish Island, men don swimsuits but women must wear full Islamic dress. Later, I visited Kish's all-female beach, where women can wear as much—or as little—as they like, and where men and cameras are strictly forbidden. If a man dared sneak a glimpse, he could be hauled off and booked by police. Surrounded by high fences, the beach was as relaxed as any I've seen in Europe. Some women basked topless while nannies minded the kids. Others wore bathing suits and romped with their children, and clusters of young friends bronzed themselves. My annoyingly conservative minder and I went for a dip in the Persian Gulf. I softened toward her then, in the clear blue shallows, both of us in underwear and no headscarves. Without her chador, I saw for the first time her vulnerability, a middle-age widow struggling to support her family and considering remarriage to a kind, earnest man.

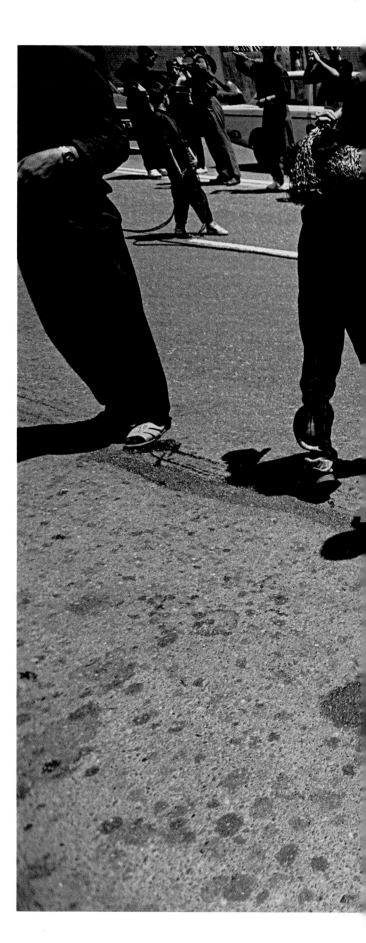

[TEHRAN, IRAN | MAY 1998]

The blood of a sacrificed lamb streaks a north Tehran street during Ashura, the day of mourning for Imam Hussain and the peak of the month of Muharram. The blood and self-flagellation with chains are in honor of the seventh-century martyrdom of Imam Hussain, grandson of the Prophet Muhammad, a figure revered by Iran's Shiite majority. As they thump their chests and shoulders in unison, the men and boys shout, "*Ya Hussain,*" in unison, progressing slowly down the street. In Iran, Muharram starts out quietly with nightly gatherings in mosques, where the story of Hussain is recounted. Observances become more emotional throughout the month until peaking in the days leading up to Ashura, and include costumed passion plays and open weeping in the mosques. Finally, during the last evening, candles are lit, emotions calm once more, and people return to their usual lives.

The film director Mohsen Makhmalbaf invited me to stay the night at his house in south Tehran, for the next day was Tasuah, one of the last days of mourning for Hussain. In his neighborhood it promised to be dramatic. Makhmalbaf's son, a young photographer, guided me through the turbulent streets as men acted out the martyrdom. Men portraying enemies of Imam Hussain rode horses cloaked in red, wore ancient-style helmets, and waved huge swords as they raced through the square, finally burning the desert tent dwellings of Hussain and his family. Mock bodies were carried through the streets and young men and boys flagellated themselves as others calmly offered them beverages to keep up their energy. I watched unmarried young women of the neighborhood take the opportunity to check out eligible young men as they participated in the day's physically taxing events.

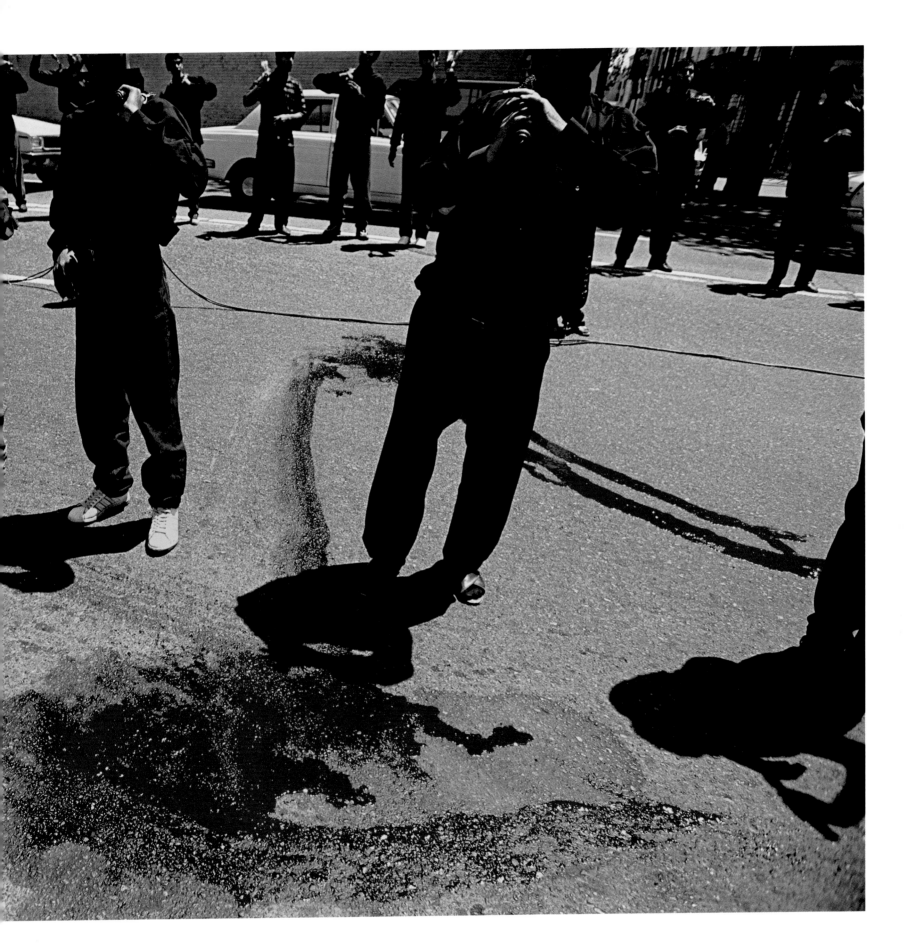

94

[TEHRAN, IRAN | MAY 1998]

At this mall, groups of teenage girls and boys get close enough
to each other to actually meet. Some even exchange phone num-
bers. In a cultural war of attrition, morality police often raid these
rebellious gatherings and drag the teens off if they can catch
them, especially in the springtime. In North Tehran there is a
small but stubborn bastion of secularism. In the streets, women
with loose hijab or young men with fashionable Western haircuts
are harassed regularly. It is a source of constant frustration for
the city's young people, all raging hormones and raw emotion.
Around 50 percent of Iran's population is under 25, and it is the
minority secular elite who allow themselves such risky opportu-
nities. Other spots for chance or planned meetings were on the
hiking trails in the Elburz Mountains above Tehran, and the ski
resorts of Dizin and Shemshak, where I saw singles meeting one
another and unmarried couples enjoying the slopes together. Iran
is full of seeming contradictions. Although Ayatollah Khomenei
once famously said, "There is no fun in Islam," the Islamic gov-
ernment has long supported temporary marriage. This technical
loophole allows couples to get married for the duration of an
affair, whether for an hour or much longer. It is looked down
upon by many Iranians as officially sanctioned prostitution, but
some with a modern outlook use it simply to be together safely
in a country where couples must routinely prove they are mar-
ried when caught out together.

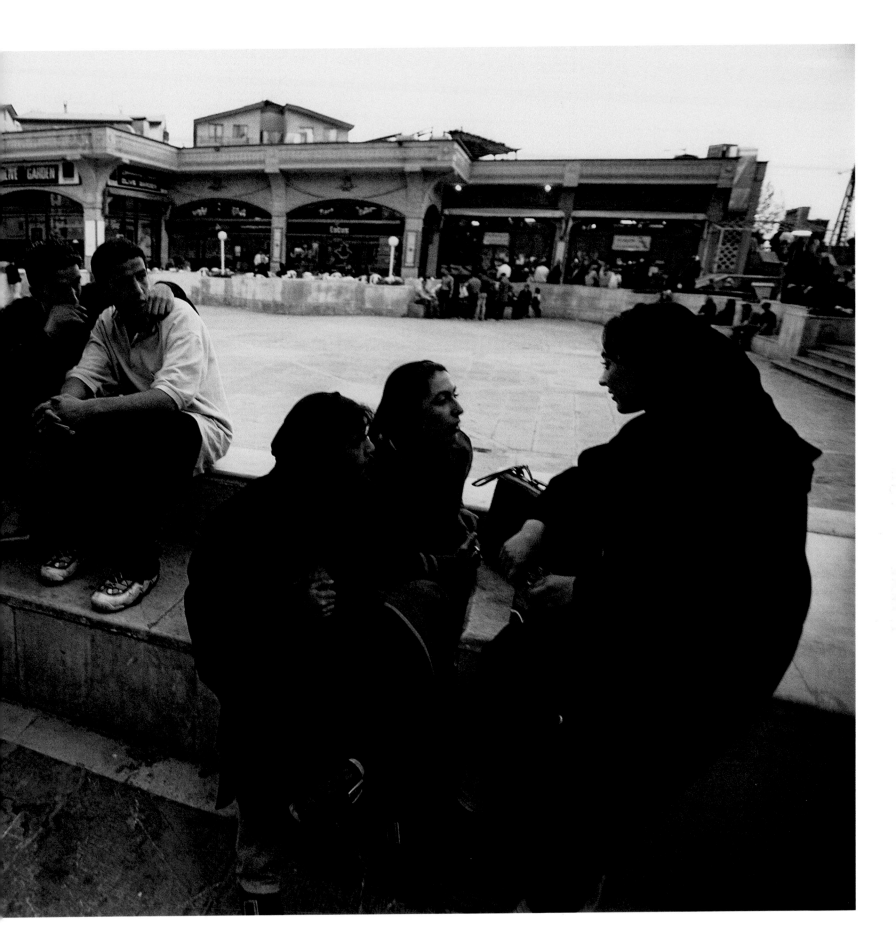

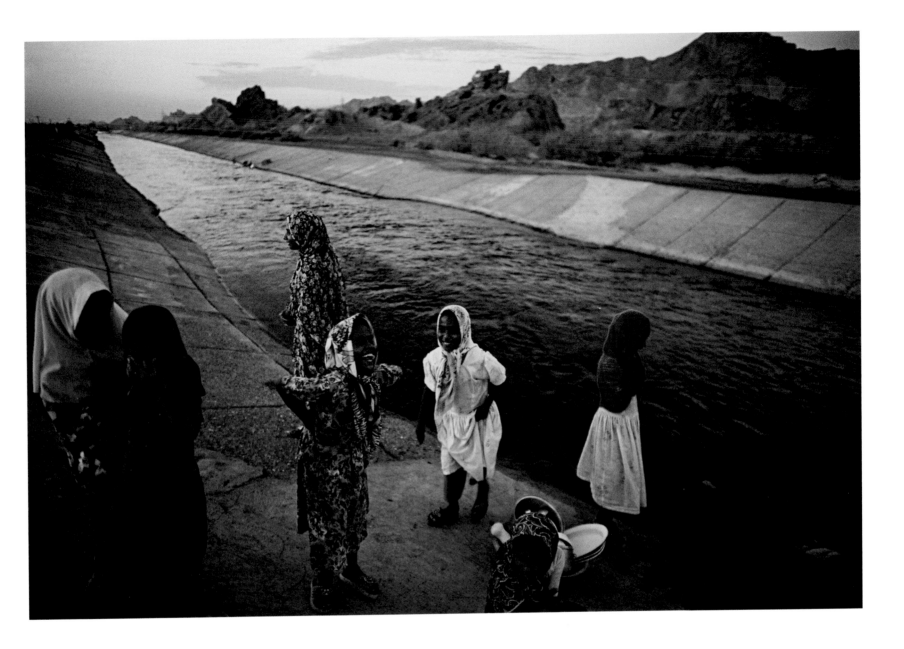

POSHTEH SHAHVAR, IRAN | NOVEMBER 1998 | Bandari girls play by a canal at the end of the day.

OPPOSITE: **MARIVAN, IRAN | SEPTEMBER 1998** | Khial Ali, 17, a Kurdish bride at Zarivar Lake.

98

These masked women take a break after shopping at the weekly open-air market. The wearing of masks in the Muslim world often has its roots in pre-Islamic customs. The masks are everyday wear for these women, and I couldn't resist trying one on to see how it felt to view the world through it. The most disconcerting thing for a novice was having my vision strictly divided between left and right by the long protruding fold between the eyes.

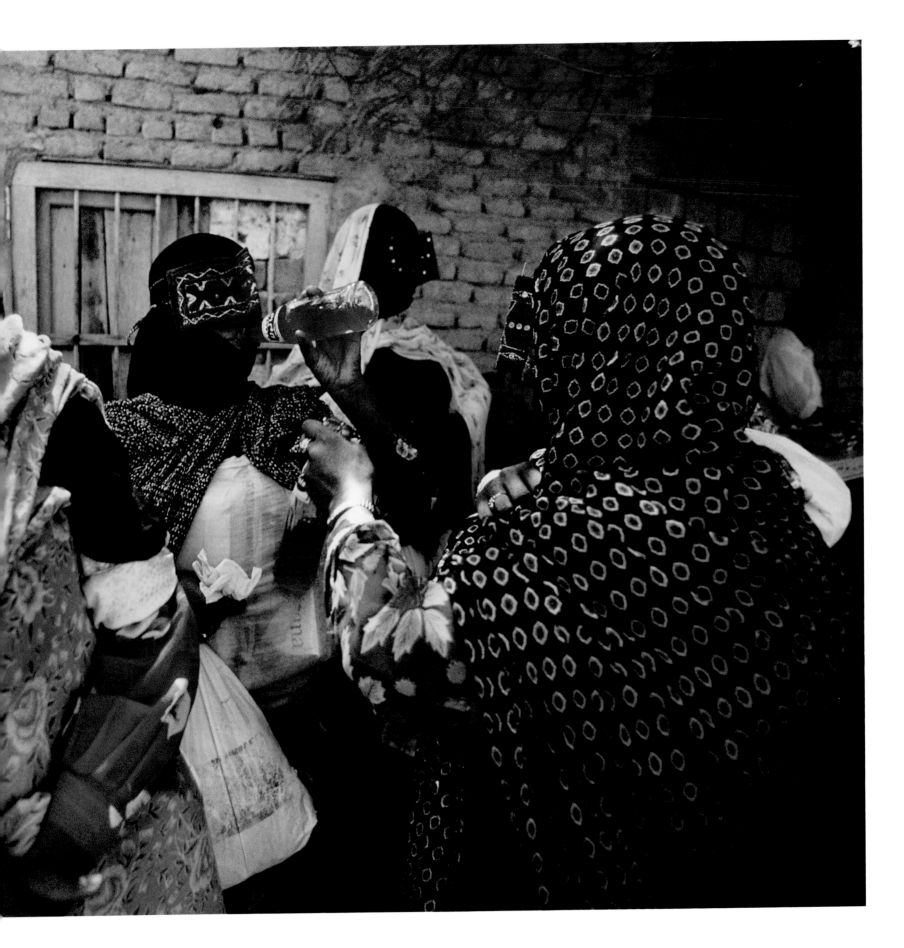

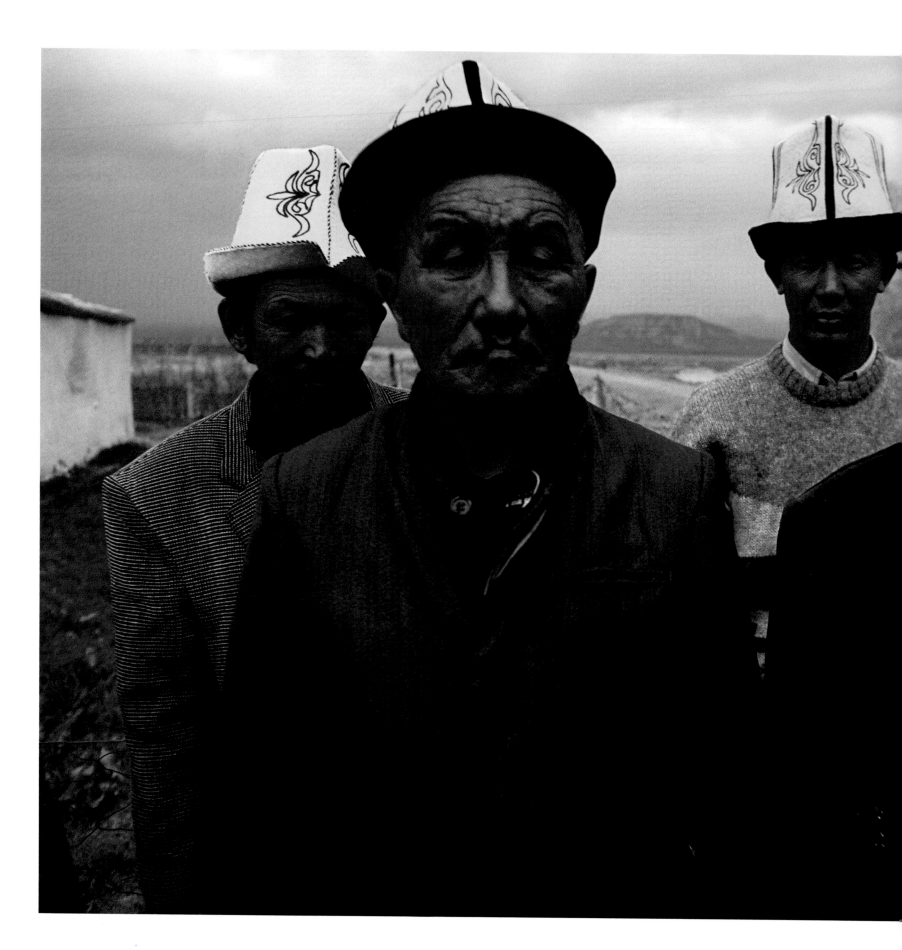

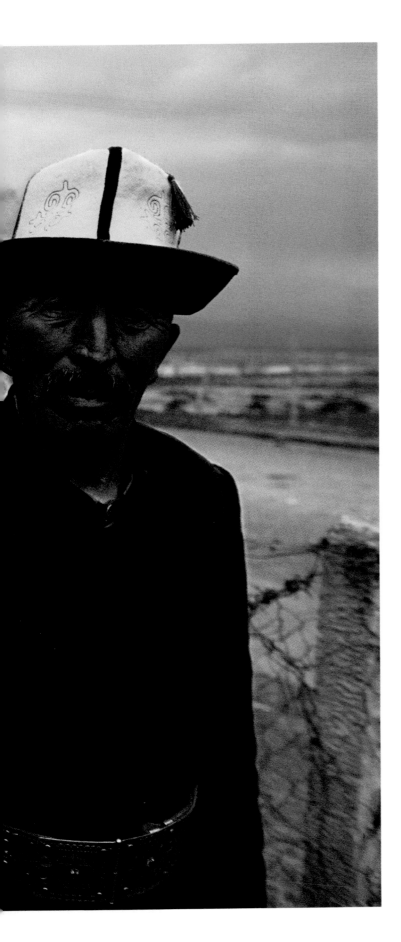

3
CENTRAL ASIA & THE CAUCASUS

AT BASHI, KYRGYZSTAN | MAY 2000 | These men wear hats made of felt, a fabric often used in traditional crafts of Kyrgyzstan. The wife of one offered me mare's milk hot from the horse to drink when she saw I was pregnant on this assignment.

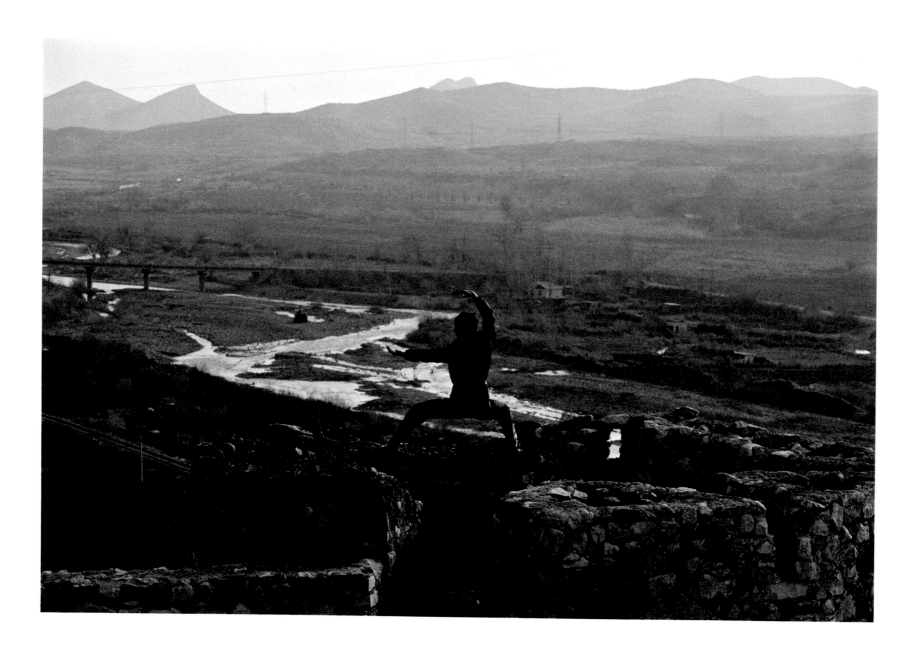

ASKERAN REGION, NAGORNO-KARABAKH | MARCH 1992 | An Armenian soldier practices
martial arts at dawn atop an 18th-century stone fortress.

آسيا الوسطى و القوقاز

I was in Egypt on vacation with my family in 1988 when news of the Armenian earthquake broke. I knew I needed to go or I would never forgive myself.

I got a visa from the Soviet Embassy in Cairo and arrived in Moscow with nothing more than a light sweater.

Moscow was an intimidating city, dark and snowy, when I arrived for my first trip behind the Iron Curtain. I did not have an official invitation, so no hotel would take me in. I was outside the system: I did not exist. I got a lucky break when a colleague found me sleeping on a hotel-lobby couch before dawn. He gave me his room, as his permission had arrived and he was off to Armenia.

My assignment to cover the earthquake was for *Life* magazine, so the next morning I made contact with the Time-Life Bureau in Moscow. I had no idea then that my life would revolve around that bureau for the next several years.

I would end up covering perestroika, the breakup of the Soviet Union, and its aftermath for *Time* from January 1989 to September 1992. I lived full-time in Moscow two of those years. I had the opportunity to cover great stories: Russia; the Baltic independence movements in Lithuania, Latvia and Estonia; the conflicts of the Caucasus; and Soviet Central Asia as it broke away. In those days, with permanent-correspondent status, it cost about four dollars to fly round-trip to the Caucasus on the frighteningly worn out Soviet airline, Aeroflot, and about seven dollars to get to Central Asia and back.

While the world was watching the Gulf War, the Soviets cracked down on the Baltic independence movements, and I covered the story. While living in the U.S.S.R., I tore myself away to cover the Israeli-Palestinian story and to photograph Iraq after the war.

In 1988 I went to Armenia, spending a month in the ruins of the earthquake in which about 25,000 Armenians had died. I wore leaky boots and a coat borrowed from a *Life* stringer, and carried a single camera bag containing my gear, film, and a change of underwear and socks. My nights were spent in a frigid, quake-damaged schoolhouse that had been commandeered by the international aid agency Médecins Sans Frontières.

When I returned to Moscow, *Time* kept me working there for another wintry month to cover the Soviet Union during the reforms of glasnost and perestroika. I remember walking in Red Square one misty morning and coming upon two beautiful, young Asian men in multi-colored robes tied with sashes and square black-and-white hats atop their heads. They spoke Russian but were so bright compared to their surroundings. I learned they were from Tajikistan. I soon fell in love with Central Asia and the Caucasus. Some of it had to do with my grandmother's roots, some with pure aesthetics. But then there was the struggle for freedom and the willingness of people to risk their own lives to gain it, a subject that had interested me since my college days.

The Soviets gave the *New York Times* bureau chief and me permission to travel to Baku, Agdam, and Nagorno-Karabakh in August 1989 to cover the beginnings of the first of many civil wars in the region between Christian Armenians and Muslim Azeris. But religious differences had little to do with a conflict that had only subsided because of decades of Soviet rule. When Soviet control began to loosen, ancient ethnic tensions and historic claims to land came to the surface again.

On the Baku-Agdam train, both the reporter and I picked up tails: a man and a woman who befriended us, speaking perfect English. The woman who stuck to me said she was an English teacher and seemed like such a lovely person I thought I had made a friend. We enjoyed the breeze through the open windows and watched the landscape go by. When she told me Arme-

nians were filthy, and their women slept with dogs, I withdrew from her company.

In Agdam, we were greeted by a kindly, middle-age Azeri Soviet official, who put us up in a Soviet-government guesthouse and presented us with carpets. Agdam was a pleasant, laid-back town before the Armenians later captured and leveled it.

The next day we moved on to Shusha, the elite mountaintop Azeri resort town in the disputed region of Nagorno-Karabakh. I photographed Azeri victims of the fighting—women and young children who were forced out of Stepanakert by Armenians. They lived in poverty and were deeply fearful for their future.

Rena Allakhverdieva, the hefty, local Chief of Communist Party Ideology, took us to a pretty, secluded, outdoor restaurant. A few Azeri musicians played traditional tunes on acoustic instruments. After lunch, Allakhverdieva abruptly turned to me. "Where are your people from?" she said. " My grandmother is an Armenian from Georgia, and…" I began. "Get out!" she said. "You Armenians from Georgia are really from Karabakh. You can walk to Stepanakert!"

She recovered slightly from her rant and calmed herself. "You must understand we cannot guarantee your safety," she told me. "When they see the name on your passport,

the fact that you are American will not save you. It is out of our hands."

I was shocked. Had I been naïve to try and cover the story in an even-handed way as an American journalist despite my ethnicity? The bureau chief and I were put in an official black car and dropped off midway down the mountain Shusha sits atop, and were left to make our way to the Armenian side at the capital, Stepanakert.

In the winter of 1992, I was in Rome when news broke of a massacre of Azeri civilians at Khojaly. By the time I got to Karabakh via Moscow and Yerevan, that tragedy was over. Still, there was the war to cover and it had gotten bad. I took more risks than ever on that trip, working amidst sniper fire, Grad missile attacks, and in front-line trenches. I stayed among Armenian refugees at night, and with Armenian troops of the Askeran battalion in an 18th-century fortress, their front-line base.

But flying bullets and missile fire were not the only dangers for a photographer. A couple of years later, I was traveling with an Armenian officer in occupied Azeri lands, and we stopped at a spring. He cupped his hands for me to drink. I refused and helped myself. We got back in his vehicle to go, and he pounced on me, moving the lever of the seat so I lay beneath him. Getting my right hand on the door handle, I managed to squeeze out from beneath him. "Give me your

Kalashnikov!" I told him, ready to walk through that dangerous territory alone rather than submit. He saw I was serious, and relented, saying "Okay, okay then. Get in." He drove like a demon back to base without saying a word, so fast I thought we would crash and be killed. When I got out, there were no apologies. He dismissed me. "Dasvidanya," he said. Goodbye.

I visited the Republic of Georgia during its various conflicts after it became an independent country. Georgia clashed with South Ossetia and with Abkhazia, where Christian and Muslim fighters were joined by Muslims from Chechnya. Like the war in Nagorno-Karabakh, these conflicts were not about religious differences. People were fighting for independence and Abkhazians eventually broke away from Georgia in the early 1990s.

For me, covering the troubles in Georgia was a way of trying to know what my family had experienced. Persian-Armenian relatives came through as refugees from the Armenian genocide on their way to Rostov. My Georgian-Armenian ancestors lived through the Russian revolution, and many were wiped out in Stalin's Great Terror.

Through a member of the ancient royal family of Bagrationi and a Georgian journalist specializing in victims of Stalin, I was able to find a family of very distant cousins in the capital,

T'bilisi. They wept that such a distant family member had sought them out.

I went to Soviet Central Asia whenever I got the chance. I liked the ancient Islamic architecture of old silk-road centers like Samarqand and Bukhara; the way Tajik women would use black makeup to connect their eyebrows into wings above their almond eyes; the old men sitting on hand-carved wooden platforms out in the open, drinking green tea and playing backgammon or chess when it was warm. In cold weather, they were beautiful in their white beards, traditional rainbow-stripe robes, and pointy rubber galoshes over cloth boots. As in the Caucasus and some other regions, the cultures and national traditions that had been repressed in Soviet times still somehow shone through the dreadful, soul-deadening, monochromatic Soviet world.

In Uzbekistan, after gaining independence in 1991, dissidents were struggling against a dictatorship where torture is common. I met Abdurahim Pulatov at a bold human-rights conference organized by the secular-democratic opposition movement Birlik. The next time I saw him, in July 1992, Uzbek government thugs had beaten him so badly they had cracked his skull. In the meantime, the U.S. government was courting the Uzbek president, Islam Karimov. I had to evade creepy men in trench coats who followed me whenever I descended the front steps of

the hotel. Each morning, I gave them a bright hello.

I gained access to two underground Uzbek Islamic fundamentalists over a period of almost two years. On a 1991 trip, after observing Saudi Korans being given away at a mosque, I asked them if Wahhabism—the conservative, centuries-old reform movement of Sunni Islam—was taking hold in Uzbekistan. "Shhhh!" they hissed. "Never say that word!"

Twice they took me to Fergana Valley, a center of Islamic opposition to the government. The first time, I was with a Russian reporter from the Moscow *Time* bureau. They fortified us before the trip, sharing a local delicacy: horse sausage.

In their tiny old Lada in the middle of a winter night, we spun out repeatedly on the icy mountain road along the border. Each time the car slid round and round terrifyingly, they said, "*Allah-u akbar.*" We finally made it to Namangan, the regional capital of Fergana Valley, and enjoyed fresh bread and yogurt in the market at dawn, eating from blue-and-white ceramic bowls decorated with stylized cotton plants.

On a second trip to Namangan in July 1992, we pulled up at a city mosque in the middle of the night. We went quickly and quietly inside to rest, lying on vast, machine-made carpets until daylight. Staying at the mosque instead of a hotel

was a way of avoiding places where we might attract unwanted official attention. Soon it was time for Friday prayers and the men flooded in. I snapped some pictures, the prayers ended, and I was immediately detained and taken to the local headquarters of the former KGB for questioning by Uzbek intelligence.

My two Islamist guides got away, and I never saw them again. Two other American photographers who had been tagging along and I were upbraided by a huge, screaming female intelligence official with gold teeth.

"You are forbidden to be here!" she yelled. I asked to call my embassy, and she yelled again. "You! You have an Armenian name! I know you understand Russian, don't you?"

"I need to call my embassy now," I repeated, and stood up huffily. To my great relief she backed down.

"Get out of Fergana now! Go straight to Tashkent and do not come back!"

On subsequent trips to Uzbekistan, I was never again able to find the two fundamentalists who had helped me. They may have given up their radical ways, gone underground in Fergana, landed in an Uzbek prison, joined the Taliban in Afghanistan, or hooked up with the Islamic Movement of Uzbekistan later. I do not know.

TASHKENT, UZBEKISTAN | FEBRUARY 1992 | I made a double exposure of children
playing in the streets and bazaar.

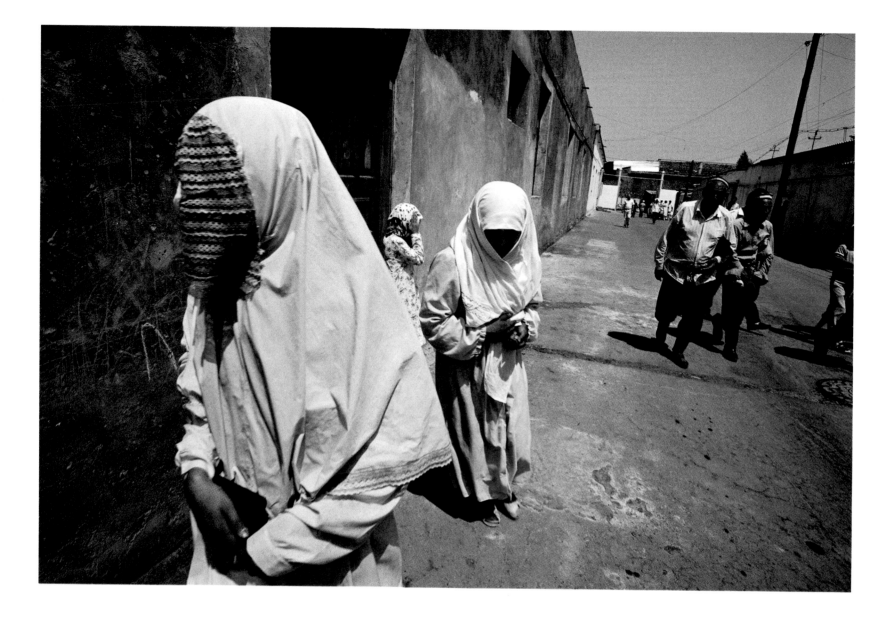

Girls leaving Jami Mosque cover up thoroughly in traditional fashion to walk in the street. After the fall of the Soviet Union, some people went to extremes in their eagerness to embrace religion and reject the control the Soviets had forced on Uzbekistan in the past. Again free to practice their religion, some Uzbeks embraced its customs. Russia has had a long and difficult history with the Muslim world at its edges. Under the former Soviet Union, religious leaders were hand picked by the regime. But once that system began to dissolve after the U.S.S.R. fell, Koranic schools re-opened and people started flocking to Friday prayers at newly renovated mosques. This respite from religious persecution would not last. Soon, the independent Uzbek government—one of the world's most autocratic regimes—launched a brutal crackdown against Islamic groups and nascent secular-democratic movements, subjecting them to harassment and persecution.

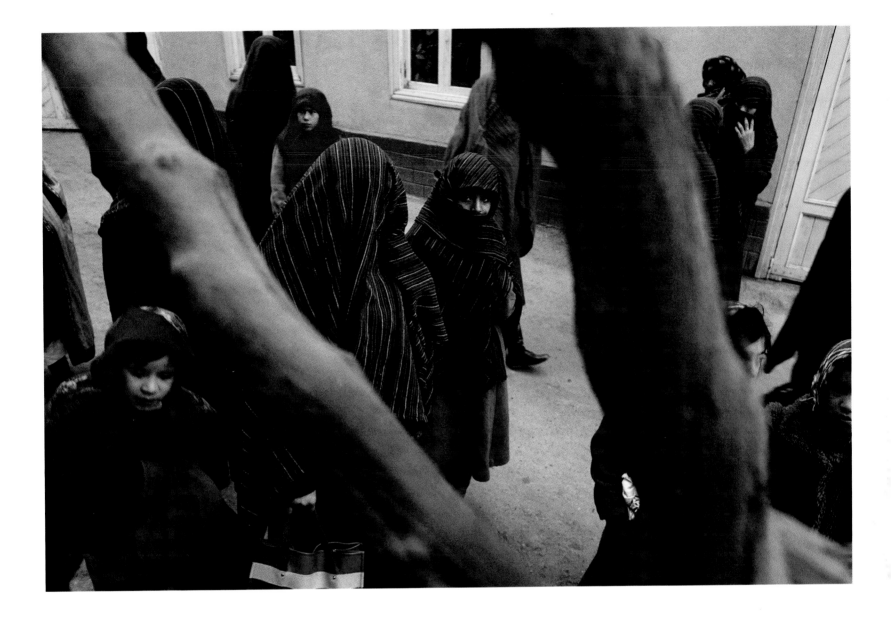

Some girls walk home fully veiled, others with faces showing after Friday prayers. As innocent as the photos on these two pages seem, they were not at all easy to get. I had to travel to the Fergana Valley, the hotbed of Islamic opposition where these pictures were taken, without official permission, guided by two Islamists willing to take the risk. Uzbek Islamist groups never got close to creating an Islamic state, but they made inroads in mosques, *madaaris* (Islamic schools), and some poor areas. The climate during these years is what led to the rise of the radical and sometimes violent Islamic Movement of Uzbekistan, which began in the early 1990s and took its name in 1998.

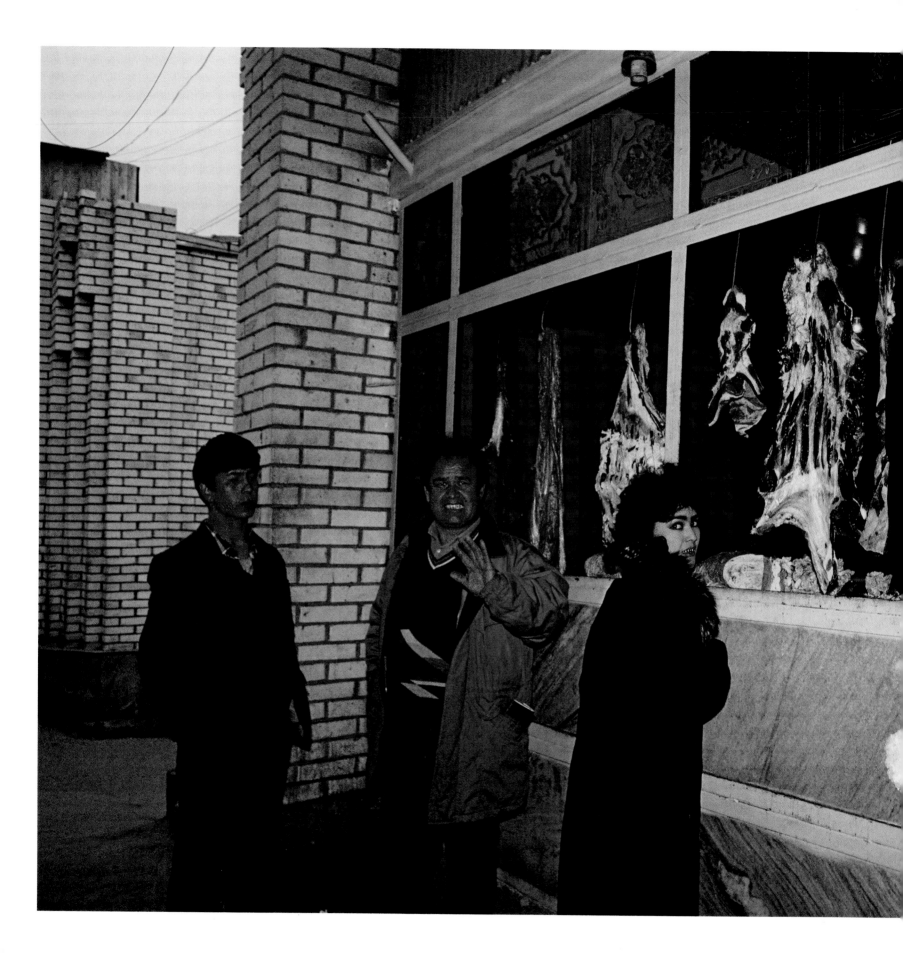

SAMARQAND, UZBEKISTAN | FEBRUARY 1992 | At a butcher shop window in Samarqand, shoppers were caught by surprise when I snapped their picture.

AGDAM, AZERBAIJAN | APRIL 2002 | This formerly vibrant town was destroyed by
Armenian troops in the Nagorno-Karabakh war.

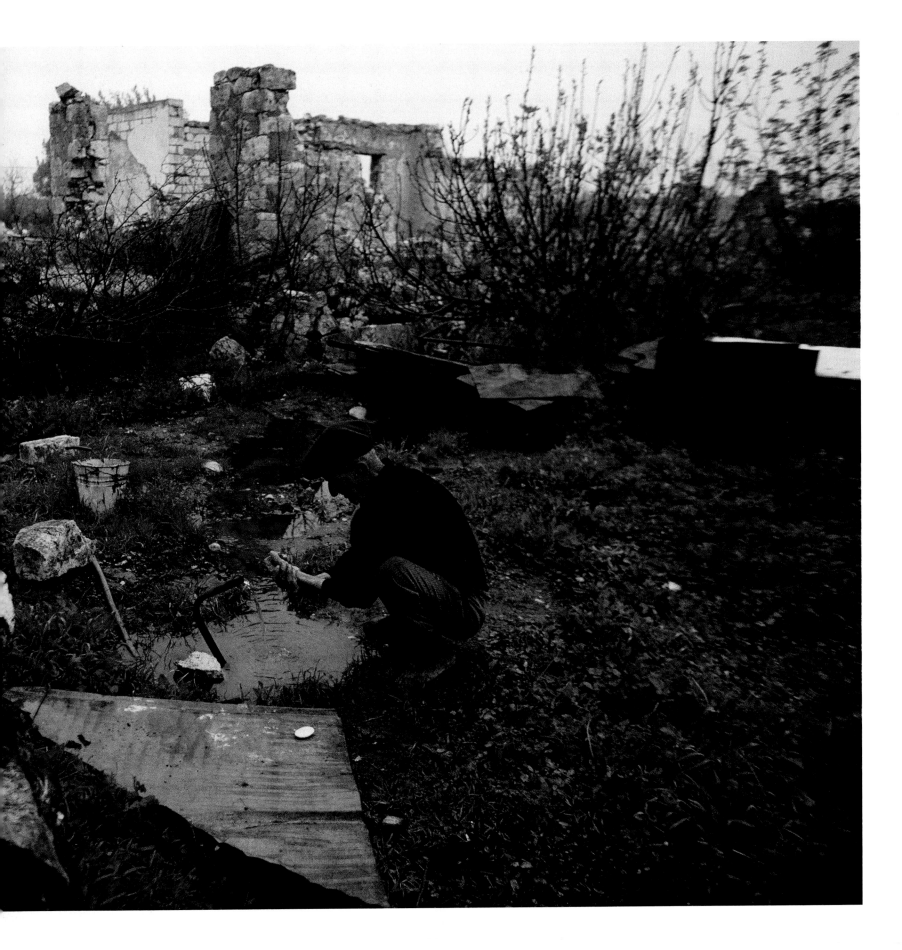

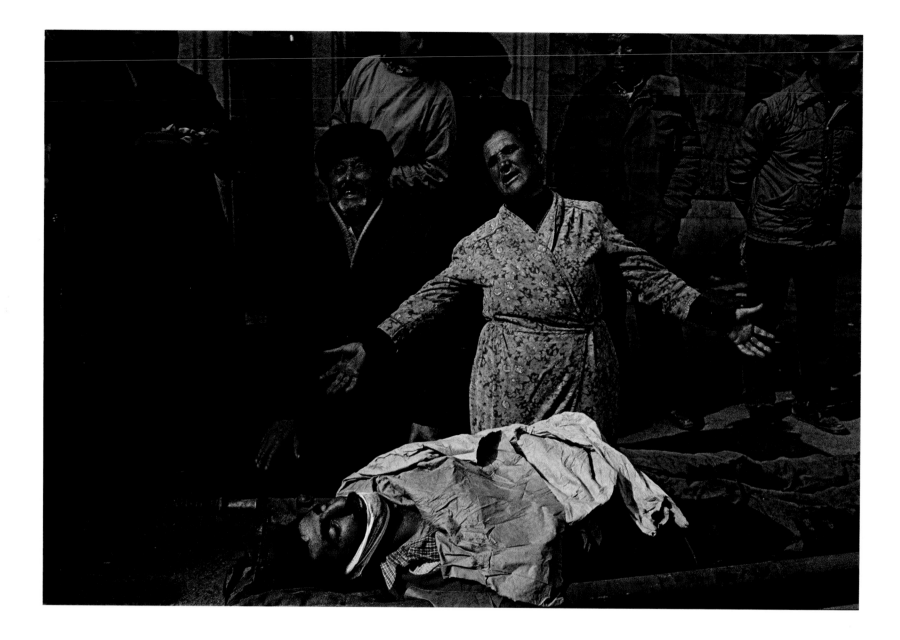

An Armenian mother and father grieve for their son, killed in battle at the edge of the capital of the enclave of Nagorno-Karabakh and delivered to a makeshift hospital at the parliament building. Nearly 160 Soviet Grad missiles rained on Stepanakert that day, launched by Azerbaijani forces from the mountain-fortress town of Shusha. Though most of the Armenian population remained underground in basements, I worked on the streets. When it was impossible because of heavy missile fire, residents welcomed me into their bomb shelters. I was moved when hungry families, half-mad from the months with little sunlight, would offer me their last egg or bread. For a time, I stayed with Armenian refugees in the missile-pocked, sewage-clogged Hotel Karabakh nearby. It was so fetid on the lower floors that I stayed on an abandoned upper floor, where artillery had blasted through a few rooms— until I heard missiles launched from Shusha in our general direction and ran downstairs.

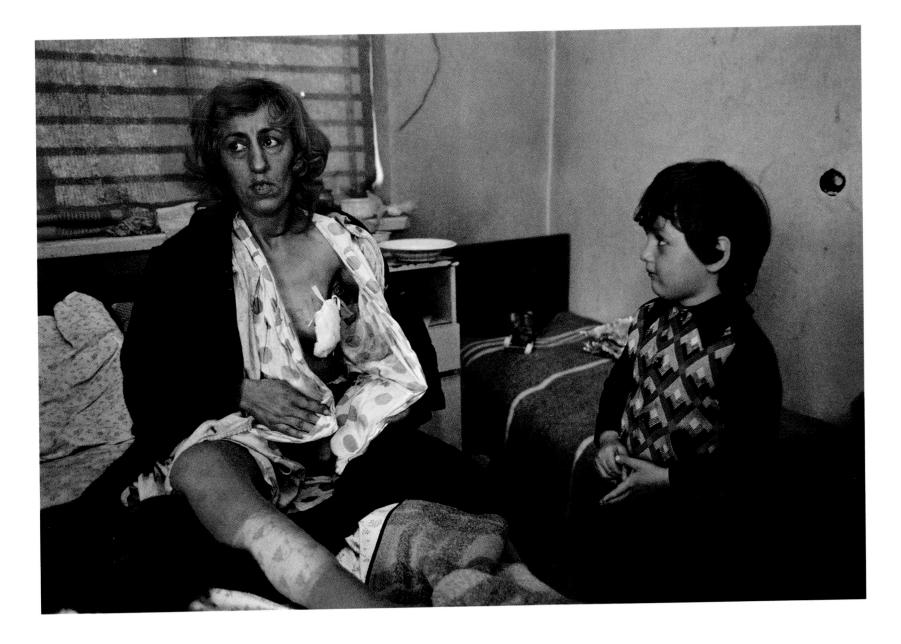

[STEPANAKERT, NAGORNO-KARABAKH | MARCH 1992]

Leonora Gregorian was tortured and raped in front of her four-year-old son by Azerbaijani troops before Armenian soldiers rescued her. Troops also burned her son with lit cigarettes. I raced on foot to reach her neighborhood at the edge of the town as Azeri sniper fire whizzed past me. I photographed her there, where she was healing with the help of a nurse. I almost never reported my own risk-taking to my editors back home in New York. It was just part of the job. And when I did, they would tell me never to endanger myself on their behalf. Of course that wasn't an option if I was going to do the best job possible. I also spared my mother most details for many years, and now I do the same for my young son. Stories like these must wait until he is old enough.

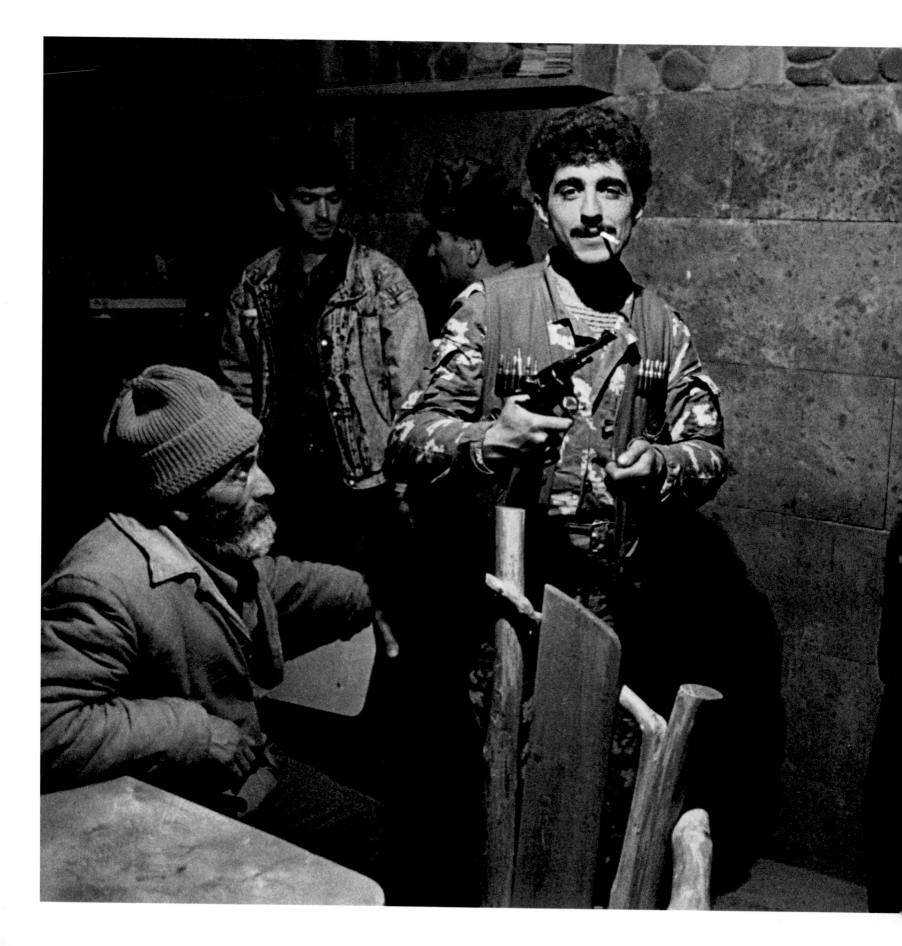

[ASKERAN | MARCH 1992]

An Armenian soldier of the Askeran Battalion posed inside their 18th-century fortress headquarters. I slept on a bunk in a roomful of Armenian soldiers during the night, working in the trenches by day. As bullets from the other side flew by, I had to crawl on my stomach to reach the Armenian fighters. The battalion commander, Vitaly Balasanian (far left, standing), took me to a meeting with his Azeri counterpart from Agdam, a man with whom he had co-owned a restaurant in more peaceful times. They exchanged civilian prisoners under the watch of the International Red Cross. As we drove away, a mortar shell flew across the hood of our vehicle. Azeri troops had tried to kill us. Vitaly's vehicle ran on a pathetic mix of kerosene and gas, and we once sputtered to a stop in the middle of a field just behind the front lines. A farmer grimly continued to plow, bullets flying past him. Our four-wheel-drive came back to life. I saw him again in 2002 while on assignment for *National Geographic*. He was by then a major general and deputy defense minister of the de facto but internationally unrecognized Republic of Nagorno-Karabakh. The ceasefire in Karabakh was often shattered by gunfire, and I passed a sniper's alley to get to the frontline trenches. By then the mother of a two year old, I held my breath and slid low in my seat; but no shots were fired that day. Vitaly has since become a member of Parliament and now advisor to the president of Nagorno-Karabakh.

118

[SHUSHA | AUGUST 1989]

Azeri children from Stepanakert fled with their families to the safety of Shusha after escaping their homes during the beginnings of war in Nagorno-Karabakh. The Azeri refugees sheltered in Shusha eventually had to flee to the lowlands of Azerbaijan, and Shusha fell to Armenian troops in the late spring of 1992. Armenian refugees who had fled from Azerbaijan then moved into the town. Shusha was a favorite summer holiday spot of the Azeri elite before the war. I visited in 1989 when mostly Azeris populated it, and again several times after the war, when it was full of Armenian refugees. In 1918-1920, there was a war between Armenia and Azerbaijan over Karabakh and two other regions. Shushi had a majority of Armenian residents, but many were massacred during the conflict and others were forced out. As in other regions of the former Soviet Union, Yugoslavia, and Iraq, tyranny quieted ethnic hatreds that were bitter and long standing.

About 800,000 Azeri refugees from the conflict fled to Azerbaijani refugee camps and towns, and some 280,000 Armenian refugees from Azerbaijan have been absorbed by Nagorno-Karabakh and Armenia. Children, like these in the photo, seem to suffer most as refugees, caught up in the violence adults engage in against each other.

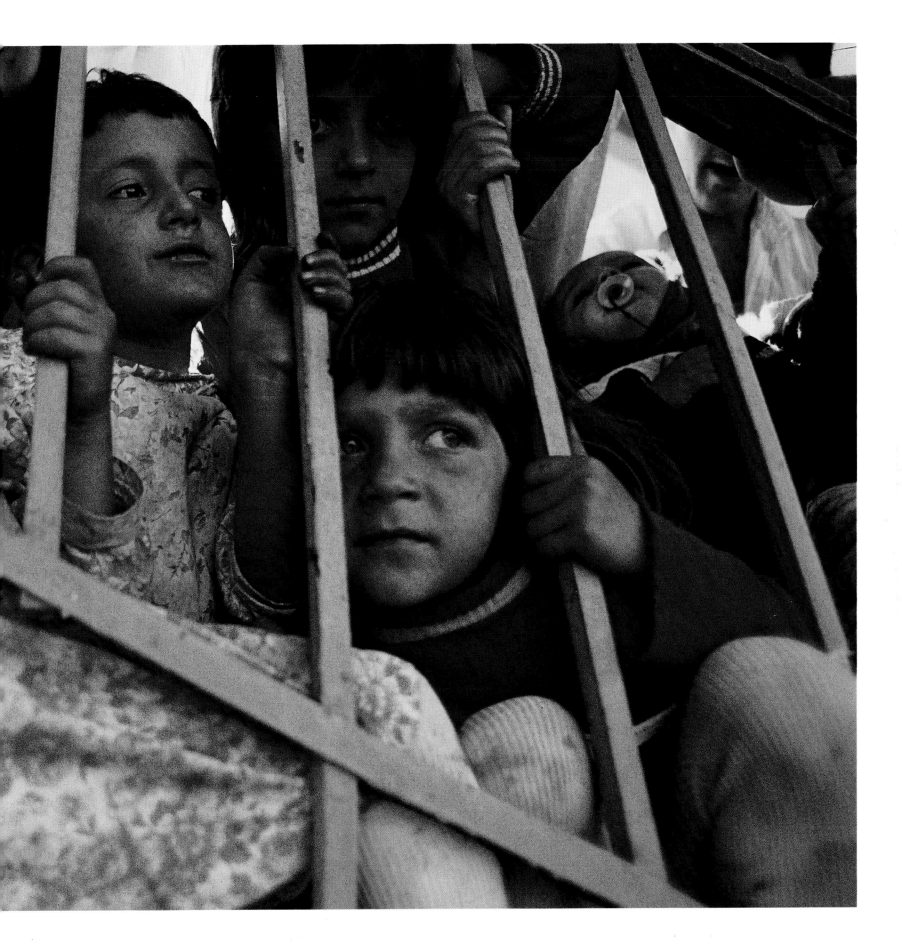

BAKU, AZERBAIJAN | AUGUST 1989 | Popular Front activists Ekhtibar and Mehdi Mamedov,
who is blind, pose for a portrait in Mehdi's home.

OPPOSITE: SOKHUMI, ABKHAZIA | AUGUST 1992 | A Georgian soldier stands on patrol in front of
a beheaded statue of Lenin.

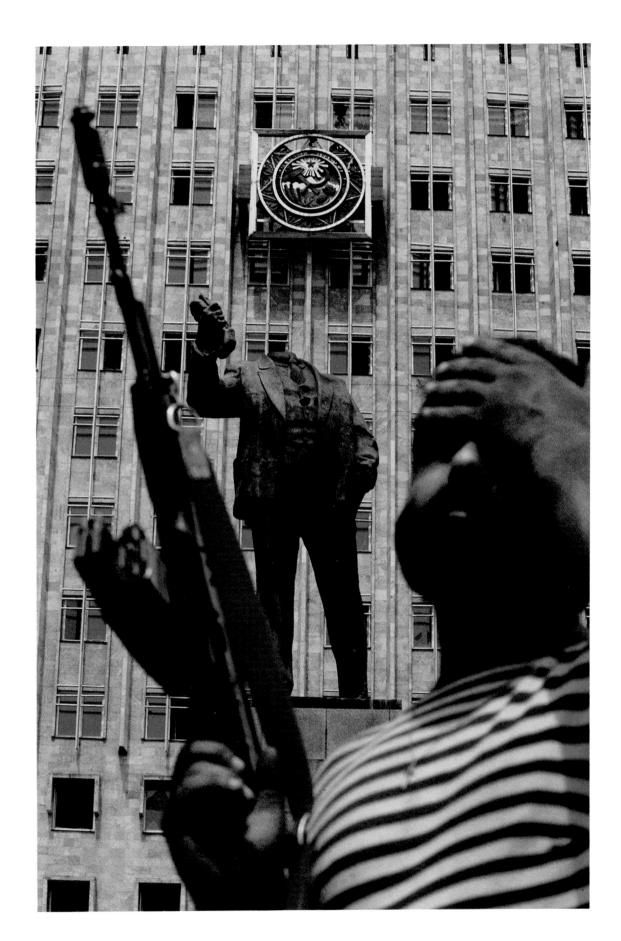

[SOKHUMI, ABKHAZIA | AUGUST 1992]

As a Georgian soldier looks on, refugees struggle to flee on boats leaving for Russia during intense battles between Abkhazian rebels, many of whom were Muslim, and Georgian troops. Though most were denied escape that day, I was able to help a vacationing Syrian family get permission to board a boat heading out. "God bless America," the father said to me. I stayed with Georgian troops in a holiday mansion that had been used by Stalin. The troops had turned it into a filthy barracks, though I could see its faded elegance in the high ceilings and the grand marble staircases and bathrooms. Amid gunshots in the middle of the night, the troops withdrew from the mansion base without alerting me and the other two journalists staying there. Awakened by the shots, I rolled off my bed to the floor and peeked out the enormous windows to see the last truckload of soldiers leaving. They had been shooting in the air in a gesture of bravado. But they would lose Abkhazia. I hardly slept the rest of the night, wondering if Abkhaz forces would lay siege to the neighborhood, entering the mansion. But the rest of the night passed without a sign of them.

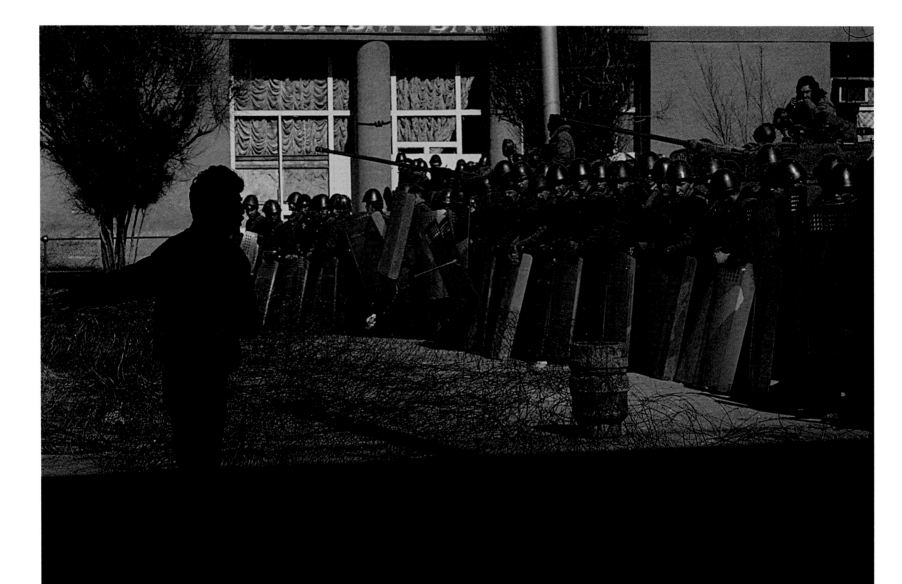

Islamic and democratic opposition groups who mounted a protest in front of Soviet government buildings face a Red Army roadblock. Astonished at the luck that had landed us in the midst of these events, the reporter and I worked among the demonstrators for two days before Soviet officials realized that there were Western journalists in town witnessing events. They demanded we return to Moscow immediately, and we were promptly escorted to the airport by Soviet troops. They arrived at our hotel in an armored personnel carrier. I traveled back to Tajikistan several times after that. The country would soon have a civil war on its hands, one that would last from 1992 to 1997.

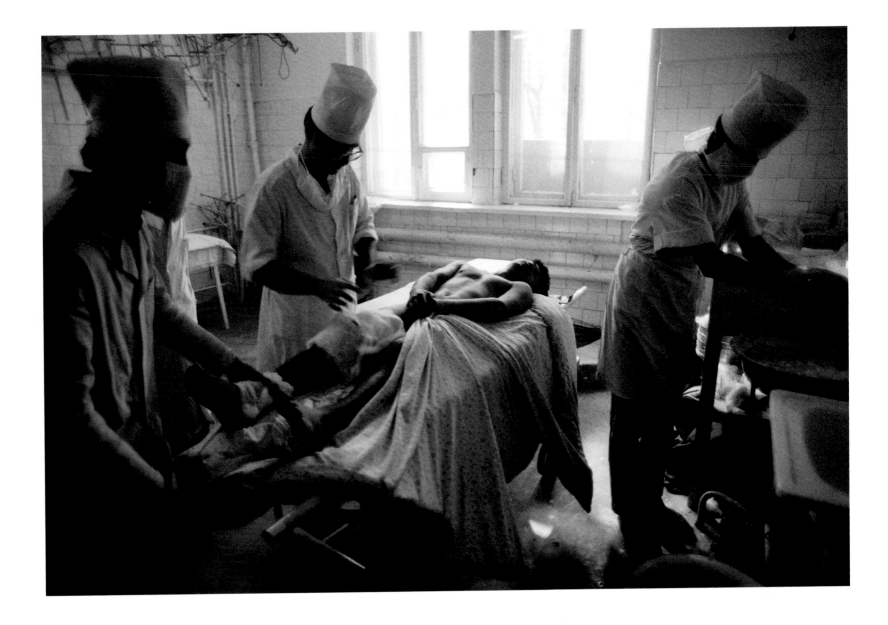

A young Tajik is treated for gunshot wounds during the first riots against Soviet rule in Tajikistan. The Tajik uprising began in response to various local grievances; it quickly turned into a much broader revolt against Soviet rule. It had a strong Islamist character, though secular democrats were involved too. The violence started when demonstrators attacked the Soviet central committee building. Then shops and cars were torched, and secular Tajik women complained of being threatened with knives for wearing makeup and no headscarves. A reporter and I were in town by chance, doing a quiet story on Soviet Central Asia for *Time*. As we stood watching, more than 20 tanks rolled into the city center to quell the uprising that had started just hours before we arrived.

126

SAMARQAND, UZBEKISTAN | FEBRUARY 1992 | Black smoke from a nearby factory clouds
the sky near a bus stop.

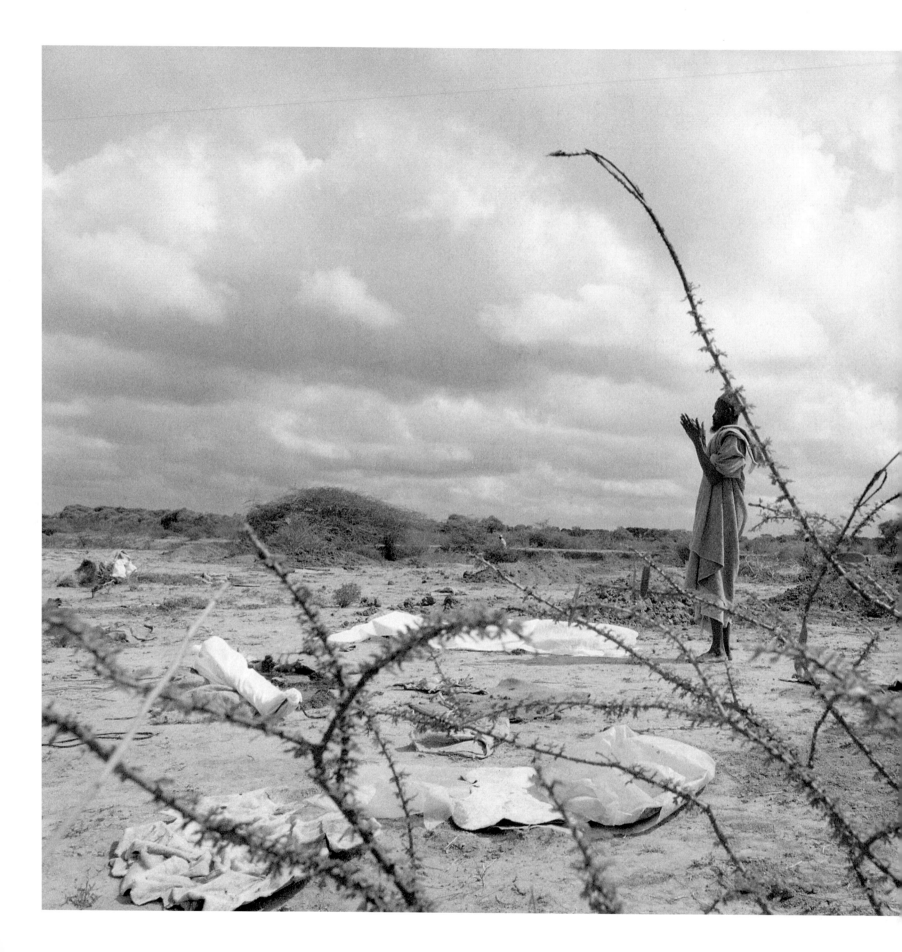

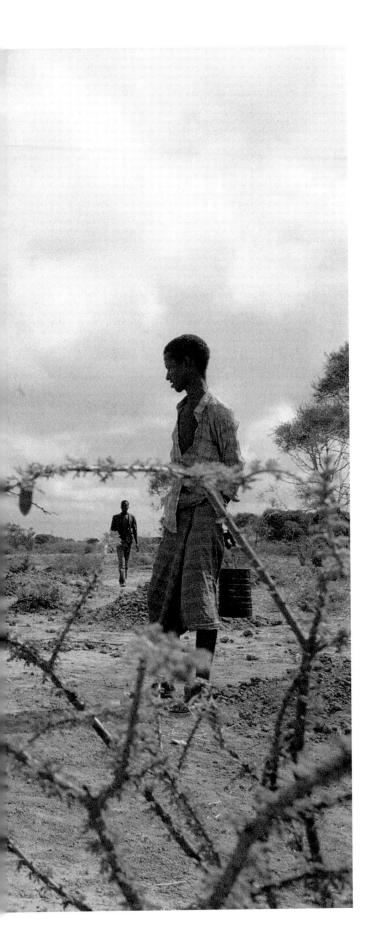

4

SOMALIA &
THE SUDAN

BAARDHEERE, SOMALIA | NOVEMBER 1992 | An imam prays over the bodies of Somalis who
died from starvation or resulting illnesses.

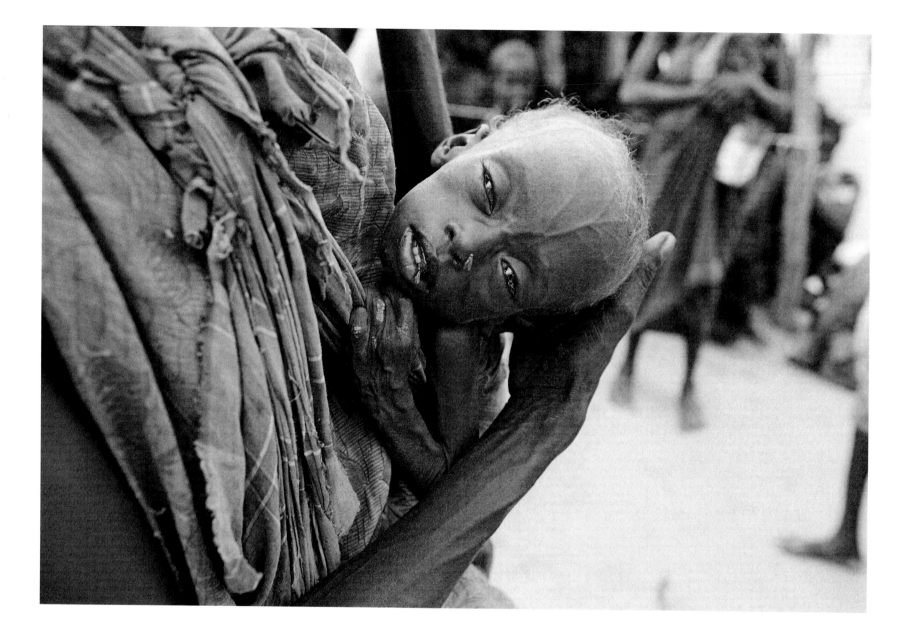

BAARDHEERE, SOMALIA | NOVEMBER 1992 | In a refugee camp, a mother holds her son as he hovers between life and death.

الصومال و السودان

Photographing in a Somali refugee camp one day, I saw a boy of about 13 on the ground outside a makeshift clinic. An older male relative was holding the boy's head up,

trying to keep him awake and alive. The light in the boy's eyes was dying. I took his picture. He looked at me sweetly and curiously, full of hope that I could do something. He seemed to be trying to smile. "Give him water!" I told the Somali women working at the clinic. "Why is this boy lying out here?" They laughed heartily. "He's dying!" they said. I thought them unbelievably cruel. I promised myself I would come back soon to check on him. When I did, within an hour, the women offhandedly told me he had died.

I kept doing my job, just as doctors must in the face of tragedy. Journalists who cover such events over the long term often pay a high price, with images of suffering seared into their brains, and firsthand knowledge of the human capacity for extraordinary cruelty.

When I first flew into Mogadishu in October 1992, listening to U2 on my Walkman, I was ready for Africa after years based in Moscow. Most of the press had left Somalia, and public interest in the story seemed to have waned. My hope was that I could be useful, updating the conditions in Somalia in the absence of a big press corps.

My short sojourn would lengthen to more than five months covering Somalia—and later Sudan— for *Time.* I stayed with aid agencies in Mogadi-

shu, Baardheere, and Baidoa, towns in the grip of severe famine, with no effective governance, and imbued with the random violence and edginess of a Mad Max movie. Gunmen stoned on the narcotic leaf *qat* raged around in trucks called technicals, equipped with anti-aircraft guns. It was the only country I had worked in where journalists required bodyguards.

Somalia was a Cold War pawn, and its former dictator, Muhammad Siad Barre, was supported by the Soviets in the 1960s and 1970s and then by the U.S. in the late 1970s and 1980s.

Somalia consists of clans and subclans and has a strong nomadic culture. Somali poetry transcribed from their rich, centuries-old oral tradition recounts a long history of clan warfare as well as love stories, tales of old age, drought, and praise for camels. During the Cold War they acquired the comparatively modern weaponry to devastate each other. Siad Barre was ousted during a rebellion led by warlord Muhammad Farah Aidid, who then fought other warlords in what soon turned into civil war. More than 350,000 Somalis died between 1991 and the end of 1992, casualties of starvation-related diseases and war. The militias created famine by forcing farmers off their land and looting their livestock; the dangerous situation pre-

vented crops from being planted and harvested and food aid from reaching the needy. When foreign aid arrived, gunmen often stole it or held up its passage. It was a ruthless universe.

I stayed with Australian CARE in the tiny town of Baardheere, hard hit by famine. Aid workers had recently returned to town after evacuating because of fighting between two warlords' militias. The aid workers' house was a run-down dump on the only main street. I slept under netting, not emerging till morning because of a cloud of dengue-bearing mosquitoes. I roamed the refugee camp outside of town during the day.

CARE searched out villages that hadn't received aid in a long time because of the civil war. I crammed into their four-wheel drive with the head of CARE Baardheere, a CARE nurse, an erudite Somali former professor and poet, and several bodyguards. The road was terrifying, especially after we crossed the Jubba River, left the refugee camp behind, and entered the desert bush, where anti-tank landmines greeted us to the left and right. A U.S. soldier would lose his life on these same roads outside Baardheere about a month later.

We drove farther as storm clouds gathered. It was after 4 p.m.—already late—when the storm

hit, and we found ourselves in a flash flood far from Baardheere. The desert turned into raging waters. We abandoned our four-wheel-drive vehicle on a rise between two sudden rivers. I held my cameras high above my head as we waded to safety.

Then we walked. And walked. Total darkness surrounded us, but our Somali bodyguards seemed able to see better than we could. The professor recited poetry and told us stories. We didn't know if we were going in circles or where we would end up, and we were afraid of landmines. The mud sucked at our feet. It was more than eight hours before we heard tubercular coughing in the distance—a sign we hoped meant we were nearing Baardheere's refugee camp.

We were, indeed, but were suddenly inundated with the unmistakable smell of decomposing dead bodies. Struggling up and down small mounds of earth, our legs sank in almost to our knees as we trudged forward in the muddy earth. To our horror, we realized we were sinking into unmarked graves of the recently buried. Quietly, grimly, we concentrated on getting out of that graveyard.

A four-wheel-drive vehicle on the edge of town flashed its headlights. A CARE worker had spotted our soaked, muddy forms. We walked down the center of Baardheere's main street, completely bedraggled. The shopkeepers and towns-people of a victorious local clan laughed derisively at us from their tin shacks and battered houses. We laughed a little, too—so relieved to be safe.

Somalia, with zero infrastructure at that time, was a cash-only country. Three bodyguards—armed only with Kalashnikovs—with a pickup and driver cost between $150 and $250 a day. Mogadishu had been knocked back decades by the war. Even the copper telephone wires had been ripped out and sold as scrap.

After Thanksgiving 1992, the BBC announced President George H.W. Bush's decision to send in U.S. troops to help provide security for the aid agencies: Operation Restore Hope. I knew there would be a flood of media, and that soon the story would change dramatically. What was now a lonely black-and-white essay updating famine conditions for the public would soon mean shooting color and taking part in the press inundation surrounding a top news story.

After the U.S. troops arrived in December 1992, food deliveries and life in Somalia stabilized for a while. In February 1993, while covering U.S. forces, I spent a night on the U.S. military base at the former U.S. Embassy in Mogadishu, when we heard there were riots enveloping the town. The next day I asked to be taken to the austere Sahafi Hotel at the traffic circle known as K4 (kilometer four from the airport), where much of the press stayed those days. They put me in a Humvee with two U.S. press officers. On the way, we had to ram through burning roadblocks as people threw stones at us. I felt less afraid than tense and alert, having been through this sort of thing many times since Haiti in 1986. But I wanted to get to my hotel.

Approaching K4, we saw several American men wearing jeans, Ray-Bans, and bulletproof vests walking down the street carrying automatic weapons. We pulled into the little base on the traffic circle and got out. The press officers decided it was not safe to cross the street to my hotel. They left for their base. UN soldiers quickly scooted me across the street.

Nigerian UN troops had been camped out on the roof of the hotel to protect journalists. They were frustrated that they had no orders to shoot back at the warlord Aidid's snipers, who had been attacking us from a building opposite the hotel. It was cheaply constructed, and bullets came through the front wall as if it were made of cheese.

Journalists often slept on the roof because of the overwhelming heat in our rooms. When the sniper attacks started, another photographer and I headed right up. He and I used to go out at 6 a.m. for a little work in refugee camps, always careful to return within two hours, because that's when the sniper attacks would begin. Returning late—too close to eight o'clock—

meant crouching low and running like hell to get inside the hotel.

We were on the roof along with a couple of U.S. Marines and the Nigerian troops when the order finally came to shoot back. The Nigerians were ecstatic and let loose, firing away.

The photographer and I followed the Nigerians downstairs and out the door as they explained breathlessly in perfect English how they were going to get the Somali gunmen in their lair across the street. The Nigerians kicked the Somali gunmen they dragged from the building and handcuffed them at the entrance to our hotel. One put his foot on a sniper's face.

Some time later, some journalists and I were having dinner in the rather dirty, bare bones, fluorescent-lit hotel dining room. We were served the usual: overcooked pasta in camel sauce. One shy correspondent for Voice of America ate by himself, as always. Suddenly four or five bullets came whizzing through the soft walls. He was hit in the leg and fell off his chair. We ran to him. We thought that Aidid's snipers were back, but in walked a handful of chagrined Nigerian troops. One of them had gotten drunk on beer an American television crew had given them and accidentally picked up his assault rifle by the trigger, letting loose a spray in our direction. The radio correspondent was taken away in an armored personnel carrier and whisked offshore to a U.S. naval ship for treatment.

Operation Restore Hope would soon fall apart. Troops that had come to protect aid supplies would begin to take part in fighting and target warlord Aidid. The conflict culminated in the October 3, 1993 Battle of Mogadishu, which resulted in the loss of 18 U.S. soldiers. Not long after, President Clinton announced that U.S. troops would withdraw from Somalia.

I went to Sudan at the end of March 1993, sent by *Time* to cover a long famine among the Christian, animist African population. Their rebels had been fighting for independence from the Muslim Arab north for nearly 20 years—creating the famine—and now it was getting worse as the rebels had split and were fighting each other.

We flew in a tiny, chartered airplane from Nairobi with no permission from the Sudanese Government—six journalists in all—landing on a rough dirt airstrip outside Ayod. We worked among the starving that day with the help of the Irish aid group Concern, with doctors and others trying to save lives in that tiny, tragic bush village. Children and old people lay on bare earth, too sick to keep gruel down.

Our plane broke an axle when we were taking off, so we spent a couple of days there waiting for another plane. When it arrived, we flew to Yuai, where we interviewed and photographed rebel commander Riek Machar. Three of us stayed on afterward. The other journalists were done and left with the evacuating UN aid workers, who decided the area was becoming too dangerous.

We slept in the abandoned UN compound for about ten days, photographing Machar's rebel troops preparing for battle with another guerilla faction, as well as daily life among the refugees. Children were hungry and tormented by flies. Rebels often performed war dances at dusk. I fielded a marriage proposal from an old, hungry tribal elder dressed in a cheetah skin with a henna-colored beard, and was moved by the talismans and beads villagers wore to ward off evil, even when they were wearing rags or nothing at all. It was a fragile hope that something—anything—could protect them.

A Reuters photographer and I needed to fly back to Nairobi, but there was no way out. We scanned the skies for a plane that never came and hoarded our film, taking only pictures we thought essential. If the battle arrived, we needed enough film to cover it or we would be useless. Using the radio equipment the UN had left behind, we finally reached colleagues in Nairobi, who sent a plane for us.

Within weeks, both Ayod and Yuai were burned to the ground by the opposing rebel faction. Any refugees too weak to run were massacred.

134

BAARDHEERE, SOMALIA | NOVEMBER 1992 | A recently deceased child awaits burial in an
unmarked grave.

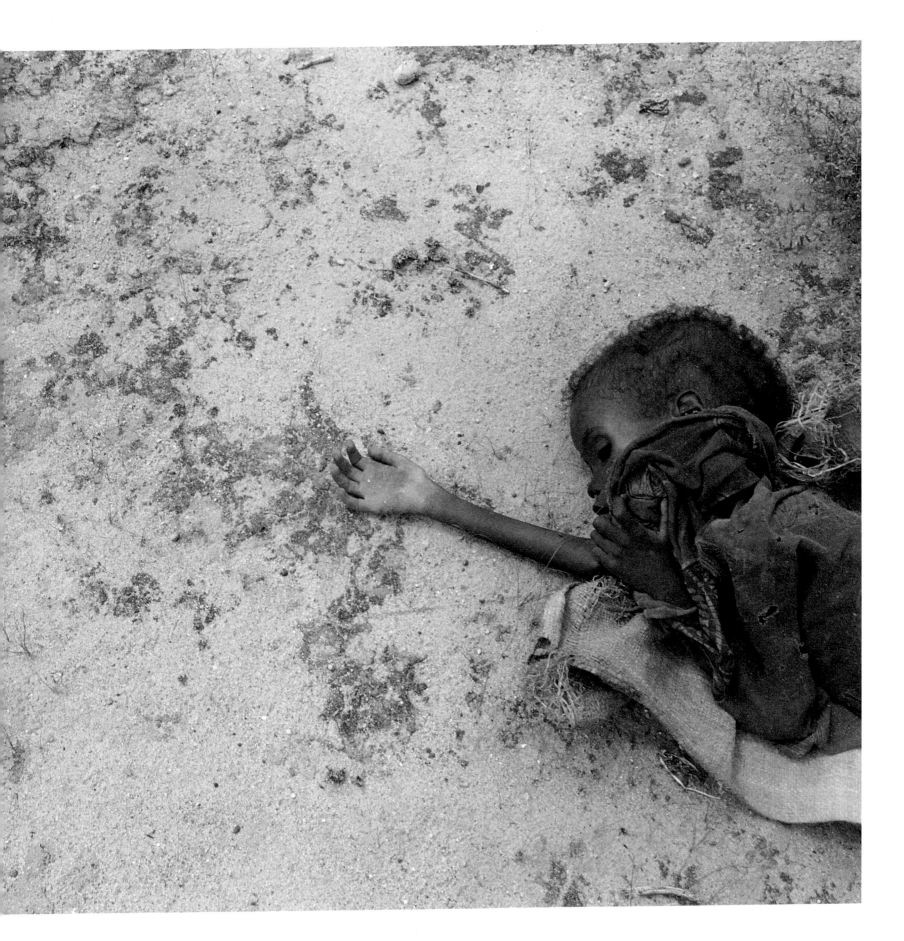

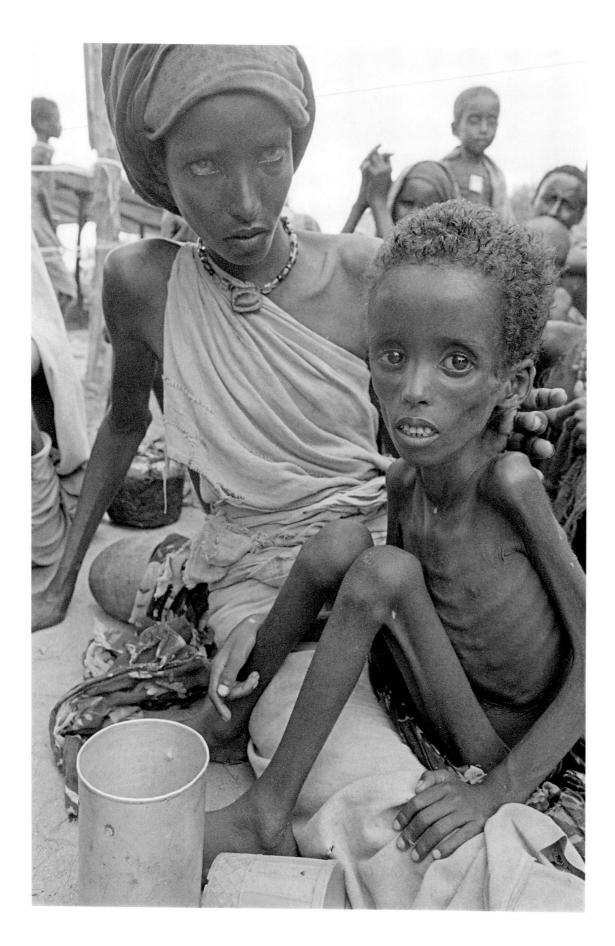

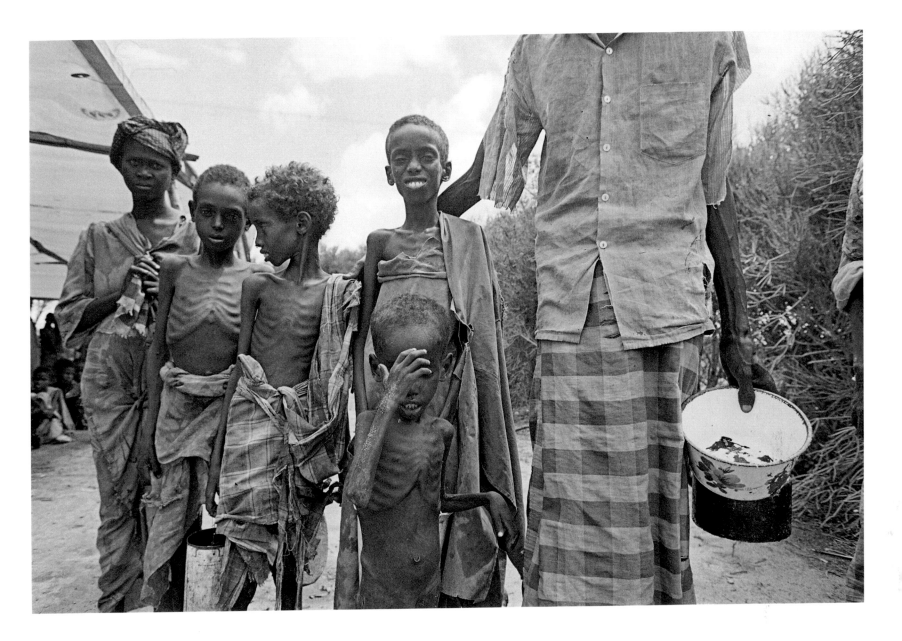

BAARDHEERE, SOMALIA | NOVEMBER 1992 | This family managed to stay together and is on their way to the refugee-camp food line.

OPPOSITE: BAARDHEERE, SOMALIA | 1992 | A mother and child at a refugee camp wait for high-protein gruel from foreign aid workers.

138

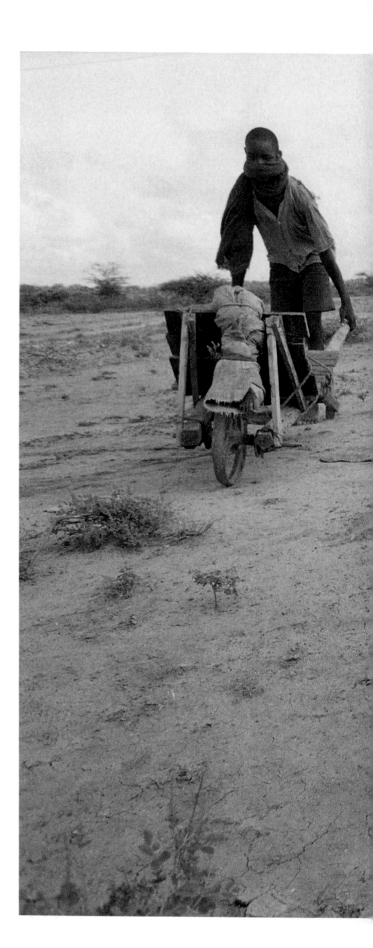

BAARDHEERE, SOMALIA | 1992 | A woman weeps for a young male relative about to be buried.

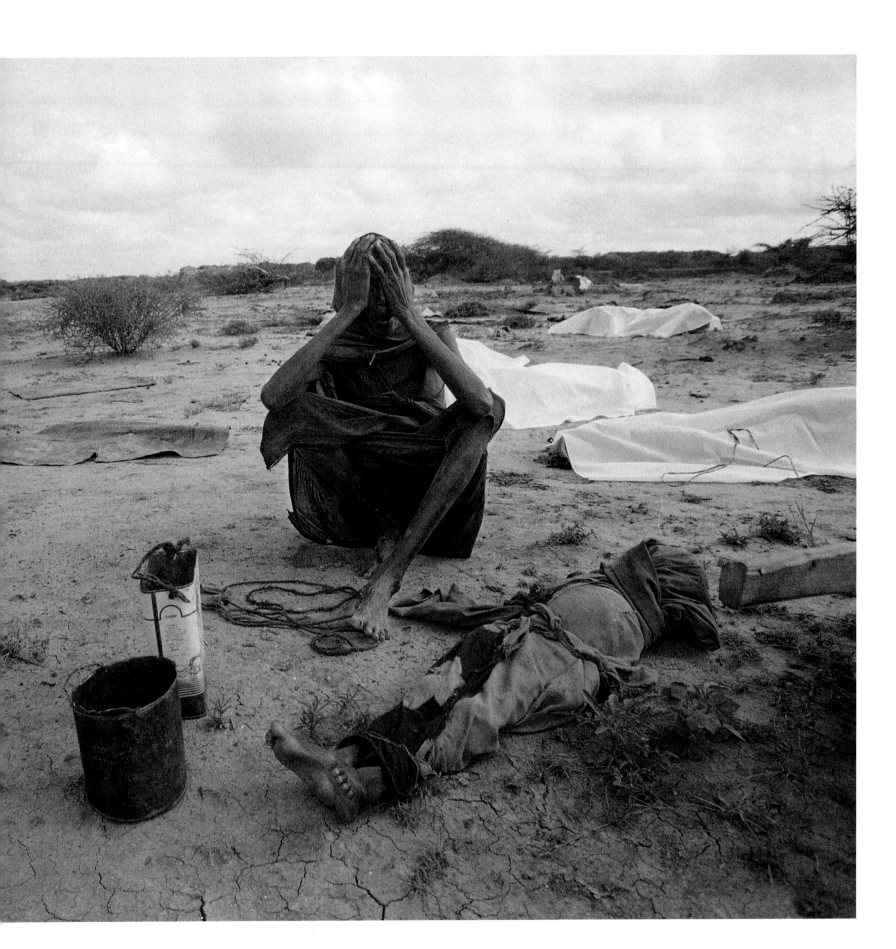

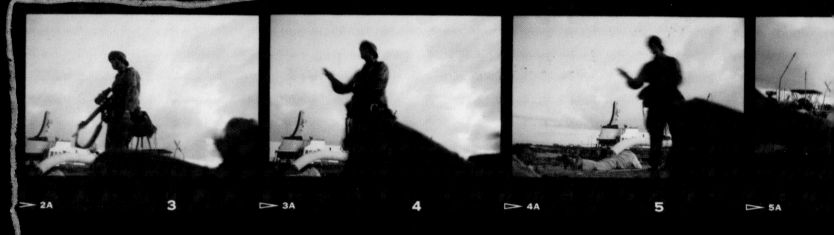

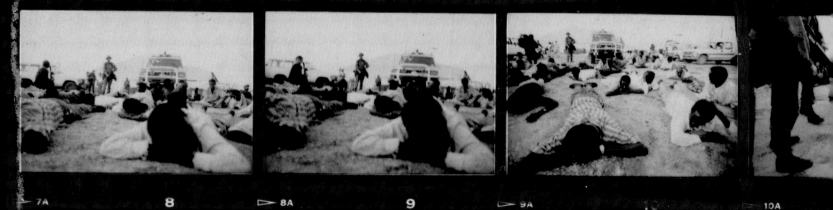

[MOGADISHU, SOMALIA | DECEMBER 1992]

U.S. Navy SEALs arrive at the port as part of Operation Restore Hope, a U.S.-initiated UN intervention. They were joined by the troops of ten other nations to ensure food and medical aid deliveries. More than one million Somalis were still at risk of starvation after a summer of fighting and death in epic numbers. Aid workers in Mogadishu estimated they lost 80 percent of aid shipments to looting clan militias. The port was still in the hands of hostile Somali gunman, but they seemed to melt away shortly before the SEALs arrived. Under a full moon, I waited there all night with a few other journalists. Cold set in around 4 a.m. Finally, atop the huge concrete breakwater, silhouetted shapes undulated like snakes. There was a smattering of gunshots, and we could find no decent cover. The SEALs emerged at dawn, green war paint on their faces. "Get your f**kin' noses in the dirt!" they screamed, making us lie on our bellies.

They confiscated weapons from our bodyguards before at last letting us up. Later, U.S. troops peppered me with questions about the situation. Why were the people they saw that first day not starving? They didn't seem to have enough information about the conflict. Some wore jungle webbing on their helmets in the middle of the city. They were weighed down with so much gear. French Foreign Legion commanders tried to convince U.S. commanders to disarm militias in Mogadishu immediately, but this was not in the UN mandate. Months later those weapons would be turned on U.S and other UN troops, but that day people were mostly friendly, curious, and watchful.

OUTSIDE BAIDOA, SOMALIA | JANUARY 1993 | U.S. Marines escort the delivery of food aid from CARE to far-flung villages the agency hadn't been able to reach safely for months.

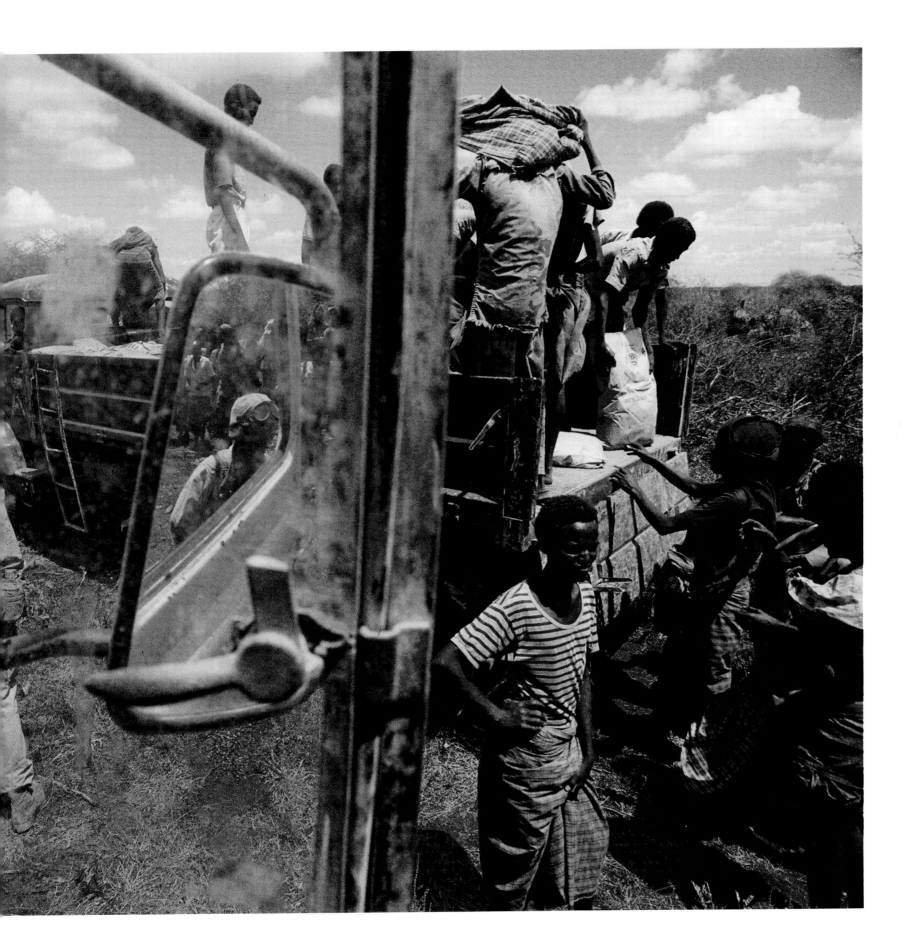

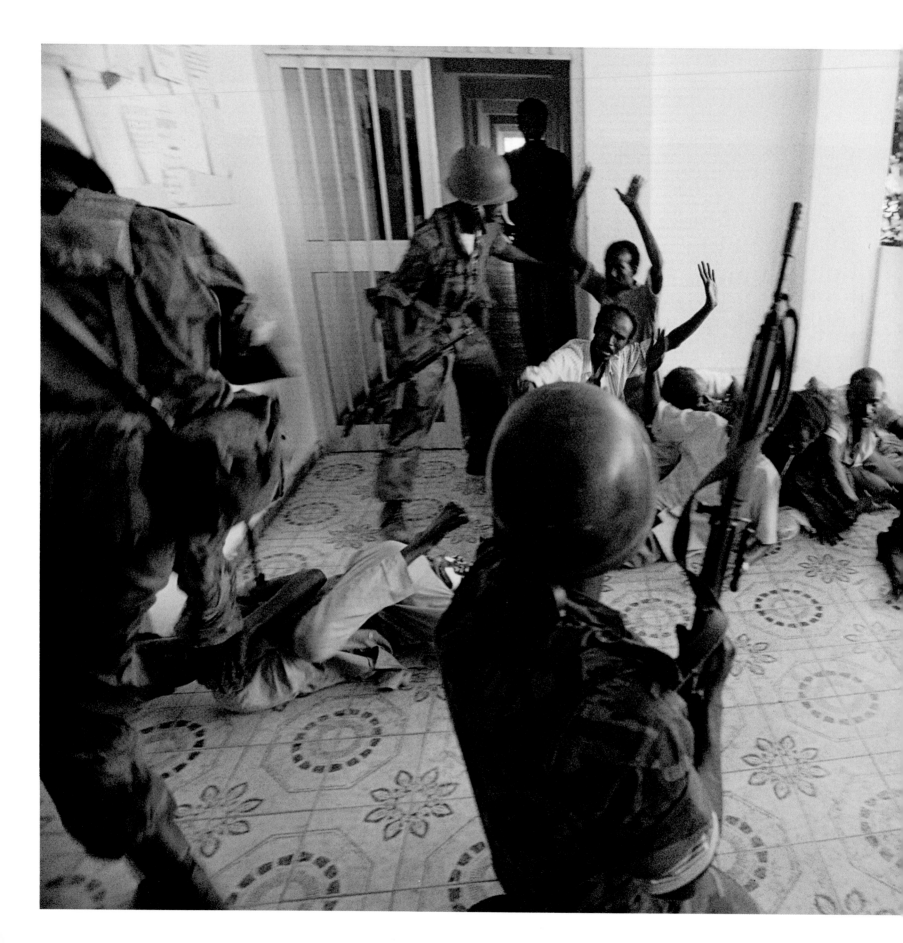

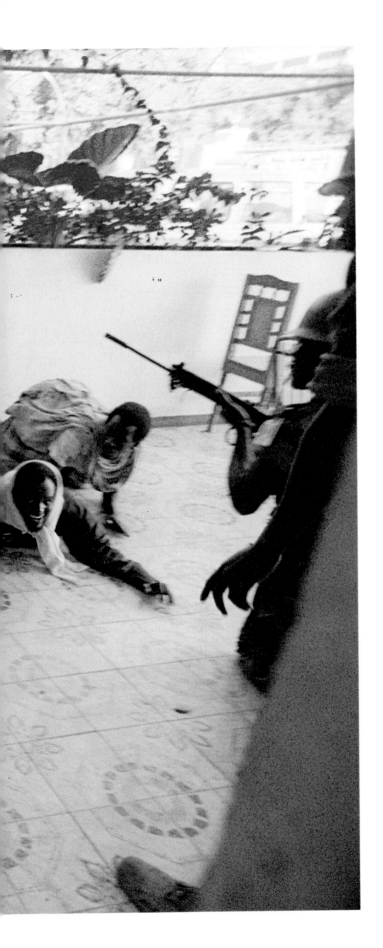

[MOGADISHU, SOMALIA | FEBRUARY 1993]

Nigerian UN troops from Operation Restore Hope arrested these Somali snipers allied with warlord Muhammad Farah Aidid's militia. They'd been attacking our hotel for days. The UN troops' arrival in December 1992 helped end the famine but they withdrew in 1995 after being drawn into fighting, especially with Aidid's militia. Since then, Somalia has suffered from floods, come under occupation by Ethiopian troops, withstood civil war between Islamist forces and a shaky pro-Western government, and been at the brink of famine.

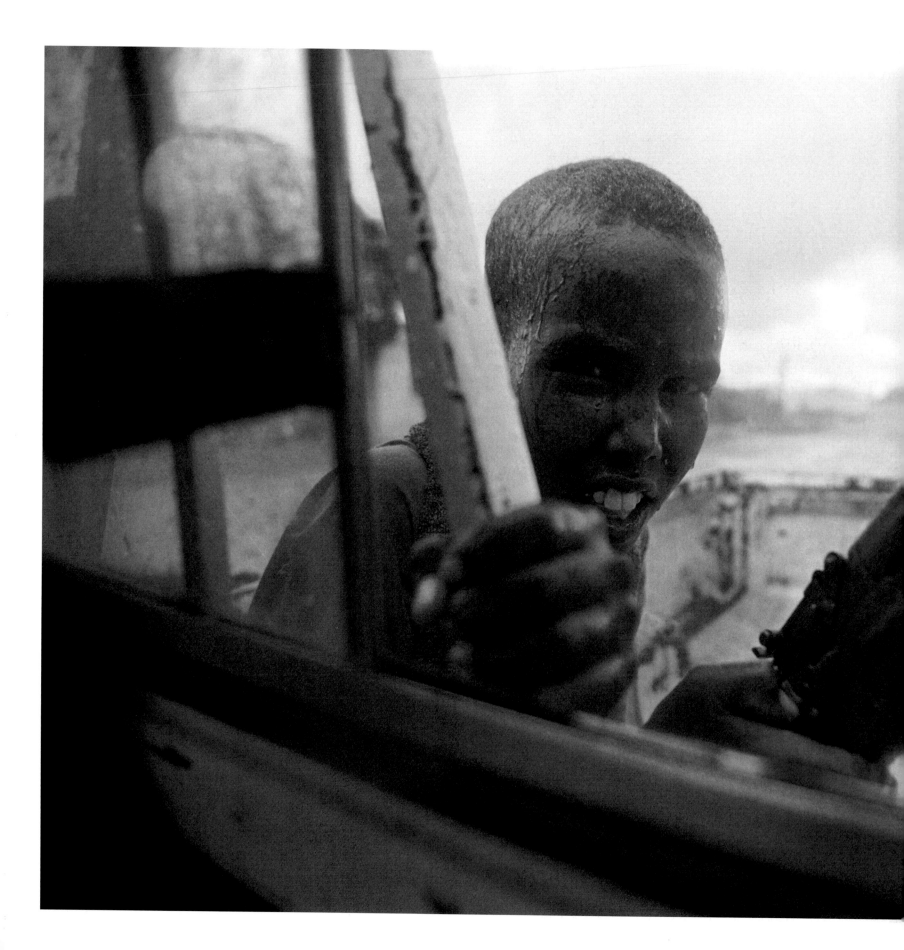

[BAARDHEERE, SOMALIA | NOVEMBER 1992]

This young gunman in the back of my pickup threatened to kill me one day. I had been friendly to him, giving him rides when he asked; sometimes he followed me around. Somalia had plenty of boys who were armed. Despite his youth, like so many Somali gunmen he already chewed *qat,* the drug that seemed to increase the violence in Somalia, especially as each afternoon wore on. One day, we were standing on Baardheere's main street, a dirt road lined with low war-blasted buildings and battered shacks belonging to merchants offering scant food and sundries. He put a bullet in the chamber of his gun and threatened to shoot me, unprovoked and for no apparent reason. Grown gunman stood around with qat in their teeth, amused, waiting to see what would happen. I was furious. "I could be your mother!" I reprimanded him. A Somali I was with translated and luckily it worked: The gunmen around him yanked his weapon away and drove him off with slaps and kicks. The boy was humiliated and offered me the universal threat, drawing his index finger across his throat as he hissed at me. In Somalia I was in threatening situations involving gunmen often, and one could be killed for nothing.

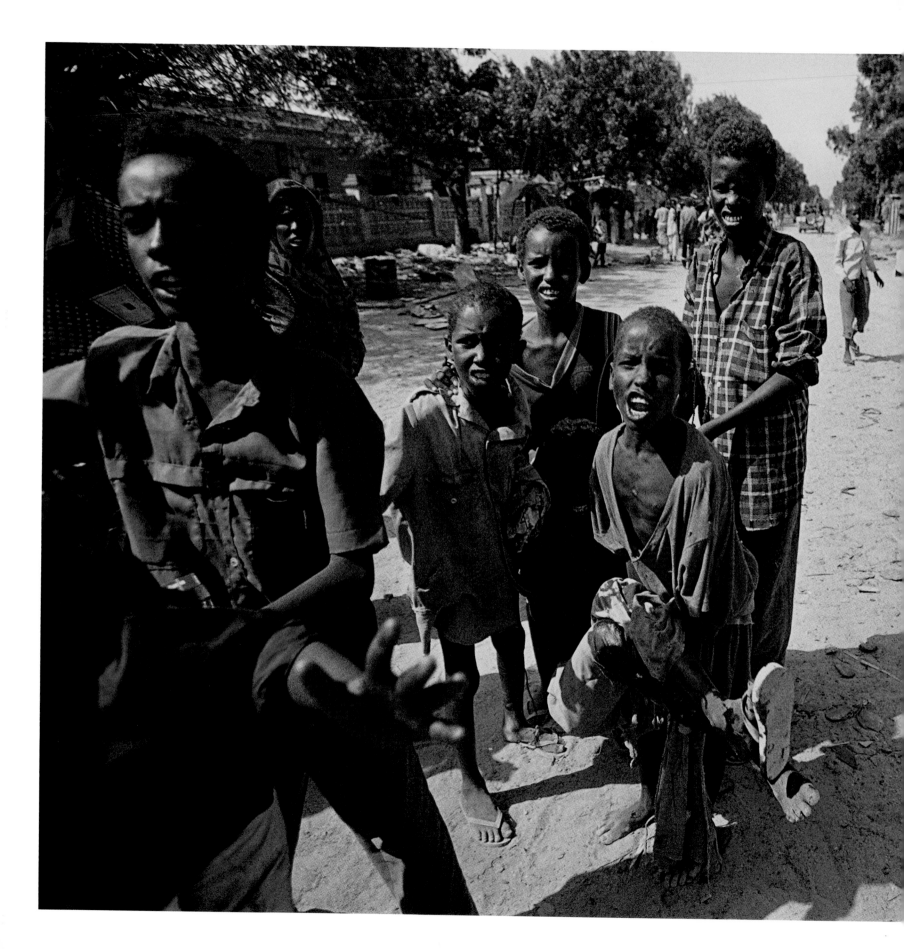

This boy was wounded during inter-clan fighting by what Belgian UN soldiers described as a stick grenade. The Belgian troops to the right did jump from their vehicle to aid the boys. In Mogadishu journalists heard that fighting was raging in this port town and that American and Belgian troops had been drawn in. A trip was organized by the Joint Information Bureau of Operation Restore Hope to demonstrate that all was under control. Their 5 p.m. daily press conference was called "Lies at Five" by many in the press. After we arrived in Kismaayo, they took us to see what they had described as a calm but tense town. From a distance, we spotted fighting and saw smoke billowing at the far end of the main dirt street. We asked our press escort to take us closer. To our astonishment, he said, "Well, you can see everything is under control here." We were promptly sent back to Mogadishu. An AP photographer and I decided to return to Kismaayo quietly and get the story. The New Zealand Air Force flew us to Kismaayo on a cargo plane. On arrival we slipped past the U.S. 10th Mountain Division that controlled the airport, found a truck full of Belgian troops, and asked to be taken to their commander. He welcomed us, gave us cots to sleep on in a tent full of soldiers, showed us the mess hall, and told us we could work freely with them—at our own risk. We accompanied troops downtown, where we photographed the mayhem. As soon as we had gotten our story, we boarded a Ukrainian cargo plane to Kenya flown by a pilot and co-pilot who appeared to be a bit drunk. Back in Nairobi I called the New York office and learned the magazine was running a positive story about Somalia that week, although the security situation was fraying.

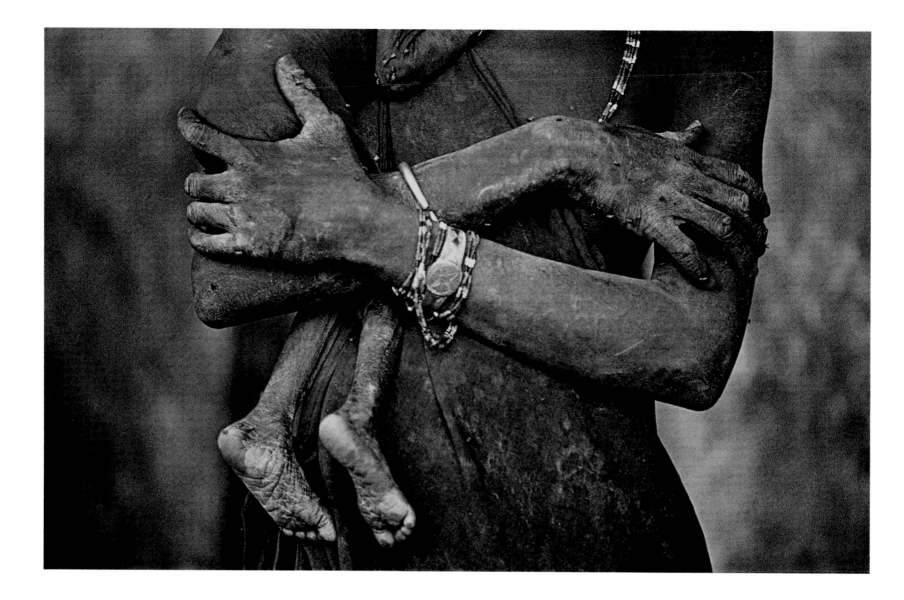

AYOD, SUDAN | MARCH 1993 | This woman and child were among the hundreds of thousands

of people at risk of starvation in southern Sudan that spring.

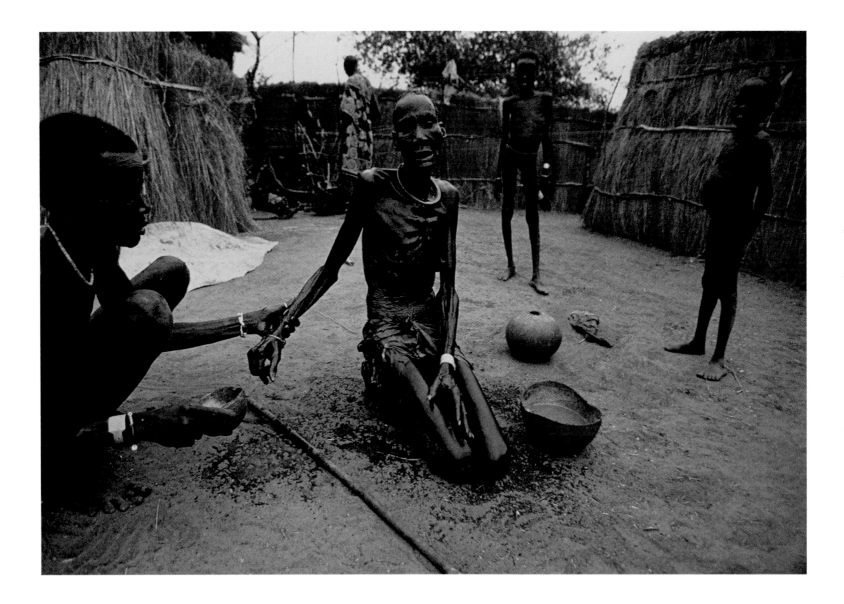

AYOD, SUDAN | MARCH 1993 | Too weak to do it herself, an aging woman is bathed.

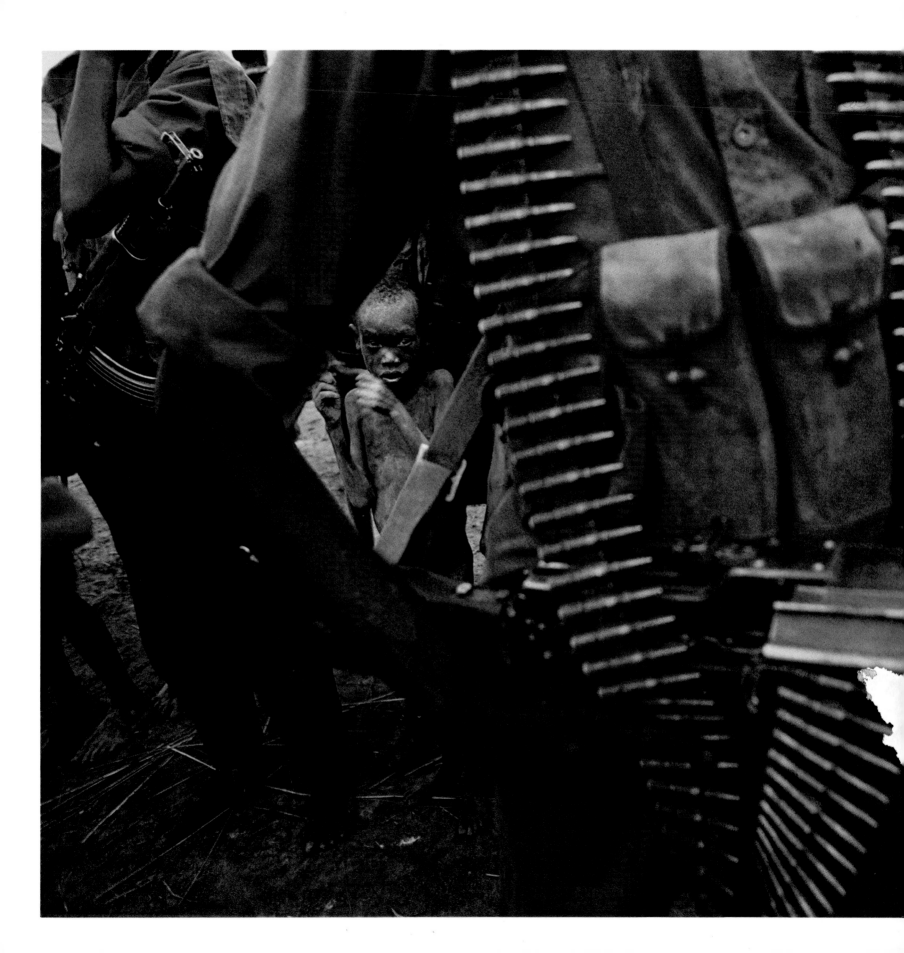

YUAI, SUDAN | APRIL 1993 | At this desert outpost, troops prepare to walk to the front line in Kongor.

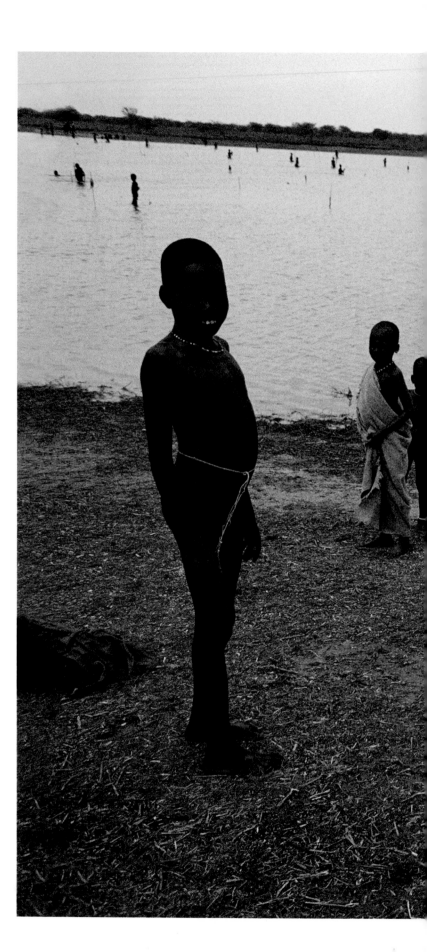

154

YUAI, SUDAN | APRIL 1993 | Boys spend the day at a nearby lake where fish were scarce.

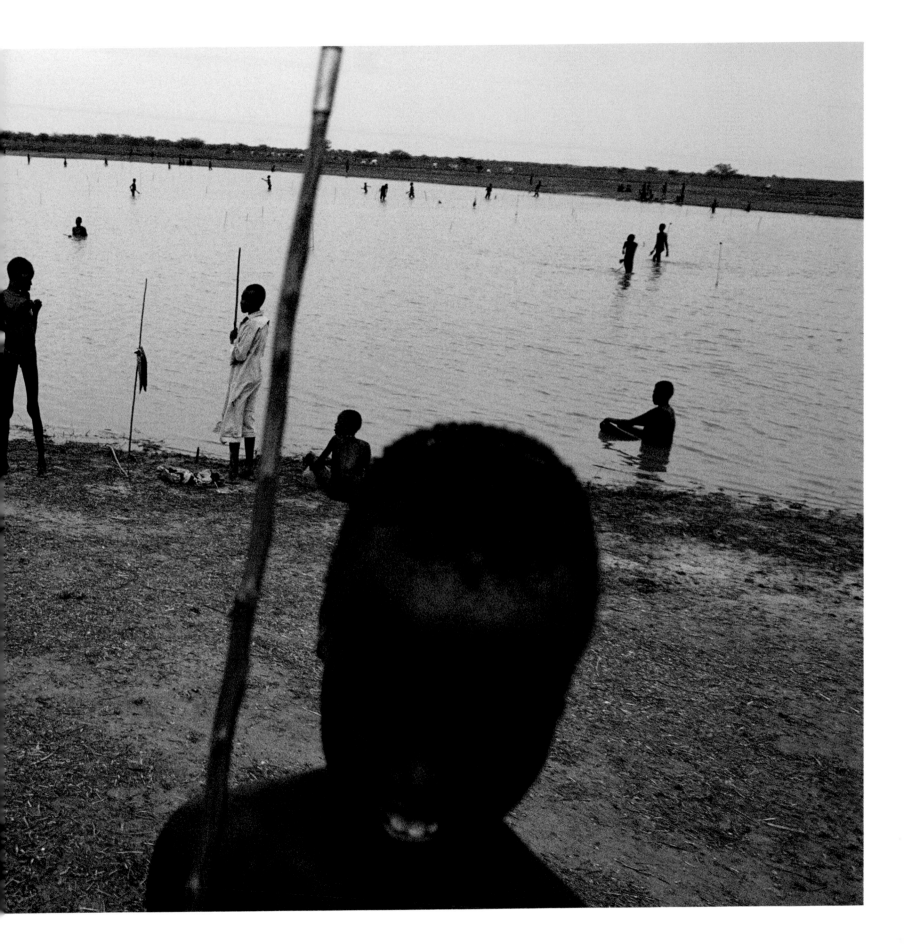

5

AMERICA

WEST CHESTER, OHIO | NOVEMBER 2001 | Inside the Islamic Center of Greater Cincinnati,
worshippers gather at dawn during the holy month of Ramadan.

أمريكا
[AMERICA]

Photographing Muslims in the United States gave me a window into their lives in turn-of-the-century America. The dynamism of the communities was as

striking as their diversity. On Los Angeles's Skid Row, Arab-American teenagers handed out free meals to the homeless. In a Mississippi village, Muslims shared a religious lifestyle in the countryside.

Muslim Americans, too, died in the attack on the World Trade Center. In New York, the Hamdani family defended the reputation of their son, killed trying to save people in the World Trade Center, only to be wrongly accused of aiding the terrorists. In Mississippi and Cincinnati, I visited Muslim families as they sat—horrified—watching the latest televised news about radical Islamic terrorists.

Before 9/11, when Americans thought of terrorism within their own borders, they thought of men like Ted Kaczynski the Unabomber, or Timothy McVeigh and Terry Nichols of the Oklahoma City bombing. After 9/11 Muslim Americans came under intense scrutiny and even suspicion by some.

The attacks brought American Muslims of different ethnic backgrounds closer together.

OPPOSITE: DEARBORN, MICHIGAN | JUNE 2002 | Diana Sa'ad, 17, a Lebanese American, visits the annual Arab International Festival.

Previously, Muslims of South Asian, Arab, or African-American backgrounds did not often mix. After the tragedy, cultural differences began to seem less important. September 11 had begun to reshape the Muslim experience in America.

What I found on my journey was mostly a wide embrace of the American dream. Each Muslim-American community has its own special character. Dearborn, Michigan, an old auto-manufacturing town, is home to many Arab residents, both Muslim and Christian. About 30,000 Arabs, most of them Muslim, live in the city of almost 100,000 people.

At first glance, Dearborn looks like Anytown, U.S.A, especially if you expect to see quick, obvious signs of Arab traditions. Instead, Middle Eastern and Middle American characteristics blend together, both in glimpses on the street or in depth behind closed doors.

Smoke from a Ford Motor Company factory billows full and grey-white in the sharp winter sun. An Iraqi-American boy arriving at the mosque sports a leather jacket decorated with an American flag. Teenage girls run around in jeans and tank tops in the summer. Endless strip malls line the main thoroughfare.

On a private school's basketball court, young Shiite grade-school children wear white robes and circle a black, cardboard replica of the Ka'aba at Mecca. They throw cotton balls instead of stones at the devil as they learn to make the pilgrimage—one of the five pillars of Islam.

I attended a fashion show just for Muslim women; watched volleyball practice where religious Muslim girls in hijab played alongside unobservant girls in shorts; and visited a therapy center for victims of torture, most of them from Saddam Hussein's Iraq. Young Lebanese-American men smoked *argila* (water pipes) on the sidewalk and watched women go by at a classic American street carnival with cotton candy, rides, games, and face-painting.

In Dearborn, during the holiday Eid al-Adha, which celebrates Abraham's willingness to sacrifice his son and the pilgrimage to Mecca, it was a challenge to find a sheep sacrifice to photograph. Fewer families still practice this tradition and they have to drive far to find farms belonging to Christians—who have hired a Muslim to perform the ritual slaughter. A third of the meat from the sacrifice is donated to the poor, another third to neighbors and friends, and the rest eaten as a holiday meal by the family.

After 9/11, tension could be felt in Dearborn at the Arab International Festival, where the FBI had a table to recruit locals. Nobody approached, except for a few who argued with the women posted there. At the Dix mosque, while I waited for permission to photograph Friday prayers, a man came out of the mosque and videotaped me, wouldn't speak to me, then went back inside. At that time, many of the Iraqi Shiite expatriates and refugees who worshipped at Dearborn's Karbala Mosque supported a possible war in Iraq, while many other Arabs in Dearborn were critical of it.

Abiquiu, New Mexico, is a diverse community of Hispanic Catholics, Native Americans, Anglo-Americans, and several families of Sufi Muslims living in one of America's most sublime landscapes, near one of its loveliest mosques. Woodworkers, teachers, and a water engineer live together in a life of worship, creativity, and hard work. The children love to snowboard in winter and swim in a nearby lake in summer. They study for degrees abroad, like Fatima Van Hattum, and volunteer in disaster zones, as her sister Taslim did in New Orleans after Hurricane Katrina.

The Dar al Islam mosque, which welcomes Muslims of all denominations to pray and study, is made of adobe and decorated with pretty ceramic tiles and arabesque doorways, uniquely combining Native American and North African design. In summer, classes are given for Muslims and non-Muslims. I heard the renowned American Sheikh Hamza Yusuf teach for three days there.

In the Chudnoff household, barefoot girls brushed each other's hair and baked bread in a lifestyle reminiscent of *Little House on the Prairie*. Khadija Chudnoff, 18, was her high school's Homecoming Queen. Her parents are from Brooklyn.

In the adobe home of my friend Karima D. Alavi and her husband, Walter Declerck, the couple broke their Ramadan fast with ripe dates, good friends, and a classic American view of the Chama River and surrounding snowy hills.

For Eid al-Fitr, the local Sufis gathered in a small, hand-built mosque and a spacious yurt. Some dressed in local turquoise jewelry or cowboy hats, others in traditional turbans and robes.

In New York City, I met a Yemeni-American police officer who organized an interfaith memorial for September 11 victims, and I befriended the Pakistani-American mother of a police cadet who died saving lives at the World Trade Center.

I visited the mosque and homes of the Sunni African-Americans of the Masjid Malcolm Shabazz in Harlem, where security guards searched my bags each time I entered. Their leader, Imam Izak-El Mu'eed Pasha, was the first Muslim chaplain of the NYPD.

Uptown on 125th Street, a marketplace sponsored by the mosque sold sculptures and mudcloth skirts. Vendors prostrated themselves between the racks at prayer time. Local African-American Muslims gave away groceries to the poor from a kiosk there at sunset.

In Chicago, I attended a service at the headquarters of the Nation of Islam, in the glittering Mosque Maryam on Stony Island Avenue. Parishioners prayed in pews and did not prostrate themselves. A deputy to Minister Louis Farrakhan gave a racially and politically charged sermon.

The Nation was an extremely difficult organization for me to gain access to. Still, I was invited to several events, including a speech by Farrakhan at the Nation of Islam's annual gathering. There he recommended a book about how to pray correctly as a Muslim. Farrakhan and his bodyguards were dressed sharply in the now-iconic suits and bowties of The Nation. The guards seemed nervous when I got too close.

The elite members of the Nation of Islam sat in the front rows, the men dressed in suits, the women in glamorous and sometimes exotic outfits with headdresses or hats. Also in attendance was a group of about eight Black Panthers, and many non-Nation fans of Minister Farrakhan.

At the Islamic Center of Greater Cincinnati, Muslim Americans of many backgrounds worship together: Pakistanis, Arabs, Africans, Central Asians, and African-Americans. During holiday celebrations at the end of Ramadan, different styles of food, dance, music, and clothing overlap in a rich American mix.

In a lush, green, Southern landscape, worshippers at the Islamic Center of Savannah played American football against a backdrop of arson: their mosque had been burned to the ground in August 2003. Previously, the mosque had been hit by gunfire, a community member's apartment was ransacked, and a racist note decorated with a swastika left behind.

The perpetrators have yet to be found. I photographed the remains of a Koran and other religious books destroyed by the fire. The mosque has since been rebuilt with many donations from Muslims and non-Muslims alike. Hate crimes against Muslim Americans have periodically spiked since the September 11 attacks. And yet several Islamic groups told me that the letters of support they had received from non-Muslims outweighed the hate mail.

Sometimes, Sikh Americans are mistaken for Muslims. In November 2004 I visited two Sikh Americans at what had been their rural Chesterfield, Virginia, gas station. The arsonists who had burned it to the ground had also used silver spray paint to scrawl, "Go Home to Bin Laden Bitch" and "F*** Arab Gas" on dumpsters.

Fremont, a Northern California town surrounded by softly undulating green hills, is popular with Afghan refugees who fled the war against the Soviets and the brutal regime of the Taliban. Men of all ages meet to fly kites with glass-coated strings, competing in one of the games that the Taliban forbade back home.

In April 2002 I visited an Afghan refugee, Asia Miskeenyar, a woman from Herat. She had fled the year before, when the Taliban discovered the underground girls' school she ran. After the Taliban was overthrown, she longed to go back and teach again, but she said the U.S. was a better place for her sons to grow up. The swimming pool of her apartment building bounced sharp light into the living room as she looked out the window, watching her boys.

There have been many conversions to Islam among Latin Americans in the U.S. In the community, they often speak about "reversions," referring to the fact that Spain was under the influence of Islam for more than 500 years.

In Houston, Zulayka Martinez and her friends went to the 2002 Cinco de Mayo parade downtown. On a blistering day, they wore hijab and waved Mexican and American flags at the floats carrying scantily clad young women, local celebrities, and politicians. The friends browsed the traditional Mexican jewelry sold by an elderly Mexican-American woman.

At a baptism party held by her family, Zulayka and a friend prayed in her mother's room, as a likeness of Jesus Christ on the cross looked down upon them from above the bed, and a toddler tried to nap. When I visited them later in the year, during Ramadan, they broke their fast Latin style with fried yucca, chicken, and hot sauce.

In Los Angeles, on the last Wednesday before No Ruz, the Persian New Year, I photographed celebrants jumping over fires, to bring good luck. Iranian officials have often tried to ban the practice in their country, considering it un-Islamic.

Many Iranian exiles living in Los Angeles call the city "Tehrangeles." Most of them are secular, but deeply attached to their Iranian heritage. This crowd is renowned for its wealth and high-society lifestyle, more reminiscent of Shah-era northern Tehran than the southern Tehran of the Islamic revolution.

Although my grandfather came from Iran, I never knew this community when I lived just a few miles away in Malibu as a teenager in the 1970s. Looking out at that same ocean where I once swam often, I realized both the length and the circularity of my own journey.

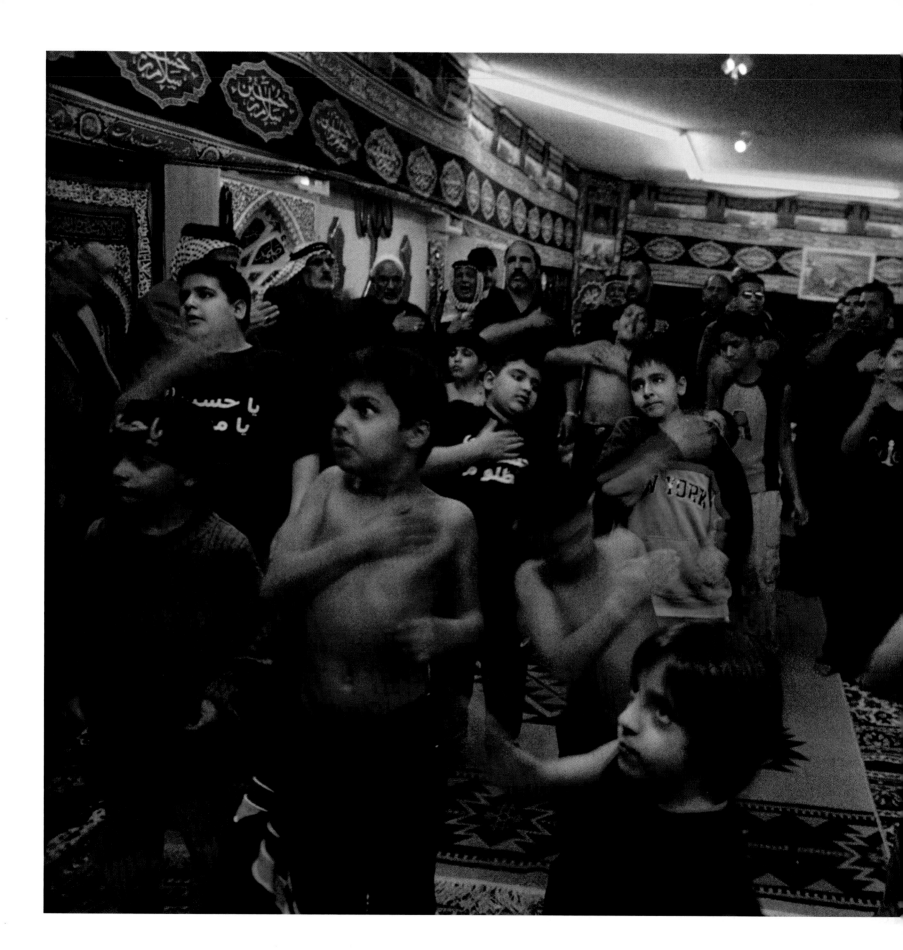

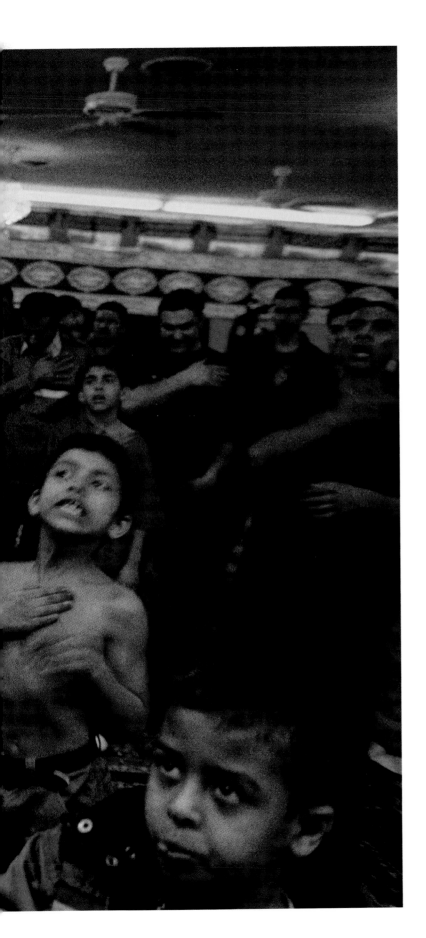

DEARBORN, MICHIGAN | MARCH 2003 | Generations of Shiite penitents attend the
Iraqi-American Karbala Mosque on Ashura, the mourning day honoring the Prophet
Muhammad's grandson, Hussain.

Lateef Muhammed, 76, relaxes at the end of the day. His wife Florence, 44, and granddaughter Kelly, 9, are reflected in a mirror. New Medinah, near Sumrall, is a village of more than 20 families, some of them farmers and most of them Muslim. It looks like any rural Mississippi village except for road signs with Muslim names. It was founded by mainstream African-American Sunni Muslims in the 1980s. Florence told me her granddaughter first visited this tiny enclave in 1999 and cried when it was time to return home to New Orleans. The family decided to have Kelly and her brother move in. "There were so many unhealthy things going on in the city," Florence told me. "To live here in New Medinah has given us a different perspective. Muslim community life makes it easy to remember God, your family, and your neighbors." Lateef will be opening an organic farmers' market soon, and Florence continues to help run Clara Muhammad Elementary School and New Medinah High School.

[NEW YORK, NEW YORK | SEPTEMBER 2002]

Saleem Hamdani (center) and his wife, Talat (right), join other surviving family members at Ground Zero for the first anniversary of the al Qaeda attacks on the World Trade Center on September 11, 2001. Their 23-year-old son Salman died when the towers came down. A New York City Police Department cadet with emergency training, Salman was trying to save others when he was killed. He was studying to be a DNA specialist for the NYPD and had been a high school football star. Mistakenly considered a suspect after the attacks, Salman has since been celebrated as a hero by the U.S. Congress and the NYPD, among others. The morning of the memorial, Talat prepared bravely at dawn for the day ahead. She told me that Salman was a very gentle soul, who felt everyone's pain. "He could not turn away his eyes if he saw a bird in distress, let alone a human being," she said. "Salman was very proud to be a Muslim and prayed five times a day. He was also very proud to be an American." Hamdani family albums are full of pictures of them visiting the Statue of Liberty, the White House, the Grand Canyon, and other great American sites. As many immigrants have, they embraced the American dream with exuberance. After his son's death, Saleem quickly became ill and died brokenhearted in 2004. Talat has become a peace activist.

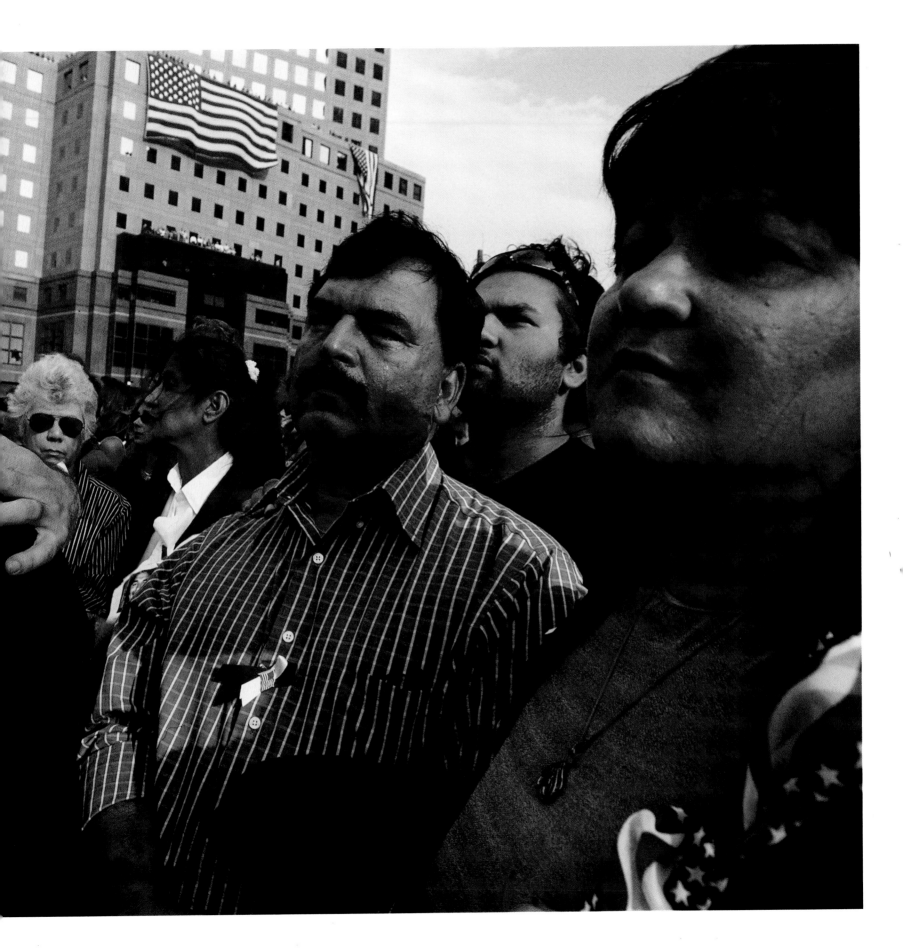

DEARBORN, MICHIGAN | JUNE 2002 | A rainstorm ends a broiling day at the Arab International
Festival, which drew thousands.

FREMONT, CALIFORNIA | APRIL 2002 | Shiite Afghan women pray during Ashura, a day of mourning
for Imam Hussain, grandson of the Prophet Muhammad, and the peak of the month of Muharram.

[ABIQUIU, NEW MEXICO | NOVEMBER 2002]

At dawn on the first morning of Eid al-Fitr, the holiday celebrating the end of the holy month of Ramadan, Fatima Van Hattum casts a shadow on the little mosque her father, Benyamin, built. Fatima was readying the mosque for an Eid celebration with other Sufi families from the area. After prayers all of them sat on the floor as a bearded Sufi man with a thick Brooklyn accent performed a *khutbah,* or sermon. Then they shared a meal. Sufism is a mystical branch of Islam.

DEARBORN, MICHIGAN | FEBRUARY 2002 | Razanne dolls are a Muslim-American alternative to Barbie.

HOUSTON, TEXAS | NOVEMBER 2002 | Zulayka Martinez, at right, who converted from Catholicism
to Islam, celebrates a family baptism.

174

DEARBORN, MICHIGAN | JUNE 2002 | Tufaha Baydayn, a Lebanese American, fled Lebanon's civil war in the 1970s.

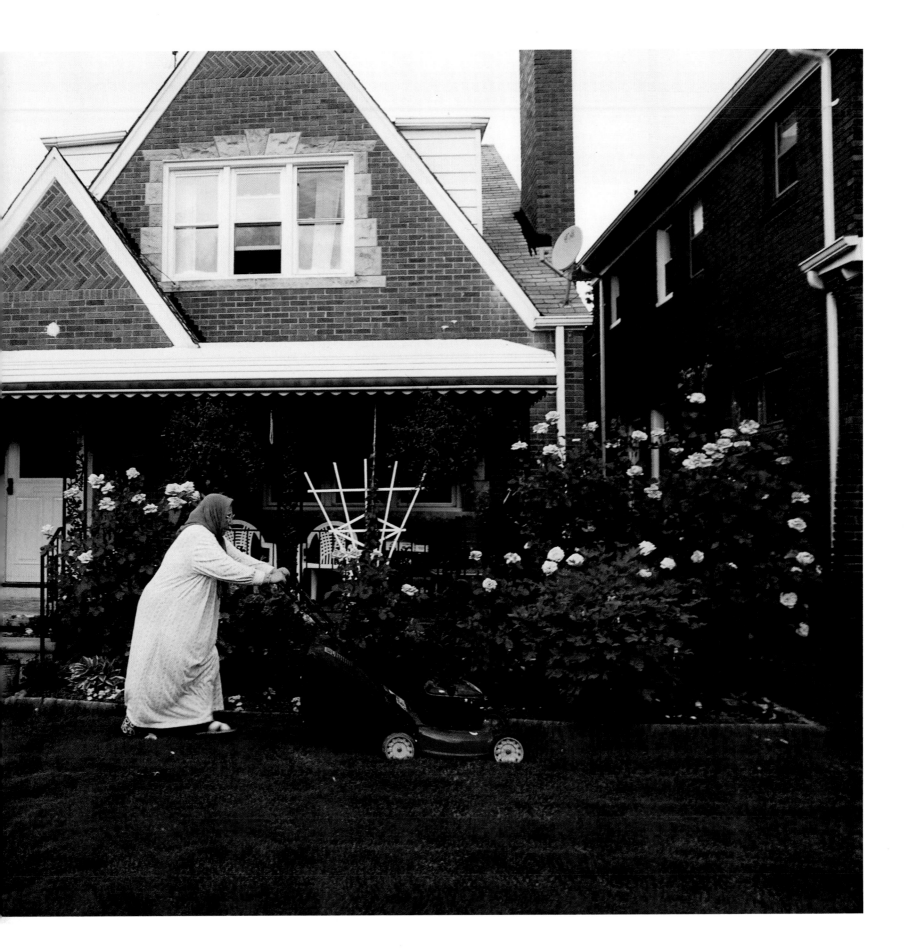

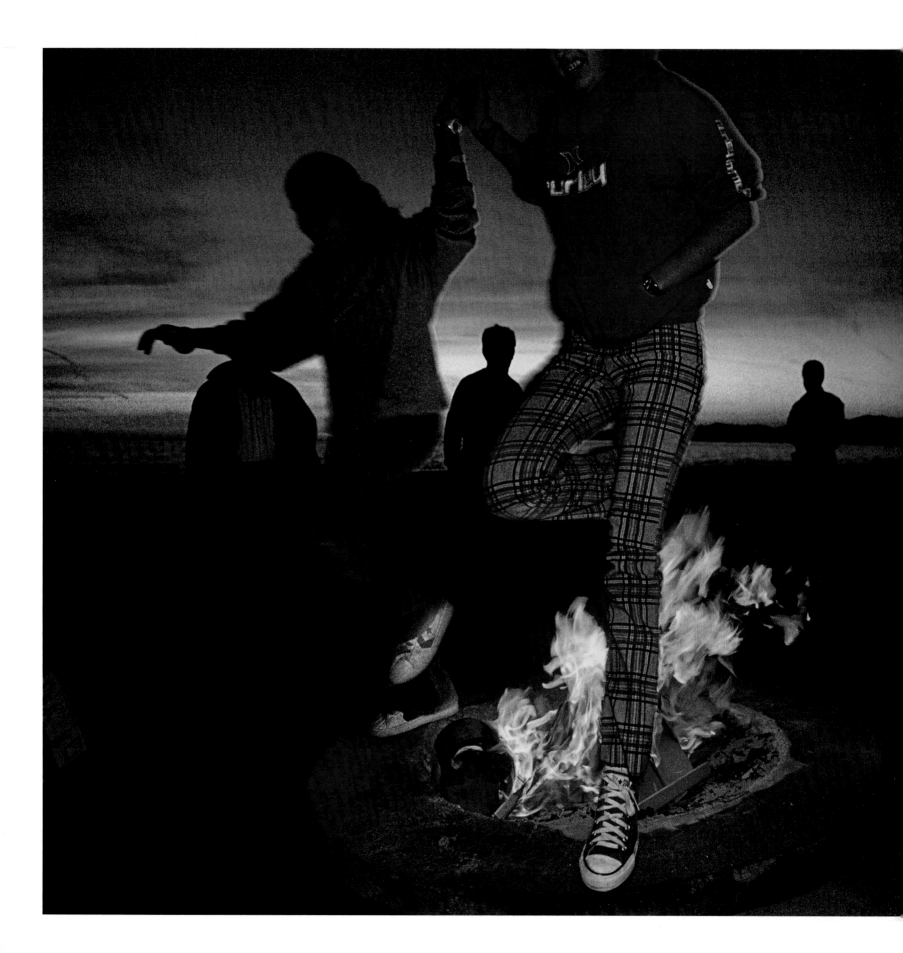

LOS ANGELES, CALIFORNIA | APRIL 2002 | At the beach, Iranian Americans jump over
a fire in celebration of No Ruz, the Persian New Year.

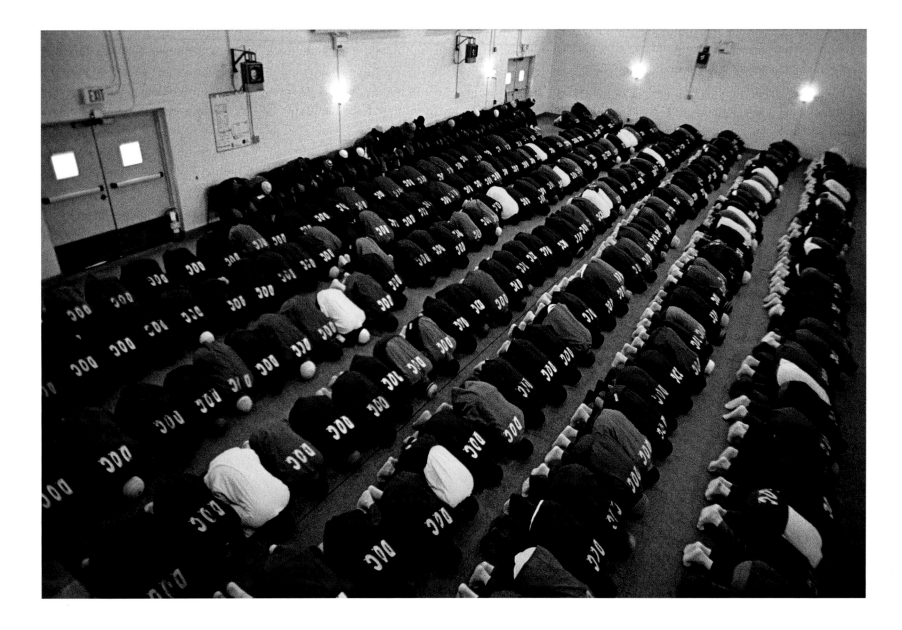

To photograph Friday prayers at the State Correctional Institution at Graterford, I needed the consent of the imam and the Muslim prison elders, who were serving life sentences. They were polite, respectful, and insisted on carrying my cameras. I was their guest, and they took it as a point of pride to safeguard me from the non-Muslim prisoners. I wore strict hijab both to show my hosts respect and also to send a stern message to the rest of the prison population that I was with—and protected by—the Muslims.

At this maximum-security prison, there were about eight hundred Sunni Muslims in a total population of 3,200. Most of them were African American. Contrary to popular belief, the vast majority of the U.S. prison system's Muslims today are mainstream Sunnis, not Nation of Islam members.

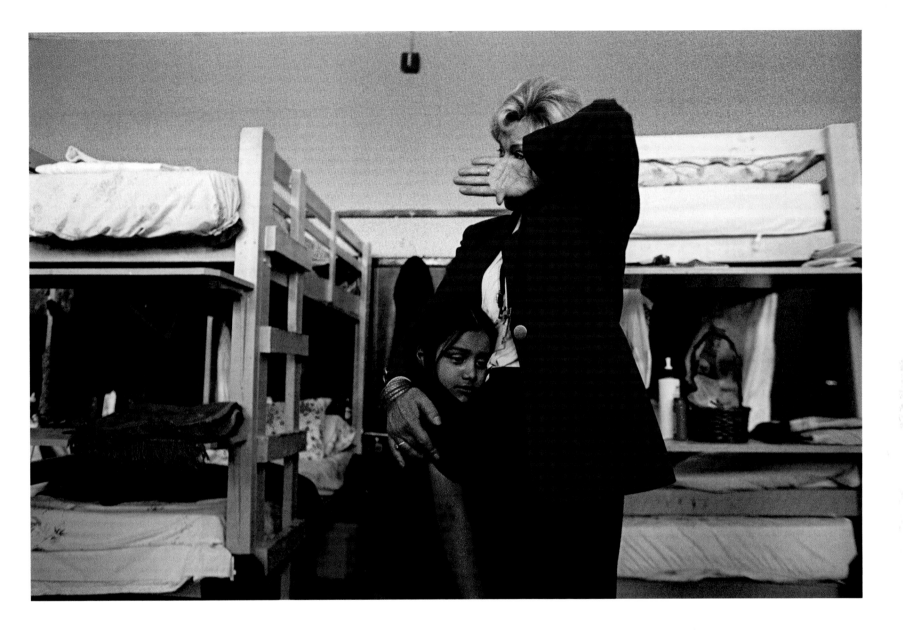

A Turkish-American volunteer for VIVE's La Casa hugs a girl whose Pakistani parents fled to Canada to beat a rapidly approaching INS registration deadline. Soon after the 2001 terrorist attacks in America, pressure to catch illegal Muslim immigrants mounted. The families I met wanted to remain in the United States and did not want to be sent back to Pakistan. Many of the children were born U.S. citizens. VIVE's La Casa is a nongovernmental agency that shelters refugees, arranges their appointments with Canadian immigration authorities, and helps them get to the border. When I was there, women and children who fled civil war in Africa were also preparing to leave for Canada.

[NEW YORK, NEW YORK | DECEMBER 2001]

Boys and girls look forward to pizza after Saturday studies in Arabic and the Koran at the East Village's Madina Mosque. Many of their parents emigrated from Bangladesh. When it was time to order lunch, one of the boys did so in a strong New York accent, as their teacher spoke little English. Several times a day, an assistant imam stepped outside the front door to perform the call to prayer. Nearby a man sold incense and fragrant oils from a table, downtown moms pushed babies in strollers, and hip denizens of the East Village strolled by in a kaleidoscope of New York culture.

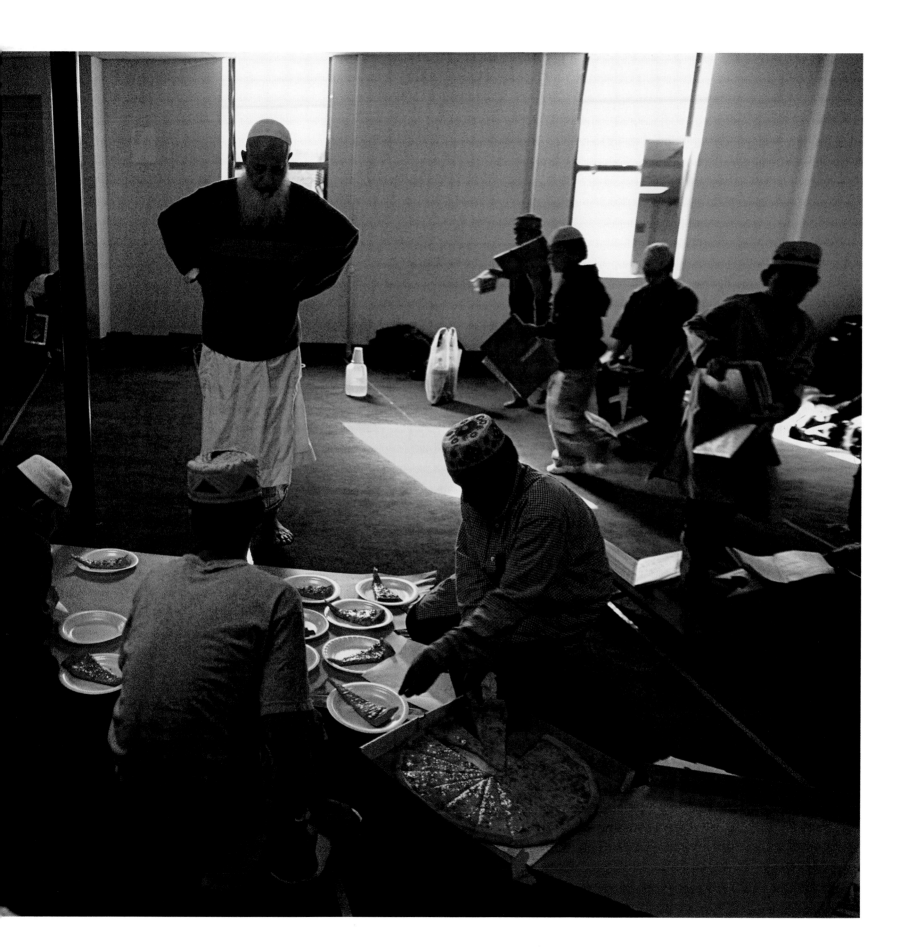

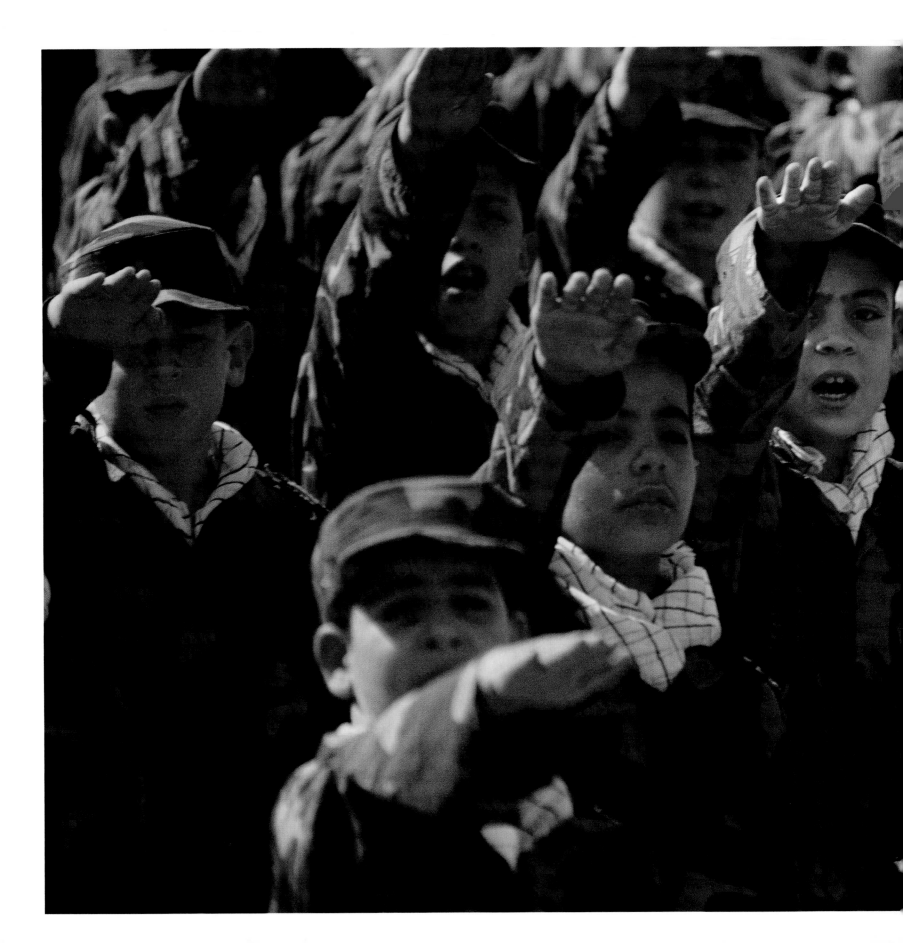

6

HEZBOLLAH

TYRE, LEBANON | NOVEMBER 2005 | On Martyrs' Day, Hezbollah's Al-Mahdi Scouts vow to commit themselves to martyrdom.

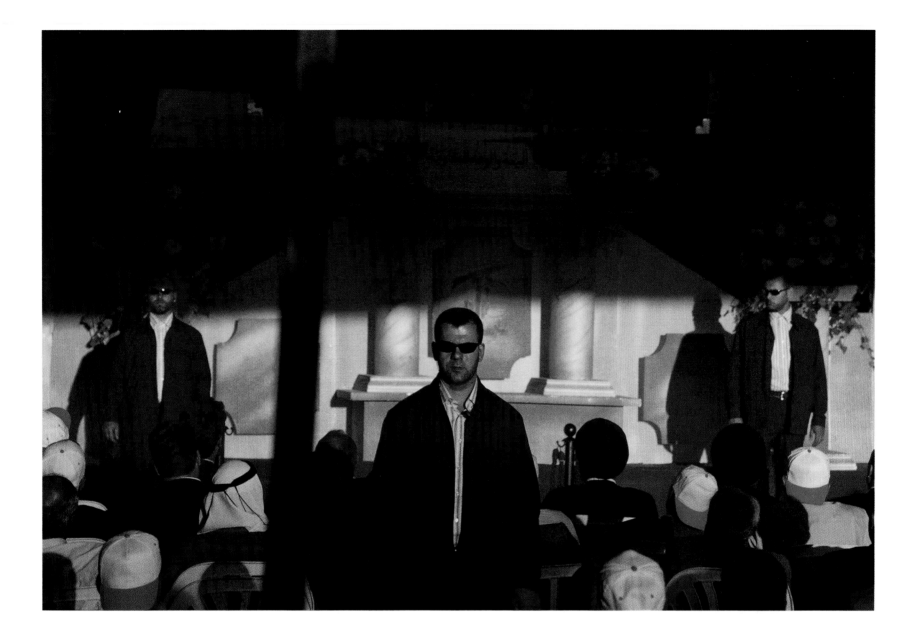

BA'ALBEK, LEBANON | JUNE 2005 | Hezbollah bodyguards at an election rally are alert as their leaders speak. When I raised my camera, they whispered into their earpieces.

حزب الله

[H E Z B O L L A H]

I had always wanted to cover **Hezbollah,** the party of God. Still, when I got the assignment in 2005, I wondered **how far** I could go with it. My editor had said,

"Get as close as possible to Hezbollah." This was almost unknown for any Westerner, let alone an American woman photojournalist. Most Western journalists had long ago given up on covering Hezbollah in any depth. Hezbollah and its world are unreachable to most outsiders. I had eight weeks to accomplish what might be impossible.

A militant political organization, Hezbollah began as an outgrowth of Shiite Islamic resistance to the 1982 Israeli invasion of Lebanon. The group is supported by Iran and Syria and is classified as a terrorist organization by the U.S. government and Israel. The U.S. holds Hezbollah responsible for the suicide truck bombing of the U.S. Marine barracks in Beirut in 1983 that killed 241 Americans and the kidnapping and murder of Americans and other Westerners throughout the 1980s, In 2002, Deputy Secretary of State Richard Armitage called Hezbollah the "A-team" of international terrorism. The U.S. backs the pro-Western government of Lebanon.

It would be a mistake, though, to focus only on Hezbollah's ties to international terrorism in trying to understand the organization. Hezbollah is also a major player—and power—in Lebanese politics and holds 14 seats in Parliament, with many allies among the other major Shiite factions and some Christian parties. To many Lebanese, even some with secular political orientations, Hezbol-

lah guerillas are considered heroes and freedom fighters for forcing Israel to withdraw from South Lebanon in 2000. Many people throughout Lebanon and the Middle East believe that Hezbollah won the summer 2006 war with Israel.

But plenty of Lebanese oppose Hezbollah's "state-within-a-state" infrastructure, independent guerilla army, and conservative religious agenda. Like many Islamic groups, Hezbollah gains popularity among its constituents through charitable organizations and extensive social services in the areas of the country it controls, including Beirut's southern suburbs, the Beka'a Valley, and southern Lebanon. In the south, the group runs schools and hospitals and even has bulldozers plow in winter to get supplies to villages cut off by snow.

In the Beka'a, Hezbollah teaches farmers how to grow organic vegetables and earn more money. The organization has permitted a tourist industry to grow around the great Roman temples of Ba'albek and even looks the other way when alcohol is served at some festivities there. At a jazz festival at Ba'albek in the summer of 2005, Hezbollah set up a propaganda exhibition next door and showed guerilla videos. The contrasts were striking—American jazz, the ruins, and footage of guerilla fighters. I could not help but look beyond the Ba'albek ruins time and again at the hill where

some of Hezbollah's American and Western hostages allegedly were kept in the 1980s.

In the course of my assignment, Hezbollah members would seem to warm to me and then mysteriously disappear—promised access would not materialize. My first point of contact was always the press officer in charge of my access, the son of a well-known Hezbollah sheikh. In the beginning, I gave him a list of story points. He replied, "impossible," to many of them. He expected me to accept no as an answer and go away. At times he would become so annoyed that he would nearly shout, "These are not requests! They are demands!" Then sometimes he wouldn't answer his cell phone for days at a time. When he finally did and I asked for a meeting, he would say, "Why? There is no reason."

Hezbollah's structure is designed in part to prevent relationships with outsiders. All members are required to report meetings with non-members. One of the secrets to Hezbollah's success is its strict and disciplined hierarchy. Faith is built in: Allah is at the top of their structure; Islamic jurisprudence in the form of Iran's spiritual leader is second.

Despite discouragements, as the assignment progressed, I realized I was getting unusual access and approvals, albeit with constraints

and conditions. I was generally not allowed to visit a Hezbollah place or person twice. When I learned there would be only one chance, I would work until long after sunset to take full advantage of the access. I had long conversations with Hezbollah members about Islam, their positions on Israel and the United States, and their experiences in battle. They seemed to enjoy the chance to talk to an American at length. These conversations did not always go easily. I was surprised at first to see that in some Hezbollah bureaucratic offices were portraits of Ayatollahs Khomeini or Khameini, but not the Lebanese president or prime minister. There were also often pictures of Hezbollah Secretary General Sheikh Hassan Nasrallah.

I spent more than a day photographing Hussein Hajj Hassan, a Hezbollah member of Parliament. He met constituents in the living room of his Beka'a Valley family home, in the Arab tradition of *diwaan*, during which he would help people resolve disputes and cut official red tape. The press office had set up our original meeting, and then, amazingly, he invited me to a big dinner during Ramadan and let me photograph it.

I visited the beach in Tyre, where a female Hezbollah supporter swam in full Islamic dress next to a woman in an orange bikini sporting obvious breast implants. Lebanon is one of the few places where one can see such contrasting images side by side. Hezbollah officials told me

they do not believe in an Islamic state for Lebanon, and to my surprise I never had to wear Islamic dress around them, except in mosques or when visiting sheikhs. In fact, they insisted I not cover my head except for those occasions. I noticed many Lebanese women living in the areas under Hezbollah control going without headscarves and wearing tight clothes.

When I was working in southern Lebanon, a U.N. official with deep knowledge of the area said there were between 400 and 500 active-duty fighters present—none of them visible. "It seems calm, but it is not. Anything can happen," he said. I saw a Hezbollah fighter with a visible gun only once. It was before 7 a.m., and I was looking for a good landscape view. I walked into an old, stone guard tower I thought was empty, but a man sat in front of a computer screen, surrounded by electronic equipment. He seemed to be observing the land. His assault rifle rested against a wall. We both gasped—astonished to see each other. Then he jumped up and shooed me out, yelling for me to leave. He bolted the beat-up metal door after me. Luckily, he had mistaken me for a blundering tourist. Two U.N. employees had been seriously beaten not long before that, when Hezbollah fighters discovered them in the wrong place at the wrong time.

Hezbollah has resorts and therapy facilities for wounded guerillas. I visited three in southern

Lebanon. One of them, run by the Association for the Injured, was for physical and psychological therapy. The wounded men let me photograph them during physical therapy, but I was not allowed to document the psychotherapy. A 40-something fighter who managed the program explained how it was a new concept in Hezbollah that fighters might experience emotional problems. This same man asked me with a big grin, "Aren't you afraid of me?" No, I was often frustrated, but never afraid.

At Fardos Resort for the War Wounded, I spent part of the day with former fighters Hussein Mazlom, paralyzed on his left side in a 1993 fire-fight with Israeli soldiers, and Tahsin Zeinadin, who was blinded while fighting in 1988. They and their families were taken by minibus to an amusement park, where the two men went on a roller coaster with the children, and on a tiny train. The close friends walked slowly around the park, watching their kids race to more amusements.

That day at Fardos, I shared a meal with all the families and the courtly but taciturn, one-legged former Hezbollah fighter who was in charge. I photographed some older, elite Al-Mahdi Scouts playing soccer nearby. That night I heard them praying with their sheikh in the mosque, vigorously chanting the Shiite *shihaada* (declaration of faith). Serious spiritual training from a Hezbollah sheikh is considered a critical part of the training

to become a high-level Hezbollah fighter. I sat under the stars with the former fighters as they smoked water pipes and gossiped.

I visited two summer camps for Hezbollah's Al-Mahdi Scouts. The Hussein Hassan Mahdi Scout Camp on the beach near the Israeli border was attended by the teenage leaders of local troops throughout the mountains of southern Lebanon. They practiced marches, ran, tied knots, and created art projects near the entrances to their tents. Outside one tent, boys designed a Star of David made of stones that they trod on when they entered. At both camps, when the boys and their leaders jumped in the water, so did I—in modest full dress with no headscarf—to keep on photographing. This always surprised the camp leaders and my minders, making them nervous for the boys and their moral training. But it also helped them relax around me.

In November 2005, I arrived in Beirut for Al-Quds Day, a holiday focused on a hoped-for conquest of Jerusalem. It was forbidden to march with weapons that day. But there were thousands of reserve fighters on display, and special forces doing maneuvers on high wires above the street. It made fine pictures, but it really was a big show for the public and press.

I met the deputy secretary general of Hezbollah, Sheikh Naim Qassem, in his office in a building under construction. I never would have guessed that one of the leaders of Hezbollah would be inside. The windows were frosted over and covered with heavy drapes. Ayatollah Khomeini's photo glared down from the wall. The three rooms I was allowed into were cleared of every scrap of paper. He felt secure enough with me that his bodyguards left the room most of the time. He prayed, wrote letters, took a call. The sheikh is about 5'7" with a trim beard, penetrating eyes, and elegant, traditional robes. When he speaks publicly, he is uncompromising. He spent about an hour with me, gave me an autographed copy of his book, and recommended story points I should cover, such as a Hezbollah social program.

He invited me to accompany him to the wake for a recently deceased sheikh. Even so, the Hezbollah press official gave no approval for me to cover those two ideas. He told me the intelligence wing would decide whether I could have access. Thus I learned that this shadowy, all-powerful wing of Hezbollah that I had never seen could nix even an idea by the deputy secretary general.

Sheikh Qassem smiled very courteously, hand over heart, when I saw him on Martyrs' Day in Tyre, where he presided over a ceremony. Even the youngest Al-Mahdi Scout swore allegiance and willingness to be martyred. Hezbollah press officials never would have told me about this event. My assistant and I heard about it on the radio at 6 a.m. the day it was to take place. We drove like wild for three-and-a-half hours and arrived in time for the ceremony. I had no permission to be there and was afraid I wouldn't be let in. But I pretended to belong.

The younger boys in their scout uniforms gathered, their faces looking worried, sad, proud, and brave as they waited for the moment when they would swear to accept martyrdom. Many of them were about seven or eight. They seemed to be taking the moment literally, many of them looking horrified, but at the same time they enjoyed playing soldier. Hezbollah scout leaders helped them straighten their little scarves. Sheikh Qassem gave his speech. Afterward, we rushed to Beirut to photograph another ceremony. Again, I pretended I belonged there. This was my last day in Lebanon, and a lucky one at that.

The story was published as a portfolio in *Time* and on the NGM website with a news peg I hadn't anticipated: the summer 2006 war between Israel and Hezbollah, which began when Hezbollah killed three and kidnapped two Israeli soldiers. I was interviewed on CNN about my experiences with Hezbollah.

The entree I obtained was among the most difficult of my career. Many of the Hezbollah offices and institutions I visited were destroyed by Israel's air bombardment in the war of 2006, however Hezbollah remains the decisive force in Lebanese politics and maintains one of the world's most disciplined guerilla armies.

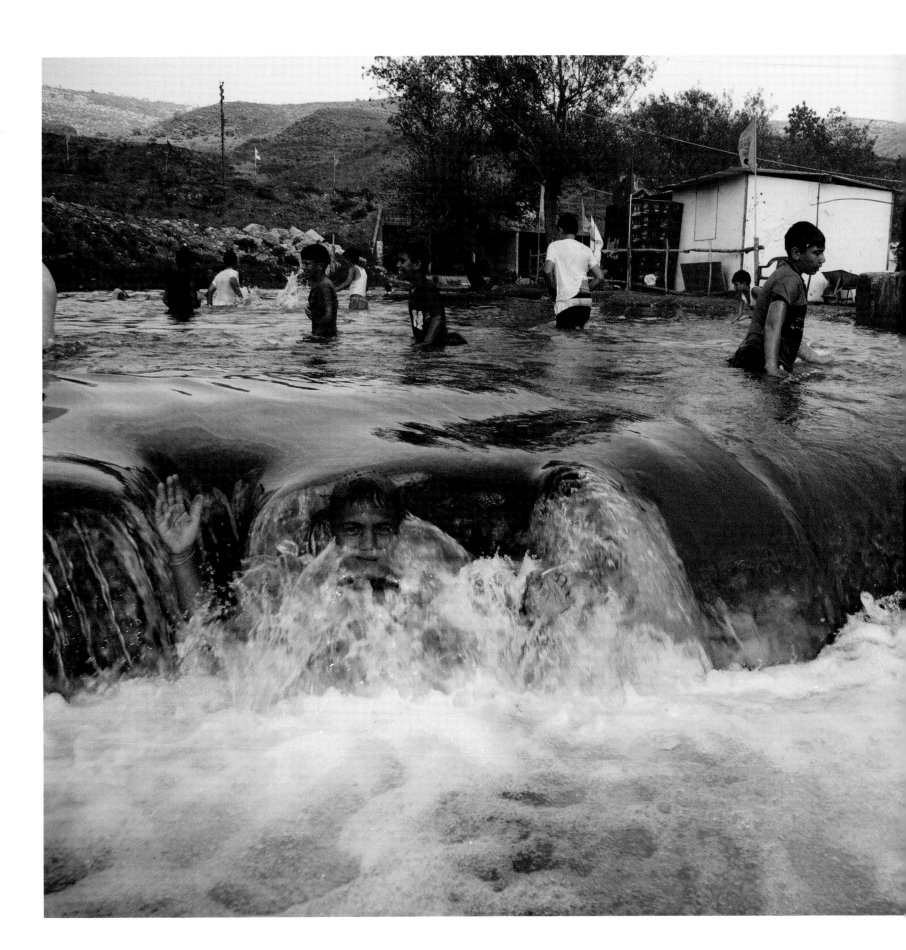

LITANI RIVER, SOUTH LEBANON | AUGUST 2005 | In summer, children who are not Al-Mahdi Scouts try out Hezbollah's Camp of the Moment (*Mukhayyam al-Wahlah*) for two days.

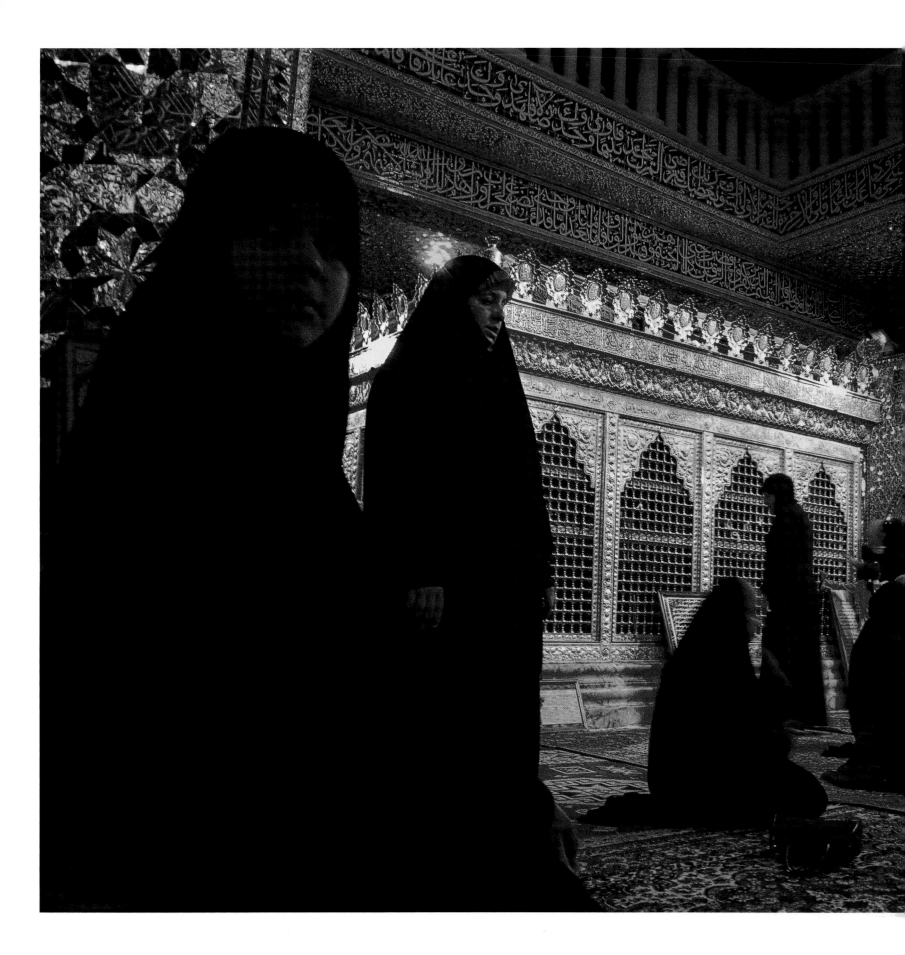

[BA'ALBEK, LEBANON | AUGUST 2005]

At the Shiite mosque and Shrine of Khawlah, Hezbollah sup-
porters pray on Imam Ali's birthday. Ali, a close relative of the
Prophet Muhammad, was Khawlah's grandfather. Prayers said
on Ali's birthday are thought to have a good chance of being
answered. I came upon this special evening by chance; benign
as it was, it was not the sort of event the Hezbollah spokesman
would tell me about. I was in Ba'albek photographing the great
Roman ruins and daily life in the Hezbollah-dominated town and
walked in unhindered and happy to photograph inside the world
of Hezbollah—taking photos until almost everyone had left.
Most aspects of the Hezbollah organization and lifestyle were
severely restricted to outsiders, so I stayed long whenever I was
invited in. The new Khawlah shrine was paid for by the Iranian
government, which supports Hezbollah politically, militarily, and
financially. On a previous visit I found Iranian craftsmen in the
mosque placing countless cut mirrors in intricate patterns on
the ceiling, and the Hezbollah member in charge gave me an
impromptu tour.

LITANI RIVER, SOUTH LEBANON | AUGUST 2005 | Hezbollah camp counselors pray at Camp Duty, one of several Al-Mahdi Scout camps throughout the region. At one point I surprised the camp sheikh, whom the boys called "Sporty Sheikh," when I walked into a tent as he carefully watched the boys wrestling. He stopped them as soon as I arrived. Sporty Sheikh taught the boys the proper ways of ritual washing (*wuduu*) and prayer (*salaat*). Another Hezbollah member taught them how to handle an ax.

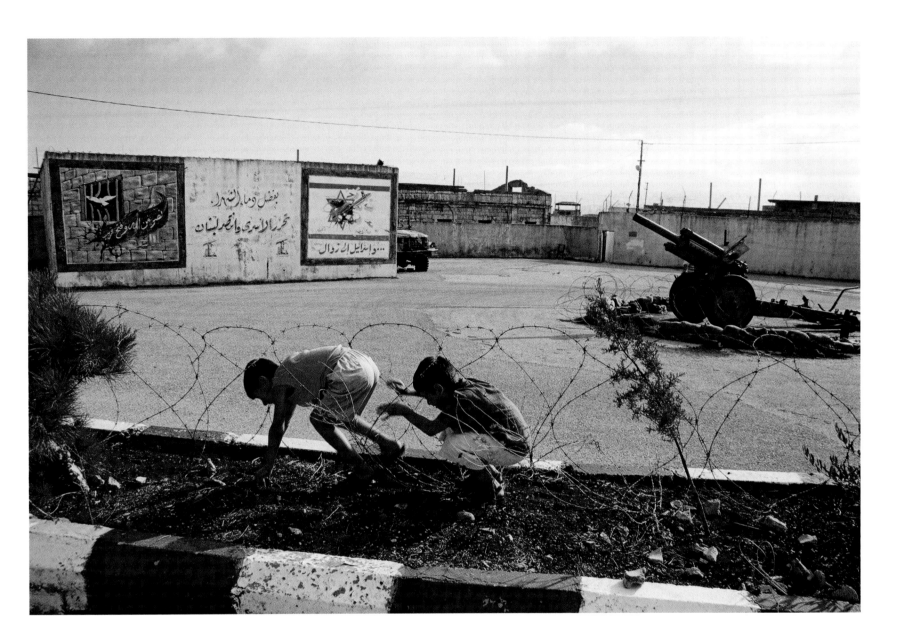

KHIAM PRISON, SOUTH LEBANON | AUGUST 2005 | At Khiam Prison, now a Hezbollah museum, boys from the nearby town play inside a roll of barbed wire. Khiam Prison was run by the South Lebanon Army (SLA), allied with Israel, from 1985 until 2000. The Israeli Army withdrew from its own bases in 2000. Many SLA members left with them and settled in Israel.

[FARDOS, LEBANON | AUGUST 2005]

At Fardos, a resort for Hezbollah's war wounded, former fighter Mostafa Hajj Hassan, 38, prepares to smoke tobacco in a water pipe accompanied by his pregnant second wife, an Islamic schoolmaster, and one of his daughters. He recounted how he became what Hezbollah calls a "living martyr" in 1986 during a firefight as his unit attacked Israeli troops. "When I was wounded, it was holy. I was so hot, lying under the sun, wounded everywhere in my body. A cloud came over me and froze my wounds. I was alone. There was crossfire. There was a second attack to rescue me after four hours. But when I felt I would be martyred, I felt real happiness. And I have never felt that way again in my life." Hassan lost parts of a leg and an arm, and was half blinded in battle. He said he remained active in "the resistance," and leading a soccer team for war wounded. He showed me how agile he was with a soccer ball. Each wounded guerilla and his family received use of a small villa on a high hilltop, communal meals, visits to local attractions, physical therapy, and use of the mosque.

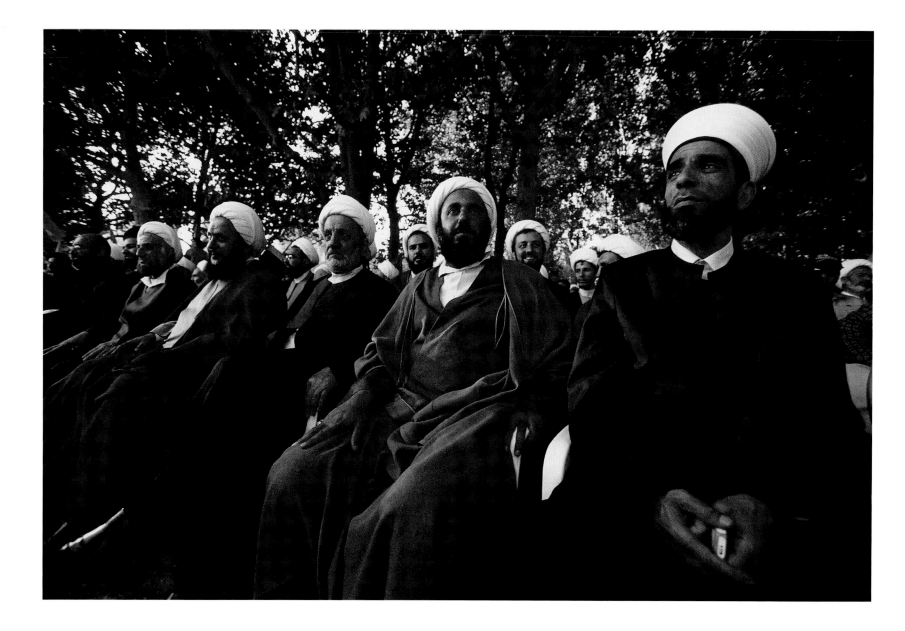

BA'ALBEK LEBANON | JUNE 2005 | At an election rally, Hezbollah members, supporters, and
other invitees awaited a speech by Sheikh Hassan Nasrallah, secretary general of Hezbollah.

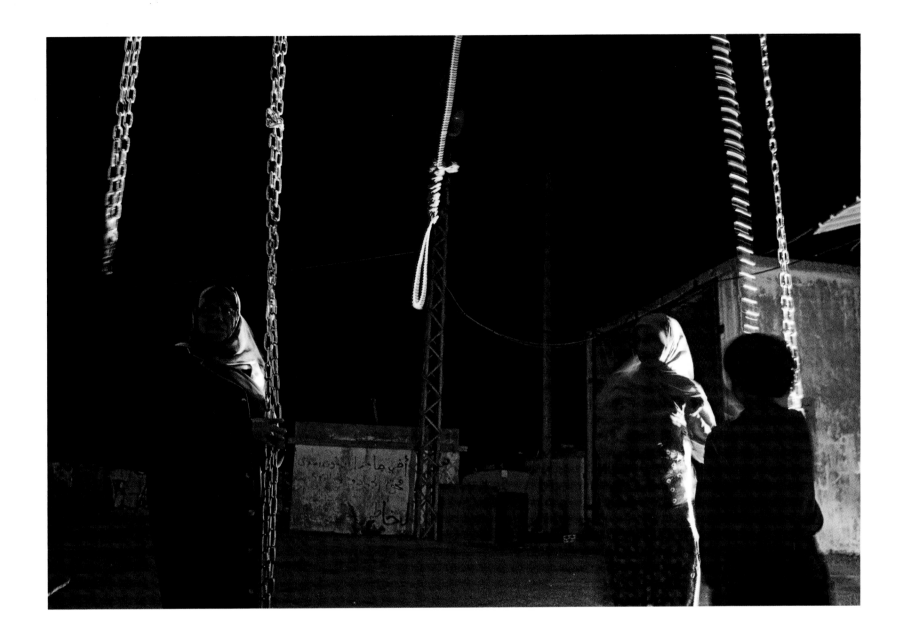

KHIAM PRISON SOUTH LEBANON | AUGUST 2005 | One-time prisoner of the SLA Sikna Bazzi, (left), 37, said she was tortured at the prison and waited to tell her story on a live television program. The noose and chains were part of the set, hung by Hezbollah's Al-Manar TV crew.

[TYRE, LEBANON | NOVEMBER 2005]

On Hezbollah's Martyrs' Day, elite Al-Mahdi Scouts wait to pledge their willingness to be martyred as a Hezbollah sheikh walks by. These young men were well into their training and would have been prime candidates to take part in the war between Israel and Hezbollah in the summer of 2006. Young leaders are vetted, singled out, and groomed for leadership roles in Hezbollah as fighters, propagandists, strategists, religious leaders, or politicians. Not everyone is recruited for actual combat. On this spot in 1982, a young man drove a car bomb into an Israeli military base, killing some 90 people.

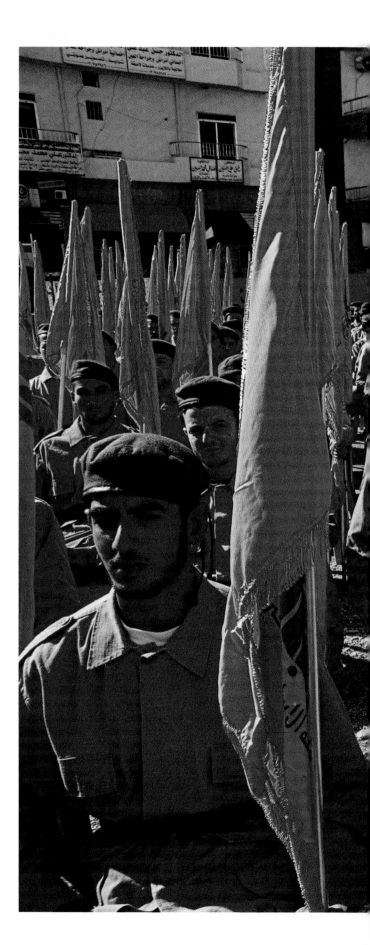

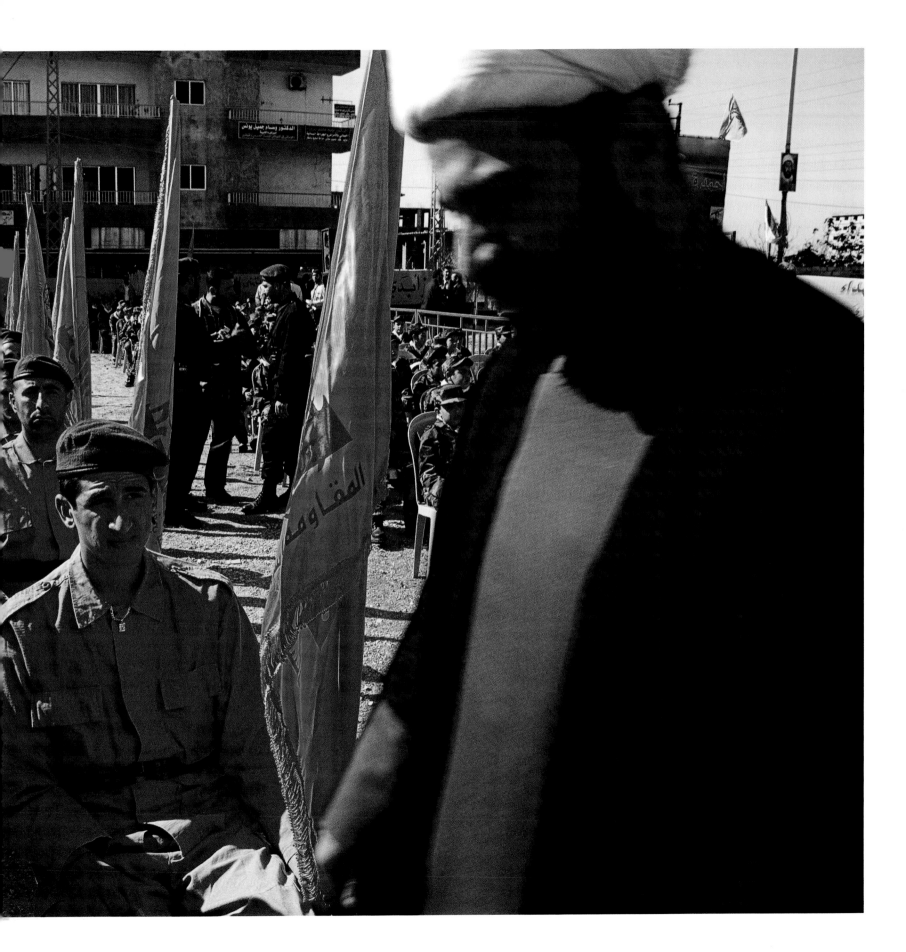

A woman and her daughter visit a grave in the Shiite martyrs section of a cemetery on Martyrs' Day. The glass boxes hold photos of the dead and a few things they held dear: a Koran, prayer beads, bullet casings. Speeches were held just outside the cemetery, with the cousin of Hezbollah Secretary General Sheikh Hassan Nasrallah presiding. The families of local martyrs attended.

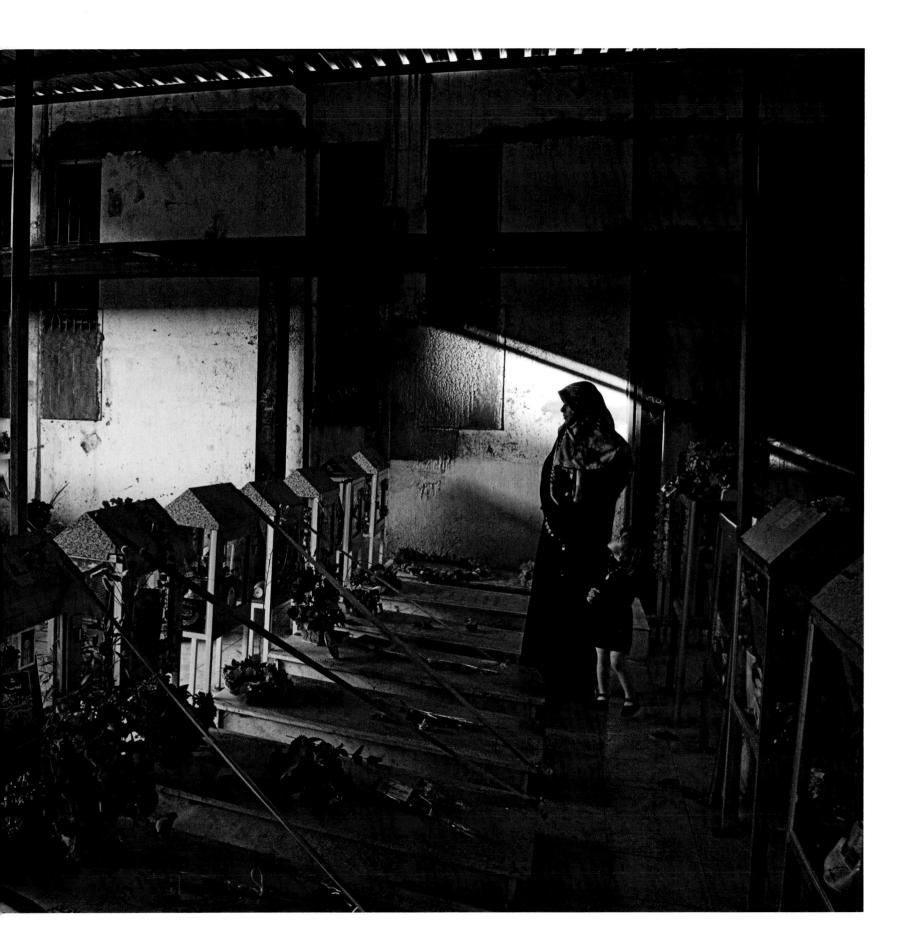

شكر و تقدير

[A C K N O W L E D G M E N T S]

I begin by giving profound thanks to Nina Hoffman, executive vice president of the National Geographic Society and president of National Geographic Books, for her belief in this project

especially during a trying time in my life and for her great warmth, strength, and honesty.

Deep gratitude also to Kevin Mulroy, senior vice president and publisher of National Geographic Books, for his invaluable support and advice throughout this project.

I have been deeply honored to work on this book with Leah Bendavid-Val, chief editor of Focal Point and director of photography publishing, National Geographic Books, with whom I have dreamt of working for years. Leah's artistic and editorial vision are legendary. Here's to your refined, wise eye, your strength, and your deep affection for our art and craft. A profound thank you, Leah, for making this book so much better. Without them the book would not exist.

An enormous thank you to senior editor Becky Lescaze, a great editor who made the text infinitely better and graciously took it on when she already had so many other commitments at the same time. Thank you to Michelle Harris, editor, researcher, and fact-checker, for her crucial input and passionate attention to detail, which I could not have done without.

Thank you to members of the editorial team: Illustrations Editor Bronwen Latimer, Art Director Melissa Farris, and freelance editor Fran Bren-

nan. Thank you Chris Brown and Monika Lynde, Manufacturing and Quality Management, and Stan Simpson, Quad Graphics Color Sponsor, for taking the time to make it right. Thank you Amin Bonnah, Riad Ibrahim, and Sanaa Akkach for helping to make sure the Arabic font and transliterations were correct. Thank you to everyone on the credits page and all those at NG Books who worked hard on this book.

I wish to give very special thanks to John Fahey, the CEO of the National Geographic Society, for writing such a kind and generous foreword. It is an honor to have him associated with my book.

My editors at *National Geographic* magazine (NGM) have been important contributors to my growth as a photographer and have supported my work. They are quite simply the best in the business, and they have given me many fantastic opportunities. In particular great thanks go to past and present Editors in Chief Bill Allen and Chris Johns, past and present Directors of Photography Tom Kennedy, Kent Kobersteen, and David Griffin (who also designed the NGM Gaza story way back when), and Deputy Director of Photography Susan Smith. Thank you Executive Editors Dennis Dimick and Bill Marr, Senior Editor John Echave, and Senior Editor for Foreign Affairs Don Belt.

More editors past and present whom I have worked with and learned from at NGM, on stories included in the book, are Robert M. Poole, former executive editor; Associate Editor Robert L. Booth; and former Associate Editor Bernard

Ohanian; Articles Editor Oliver Payne; Senior Editor for Features Lynn Addison; Design Director David Whitmore; Senior Design Editor Elaine Bradley; and designer Bob Gray. Thank you to Research Editor Mary McPeak for extensive help on Muslims in America.

In the context of this book, I wish to thank especially NGM Senior Photo Editor Elizabeth Cheng Krist, who helped me make the wider picture selection from which the book was edited, critiqued the book dummy several times, and helped me edit text. She was also my editor for NGM stories on Gaza, Iran, and Armenia. She has a truly great eye, and her deep heart and wisdom are in her edits. I am profoundly grateful to her.

Senior Editor Susan Welchman was the NGM editor on Muslims in America and Hezbollah and is renowned for her astute and elegant eye, her dedication, and love of photography. Both of these terrific women shaped those original stories with me.

I would like to thank Tim T. Kelly, president, Global Media Group, and president and CEO of National Geographic Ventures, and Lisa Truitt, president of National Geographic's Giant Screen Films and Special Projects, for *Iran: Behind the Veil*, the National Geographic Explorer documentary about my work. Thank you to Gregory McGruder of NG Live and the museum.

Immense gratitude goes to Robert Pledge, director and editor of Contact Press Images, who has been a mentor for more than 20 years. His artistic vision

OPPOSITE: WASHINGTON, DC | May 2005 | The author's son, Sebastian, plays among cherry blossom trees along the Potomac River.

is unmatched, and his creative mark is clearly on this book. Pledge and Jacques Menasche, great editor/journalist/author/friend at Contact, convinced me this book should be a memoir, and edited and proofed many versions of the dummy and text. Deep thanks, Jacques, for helping me get at the essence and much more. Also special thanks to Jeffrey Smith, director of the Contact NY office and old friend, for his help negotiating the contract and checking out the book dummy; Ronald Pledge; Catherine Pledge; Dustin Ross; and Audrey Jones who assisted with various picture searches; Tim Mapp; Bernice Koch; and Samantha Box. Thank you to Dominique Deschavanne of Contact Paris for her support in so many ways through the years. Thanks to everybody present and past at Contact NY and Paris.

Great appreciation goes to the editors for whom I took many of these pictures on assignment over the years: renowned editors Michele Stephenson, former director of photography, *Time* magazine and Robert Stevens, former photo editor of the World Section, *Time* magazine. A champion of women photojournalists, Robert kept me working and living around the world for almost a decade. Thanks for letting me run with the ball, and more.

Deep thanks to Kathy Ryan, director of photography, *New York Times* magazine for whom I did many cover stories over a period of many years—they also ended up in this book—and to Peter Howe, former director of photography at the *New York Times* magazine, for his early support.

Thanks also to Colin Jacobson for support at a critical moment when he ran a portfolio and cover in the *Independent* magazine. Thank you to Mary-Anne Golon, former director of photography at *Time* magazine for the Hezbollah portfolio. Thanks to Grazia Neri and *Corriere della Sera* magazine, and *Anderson Cooper 360* for running Hezbollah portfolios and interviews, too. Thanks to the NG website and podcast staffs.

Thank you to Mark Bussell and Woodfin Camp, beloved friends and mentors who gave me creatively rich, early support. Thank you to those at Woodfin Camp & Assoc. Thanks to the Bou-

lat family for their deep support in Paris. Thank you to Jean-Francois Leroy, director, curator and founder of Visa Pour l'Images photo festival in Perpignan for his great friendship and support in showing my work over the years. Thanks to Dick Doughty, assistant editor of *Saudi Aramco World Magazine*, for the Islam in America portfolio and cover and use of quotations I had obtained for it. Thanks to *U.S. News & World Report* for the Islam in America portfolio, especially David Griffin, who was there at the time.

There is no end of thanks to my husband, Andrew Parasiliti, who devoted a great deal of time and effort to editing and criticizing my text, even while traveling in India and the Middle East, and who always encourages and protects me, and to my son, Sebastian Avakian Parasiliti, an extraordinary boy of great sweetness and enthusiasm, who waited patiently for me to come home from abroad and to stop typing. Deep gratitude to my mother, Dorothy Tristan, and my stepfather, John D. Hancock, who always believe in me, helped edit the text and critique the book dummies, took care of me and my family during the challenging time that coincided with the editing of the book, and worried about me when I was on the road making the pictures. Big thanks to Anna Avakian and her late father, Armenak Avakian. Her memories and his memoirs helped me with family history. Thank you to relatives Sonik Hovanessian and Charles Freericks and to Medik Babloyan for the use of a family photograph. Major thanks to Uncle George Avakian and Aunt Anahid Ajemian for their encouragement and hospitality while I worked on edits in New York and for so much more. Thanks to childhood friend James Marquand for writing advice and for listening, and to Carol Southern, lifetime friend, who helped with the contract.

I also thank especially the following friends, colleagues, and experts who advised and supported me with their friendship, generosity, expertise, and many kinds of support during the actual making of the photographs in this book. I appreciate you deeply: Alfred Yaghobzadeh and Nadine Cam-el-Toueg of Paris; Ahmed Jadallah and Abeer Elo-tol, Nabil and Ebtisam Joudah, Nidal al Mughrabi, and Sami Zyara of Gaza; the Abdul Jawad Saleh

family of Ramallah; Jim Hollander, Annie and David Rubinger; the Jerusalem Time-Life Bureau of 1988-1996; Manoocher Deghati, Marie Colvin; Robert Fisk; Leena Saidi and family of Beirut, Andrew Cockburn, Milos Strugar, Hassan Siklawi, Hisham Melhem, Giandomenico Pico, Persheng Vaziri, Mohammad Farnood, the late Kaveh Golestan, Nazila Fathi and family of Tehran, the Farmaian family of Tabriz, the Mahallati family of Shiraz, Christiane Amanpour, Nora Arissian, Hirair and Anna Hovnanian, Ruben Adalian, Avet Demuryan, Vardan Hovhannisyan, John Esposito, Zahid Bukhari, Said Sayeed, Bill Mokdad, Aida Hamza, Karima D. Alavi and Abdur Ra'uf Walter Declerck, Florence Muhammed, Rosa Shareef, Talat Hamdani, Karen Dabdoub, Shakila Ahmad, the Moscow Time-Life bureau of 1988-1992, Yuri Kotler, the Stas Namin family of Moscow, Bill Keller, David Aikman, Anne Slowey, the Nairobi *Time* bureau of 1992-1993, Donatella Lorch, Corinne Dufka, Rory Nugent, CARE Baardheere, ICRC Baardheere, Caritas Mogadishu, and Concern Southern Sudan.

On a 20-year journey across a region one makes many friends along the way. There are too many individuals to list. They helped me and they know who they are: the very special friends, journalists, editors, diplomats, press advisors in many countries, academics, friends, fixers, editorial and field assistants, translators, great shooting partners, drivers who went the extra mile in more ways than one, pilots, dear baby sitters, doctors, aid workers and helpful strangers. I am deeply grateful for your kindness, bravery, and input.

Thank you to the people who were present during events in this book and not named out of courtesy, discretion, or for editorial reasons. My love forever for the late Aram Avakian for being such a great father and a source of so much inspiration in my work and life. Profound thanks to the people in the photographs and text; in many ways this book belongs to you. The writing and editing of this book coincided with my diagnosis, treatment, and survival of breast cancer. The book and these acknowledgments therefore have an even deeper personal meaning to me.

<div dir="rtl">

فهرست

</div>

[I N D E X]

WINDOWS OF THE SOUL

Alexandra Avakian

Published by the National Geographic Society

John M. Fahey, Jr., *President and Chief Executive Officer*
Gilbert M. Grosvenor, *Chairman of the Board*
Tim T. Kelly, *President, Global Media Group*
John Q. Griffin, *President, Publishing*
Nina D. Hoffman, *Executive Vice President;*
 President, Book Publishing Group

Prepared by the Book Division

Kevin Mulroy, *Senior Vice President and Publisher*
Leah Bendavid-Val, *Director of Photography Publishing*
 and Illustrations
Marianne R. Koszorus, *Director of Design*
Barbara Brownell Grogan, *Executive Editor*
Elizabeth Newhouse, *Director of Travel Publishing*
Carl Mehler, *Director of Maps*

Staff for This Book

Bronwen Latimer, *Illustrations Editor*
Melissa Farris, *Art Director*
Rebecca Lescaze, *Text Editor*
Fran Brennan, *Text Editor*
Michelle R. Harris, *Researcher*
Sanaa Akkach, *Text Consultant*
Ric Wain, *Production Manager*

Jennifer A. Thornton, *Managing Editor*
Gary Colbert, *Production Director*
Meredith C. Wilcox, *Administrative Director, Illustrations*

Manufacturing and Quality Management

Christopher A. Liedel, *Chief Financial Officer*
Phillip L. Schlosser, *Vice President*
Chris Brown, *Technical Director*
Nicole Elliott, *Manager*
Monika D. Lynde, *Manager*
Rachel Faulise, *Manager*

Founded in 1888, the National Geographic Society is one of the largest nonprofit scientific and educational organizations in the world. It reaches more than 285 million people worldwide each month through its official journal, NATIONAL GEOGRAPHIC, and its four other magazines; the National Geographic Channel; television documentaries; radio programs; films; books; videos and DVDs; maps; and interactive media. National Geographic has funded more than 8,000 scientific research projects and supports an education program combating geographic illiteracy.

For more information, please call 1-800-NGS LINE (647-5463) or write to the following address:

National Geographic Society
1145 17th Street N.W.
Washington, D.C. 20036-4688 U.S.A.

Visit us online at www.nationalgeographic.com/books

For information about special discounts for bulk purchases, please contact
National Geographic Books Special Sales: ngspecsales@ngs.org

For rights or permissions inquiries, please contact National Geographic Books Subsidiary Rights:
ngbookrights@ngs.org

Map on endsheets by Sahab Geographic and Drafting Institute, Iran, for Avakian Bros.

ISBN: 978-1-4262-0320-6

Library of Congress Cataloging-in-Publication Data

Avakian, Alexandra.
 Windows of the soul : my journeys in the Muslim world / Alexandra Avakian.
 — 1st ed.
 p. cm
 Includes index.
 ISBN 978-1-4262-0320-6
1. Islamic countries—Pictorial works. I. Title.
 DS36.6.A83 2008
 305.6'97'—dc22

 2008021389

Printed in USA